The Best of
Portrait
Painting

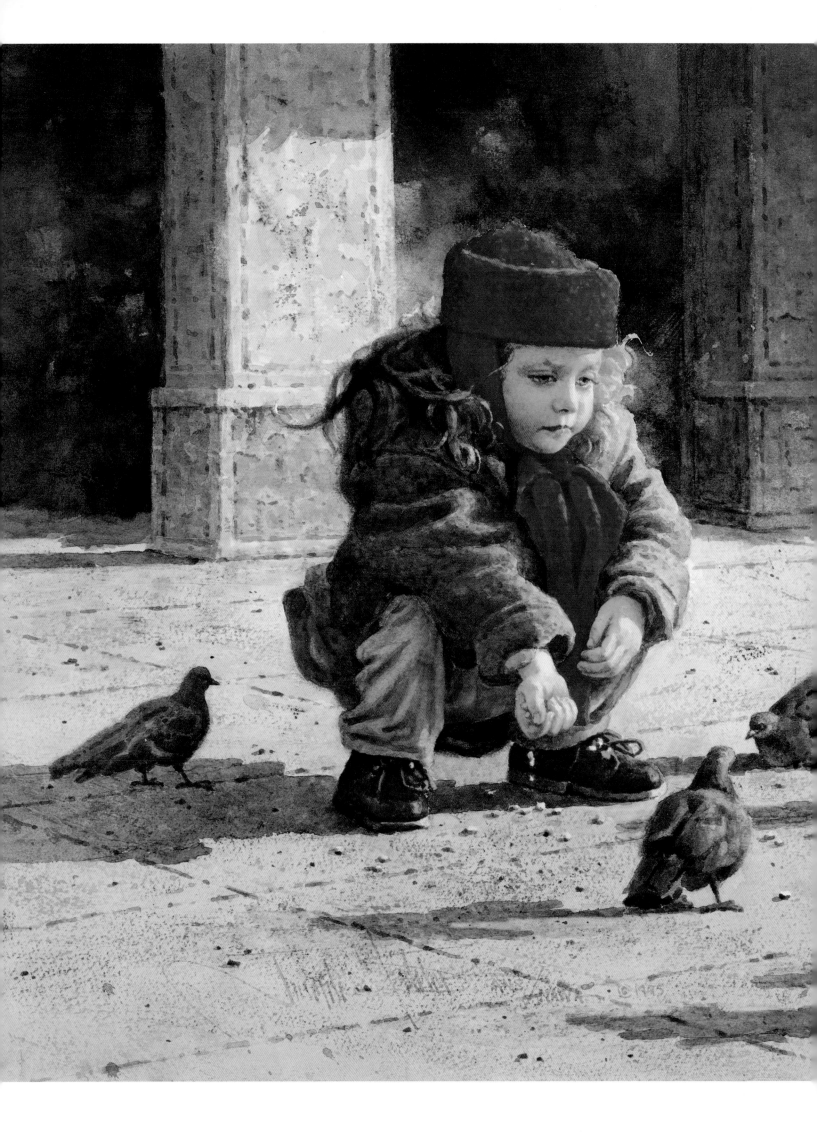

The Best of
Portrait
Painting

Edited by Rachel Rubin Wolf

NORTH LIGHT BOOKS

CINCINNATI, OHIO

ABOUT THE EDITOR

Rachel Rubin Wolf is a freelance writer and editor. She acquires and edits fine art books for North Light Books and, in this capacity, has the privilege of working with many fine artists who paint a wide range of subjects in a variety of styles. Wolf is the project editor for the *Splash* watercolor series and for many of North Light's *Basic Techniques* series paperbacks, as well as the books *The Best of Wildlife Art, Painting Ships, Shores & the Sea* and *The Acrylic Painter's Book of Styles and Techniques.*

Wolf studied painting and drawing at the Philadelphia College of Art (now University of the Arts) and Kansas City Art Institute. She continues to paint, in both watercolor and oils, as much as time will permit. She resides in Cincinnati, Ohio, with her husband and three teenage children.

The Best of Portrait Painting. Copyright © 1998 by North Light Books. Printed and bound in China. All rights reserved. No part of this book may be reproduced in any form or by any electronic or mechanical means including information storage and retrieval systems without permission in writing from the publisher, except by a reviewer, who may quote brief passages in a review. Published by North Light Books, an imprint of F&W Publications, Inc., 1507 Dana Avenue, Cincinnati, Ohio, 45207. (800) 289-0963. First edition.

Other fine North Light Books are available from your local bookstore, art supply store, or direct from the publisher.

02 01 00 99 98 5 4 3 2 1

Library of Congress Cataloging-in-Publication Data

The Best of Portrait painting / edited by Rachel Rubin Wolf. -- 1st ed.
 p. cm.
 Includes index.
 ISBN 0-89134-851-4 (alk. paper)
 1. Portrait painting --Technique. 2. Portraits -- Catalogs.
ND1302.B47 1997 97-22779
751.45'42--dc21 CIP

Edited by Rachel Rubin Wolf and Jennifer Long
Designed by Clare Finney
Cover Art: *Clare,* by Margaret Carter Baumgaertner, oil on linen, 32" x 26" (81.5cm x 66m).
Title Page Art: *Afternoon Sunshine — Piazza San Marco,* by Joseph S. Bohler, transparent watercolor on Arches 300 lb. cold-pressed watercolor paper, 22½" x 29½" (57cm x 75cm).
The permissions on pages 139–141 constitute an extension of this copyright page.

ACKNOWLEDGMENTS

Thank you to Tara Horton, Jennifer Long and Patrick Souhan at North Light, who helped with the myriad details of putting this book together.

A very special thanks to all the contributing artists who shared with us both their beautiful pictures as well as their insightful words, born of experience.

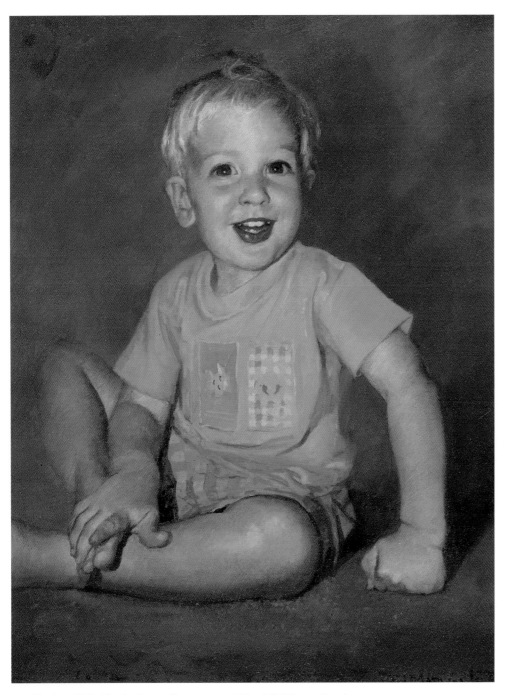

Brack by Ronald L. Marvin, Jr., acrylic on canvas, 30" x 24" (76cm x 61cm)

CONTENTS

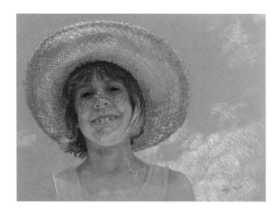

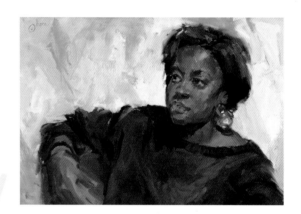

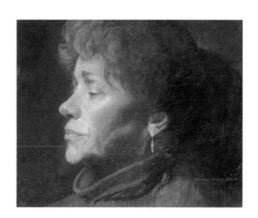

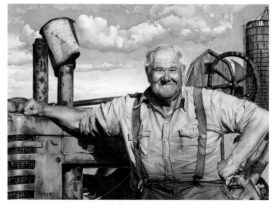

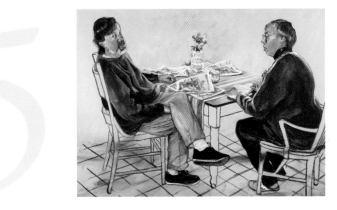

5

SET THE STAGE WITH
DESIGN & COMPOSITION *page 74*

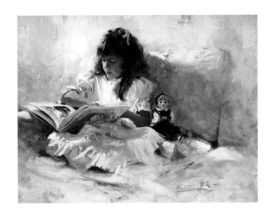

6

TURN THE VIEWER ON WITH
LIGHT
page 88

7

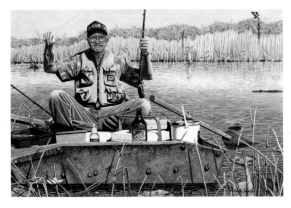

DESCRIBE YOUR SUBJECT WITH A
POSE OR GESTURE
page 104

8

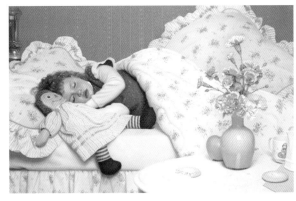

TELL A STORY WITH
SETTING OR PROPS
page 120

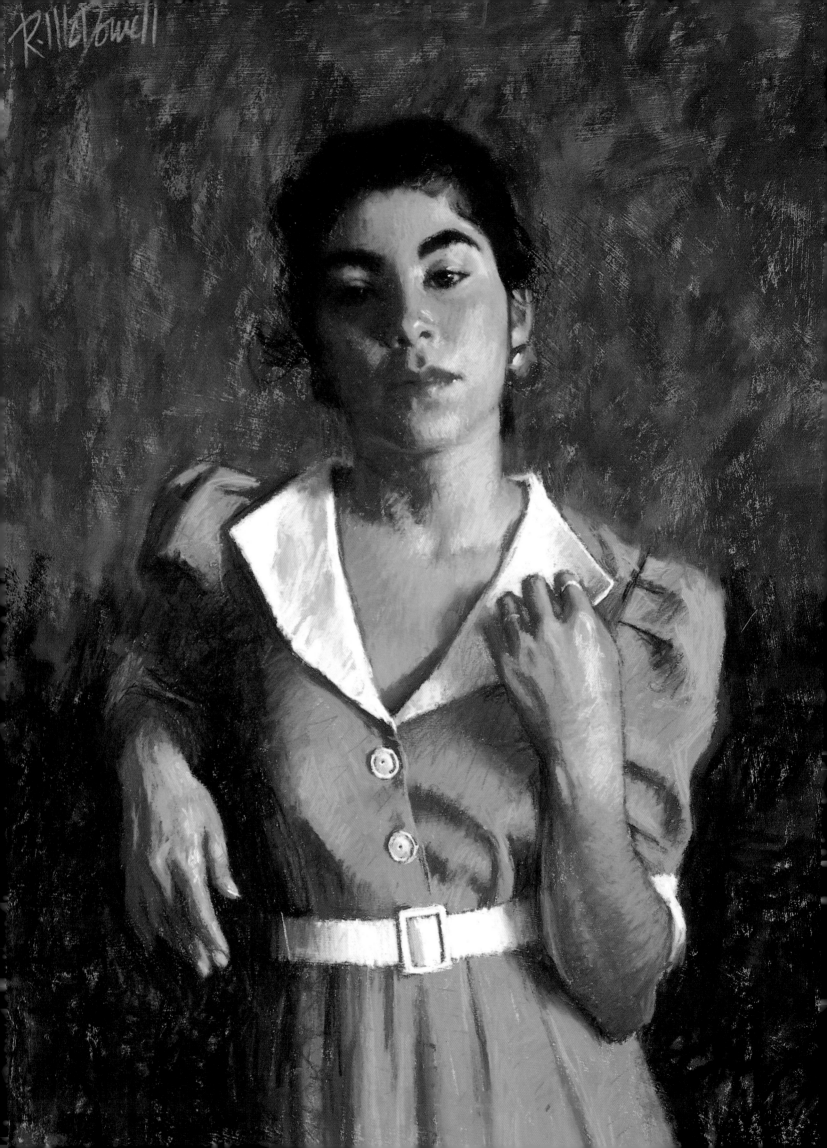

INTRODUCTION

No subject reveals the magic of painting as clearly as a portrait. The magic I speak of is that transformation that takes place — seemingly beyond the artist's effort — in which dots and splotches of paint, applied in carefully studied color and tonal value, suddenly become recognizable objects in space. How much more magical that transformation is when that recognizable object appears to be one of us.

There are cultures still today who forbid their picture being taken for fear of their soul being somehow captured. Perhaps it is a valid fear — certainly that's what the artists in this book seek to do in their portraits.

Most of the artists represented here feel that capturing a reasonable likeness is not enough — their higher goal is to communicate the personality and, yes, the "soul" of the subject. In addition to showing the personality of the sitter, many of the artists also want to express their own feelings about the sitter. All this with a little color on a two-dimensional surface!

There is no simplistic way to achieve this goal. Most of the artists say that working from life is always better when possible. An animated subject provides you with more information. But even those who most stress working from life still occasionally use photographs; many prefer to work from black-and-white photos along with color sketches

done from the live model, so that the capriciousness of color film does not affect the outcome of the painting.

Most, but not all, of those who paint children feel the need to work from photographic reference. Children are, after all, "moving targets," as one artist put it. But even those who work exclusively from photographs emphasize the need to spend time with their subjects to get to know him or her, as well as to take lots of pictures.

Almost all of the artists express the idea that a good portrait is not just a picture of a person, no matter how much it may look like the sitter: It is equally a work of art and must be successful as such, judged by the same artistic standards as any painting. It should be compelling to all viewers, not just those in the subject's family. Artist Joseph Sulkowski said, "The great figurative artists like Rembrandt, Velázquez and Sargent inspired me to see and appreciate that a portrait is first of all a work of art, one that is inspired by the beauty and grace of the human form and its expressive qualities."

With that in mind, I hope that the wonderful array of styles and concepts in this volume will inspire you and provide you with ideas that will bring you to a new level of excellence in your own endeavors in portrait painting.

— *Rachel Wolf*

White Lapels by Ron McDowell, pastel on pumice board, 24" x 18" (61cm x 46cm)

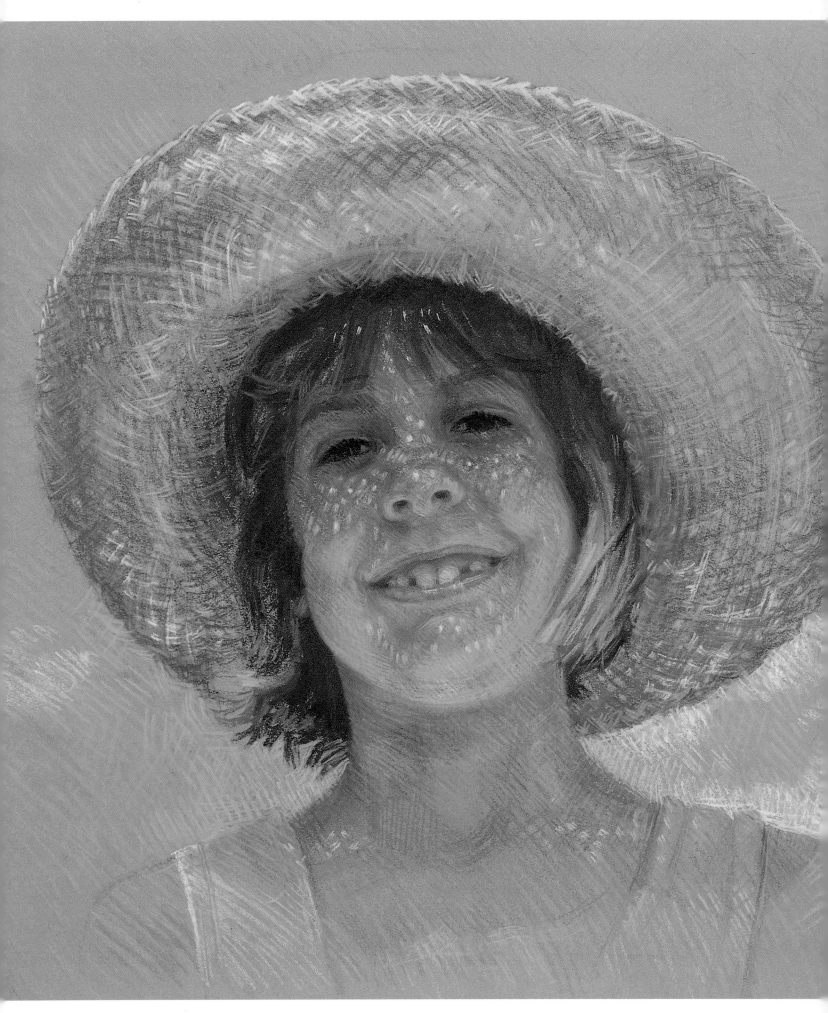

Smile by Carol Bruce, Rembrandt soft pastel on Holbein Sabretooth pastel paper, 23" x 28" (58.5cm x 71cm)

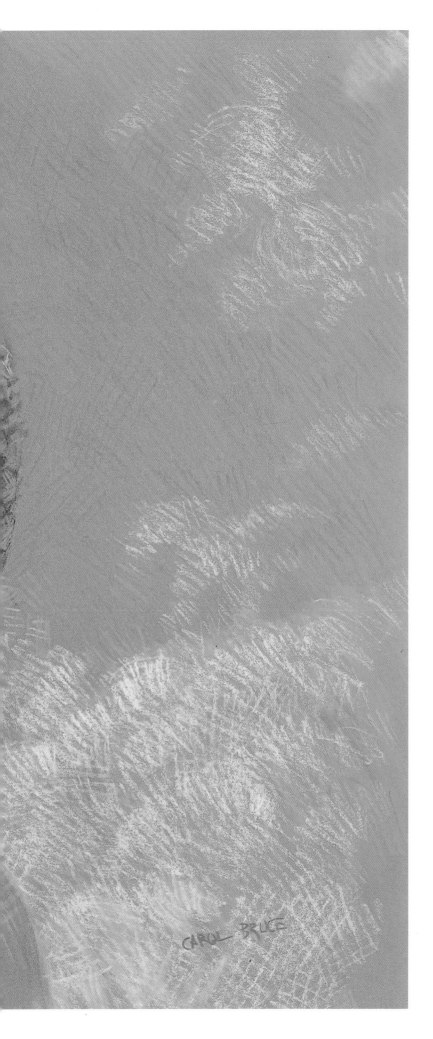

EXPRESSION OR ATTITUDE

Your subject's expression can determine the response to your painting. *Smile* was inspired by the expression of pure joy on this child's face, an expression enhanced by the playful sunlight filtering through her hat. Viewer reaction to the finished painting determined its title: It made everyone smile.

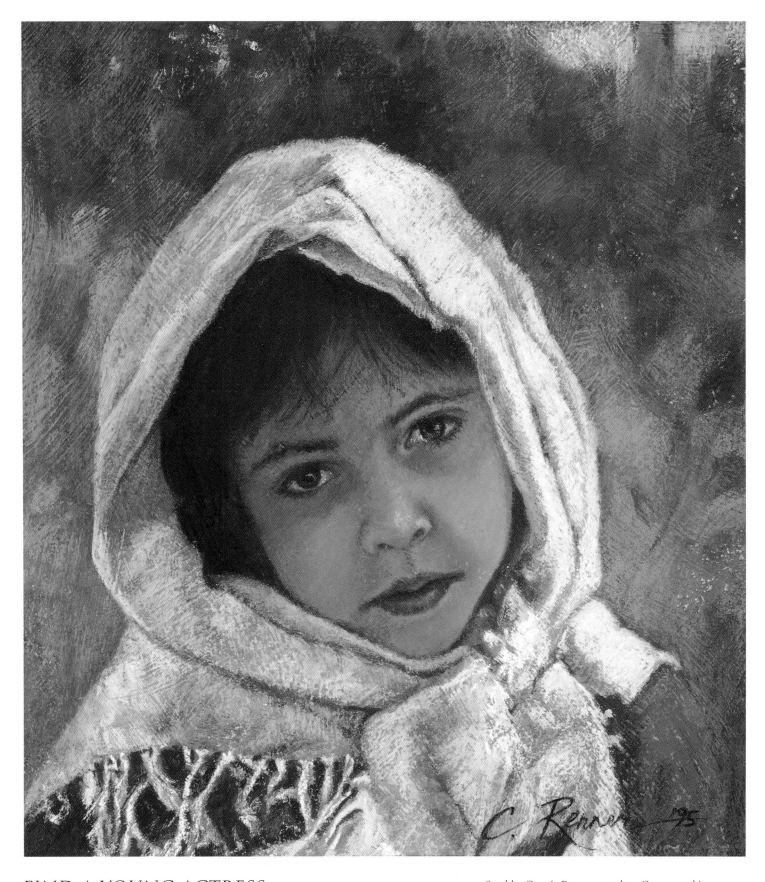

FIND A YOUNG ACTRESS

CONNIE RENNER

Sarah was inspired by a late-eighteenth-century Russian piece by Richard Clausen. I asked my five-year-old daughter, Sarah, what she thought the little girl in Clausen's piece was feeling. Sarah said, "I think she is hungry or has lost her family." I put a scarf on Sarah's head and asked her to pretend she felt the same way. I then painted her from the photographs I took. *Sarah* is painted on textured paper made by brushing a mixture of two parts acrylic gel medium and one part ground pumice onto German etching paper. I toned the surface with a medium-value cool green acrylic wash to complement the red fleshtones.

Sarah by Connie Renner, pastel on German etching paper, 13" x 12" (33cm x 30.5cm)

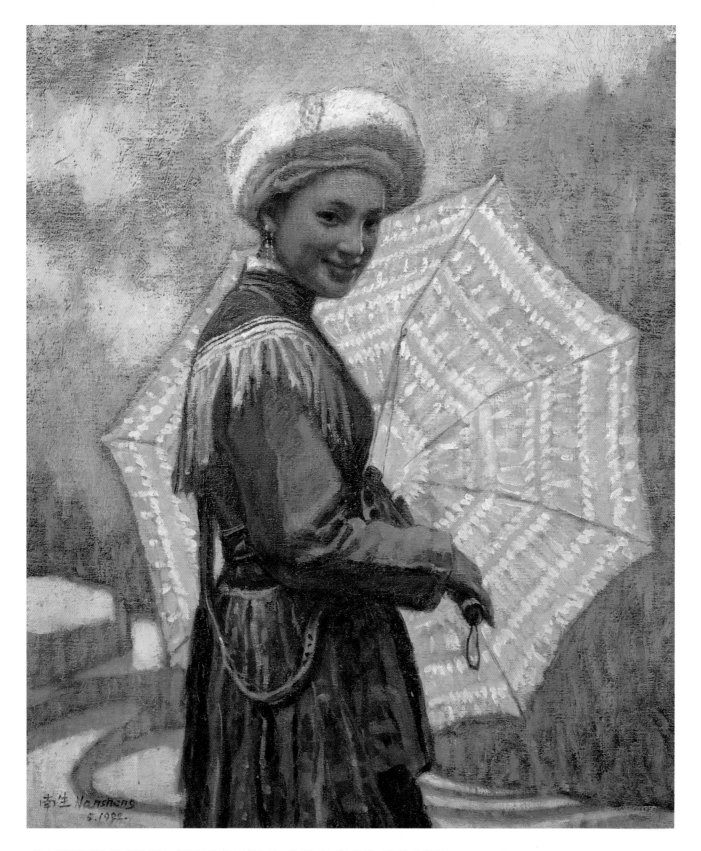

CAPTURE THE SHY SMILE OF INNOCENCE

NANSHENG LIU

Chinese Beauty in Yao Dress
by Nansheng Liu, oil on canvas,
22" x 18" (56cm x 46cm)

In the spring of 1991, I visited a Yao village in the mountainous regions of Guilin, China. During my visit, I stayed with the Zhangs, a traditional Yao farming family. Their seventeen-year-old daughter, Xiu Lan Zhang, posed for me — high in the misty mountains of Guilin — in a wedding dress that transformed her from a simple country girl into an exquisite beauty. As she opened her umbrella and smiled, I knew I had to capture the beauty of her innocence. Her shy smile reminded me of the magical fairies in Chinese legends. I usually paint the subject first and then the scenery, adjusting the background colors to achieve the desired effect. My handiest tool is a simple magnifying lens, which I use to study the picture for details while I am painting.

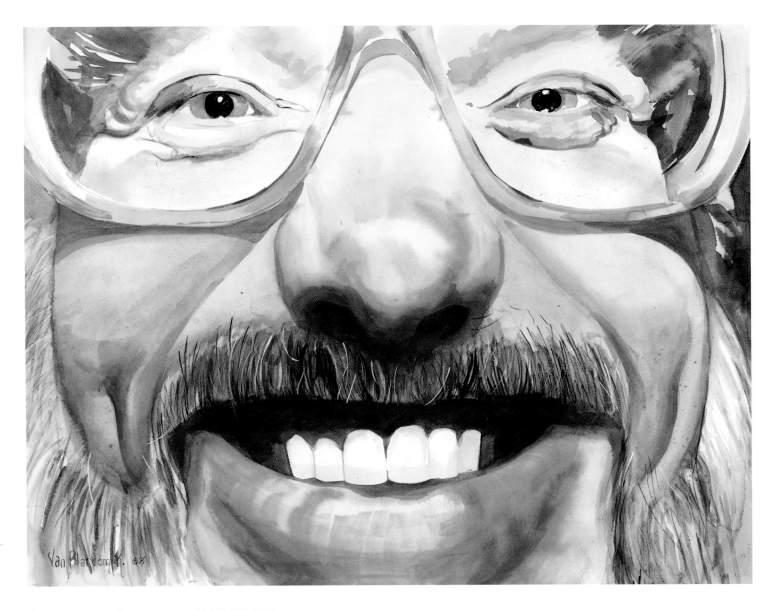

"HUMOR" YOUR SUBJECT

ANNE VAN BLARCOM KUROWSKI

The playfulness of my husband's grin tickled my soul. This image was painted from a spontaneous photograph taken at very close range, causing the distortion that I then exploited. Fully aware of the humor involved, it communicates more of his personality than I ever would have expected. I was grinning the whole time I was painting — I think it invokes the same response in viewers. Using only transparent watercolor, the colors were built up quickly, primarily wet-into-wet with a 2-inch brush. A few of the very fine whiskers were masked to avoid opaque overpainting.

Face Up by Anne Van Blarcom Kurowski, transparent watercolor on Arches 140 lb. cold-pressed paper, 22" x 30" (56cm x 76cm)

LET YOUR DESIGN ENHANCE EXPRESSION

JANE DESTRO

Many of my commissions are of children, and watercolor lends itself readily to expressing the delicate color and freshness of their skin. I prefer natural, informal poses, which are much more likely to reveal personality. This young lady's wonderful expression of directness and confidence is enhanced by placing the darkest values around her head.

I'm Ready! by Jane Destro, transparent watercolor on Arches 300 lb. cold-pressed watercolor paper, 30" x 22" (76cm x 56cm)

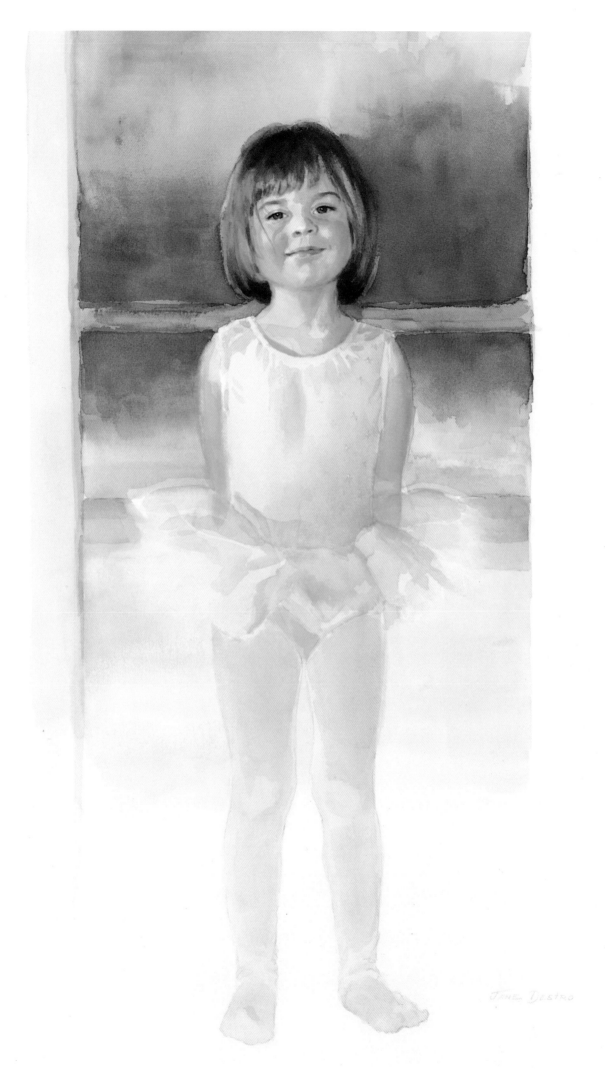

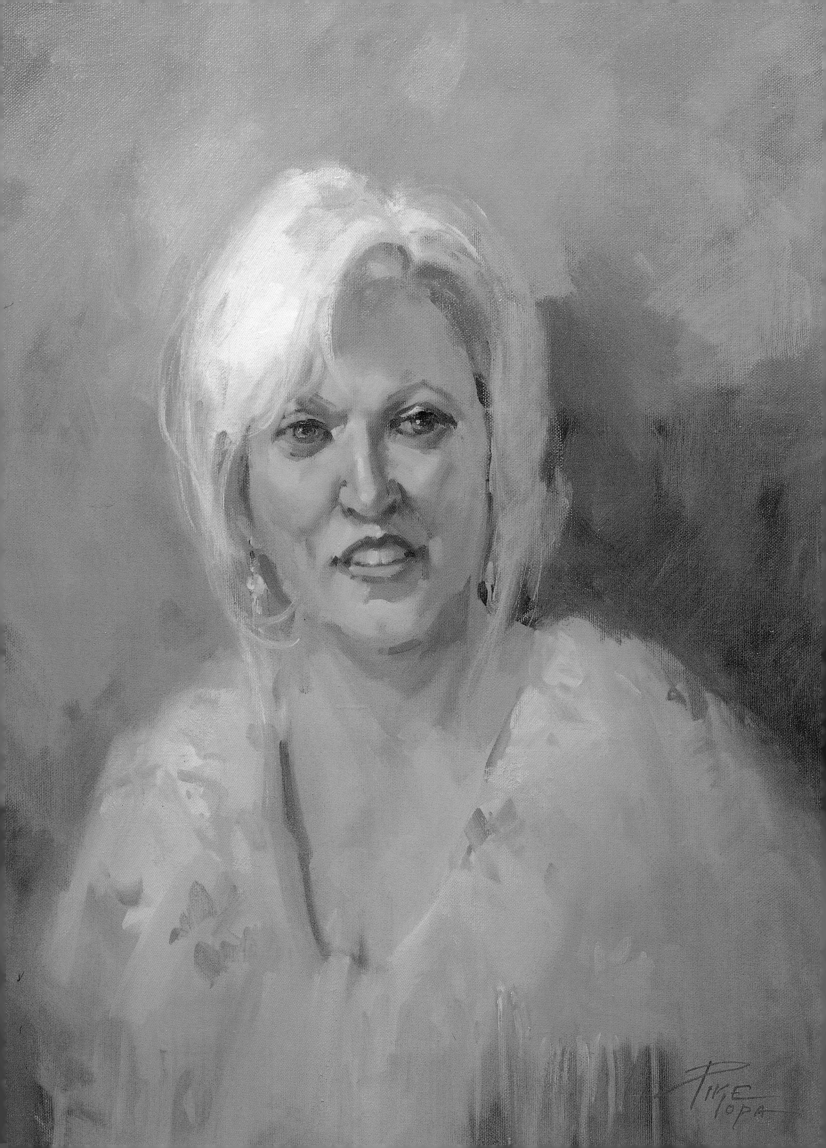

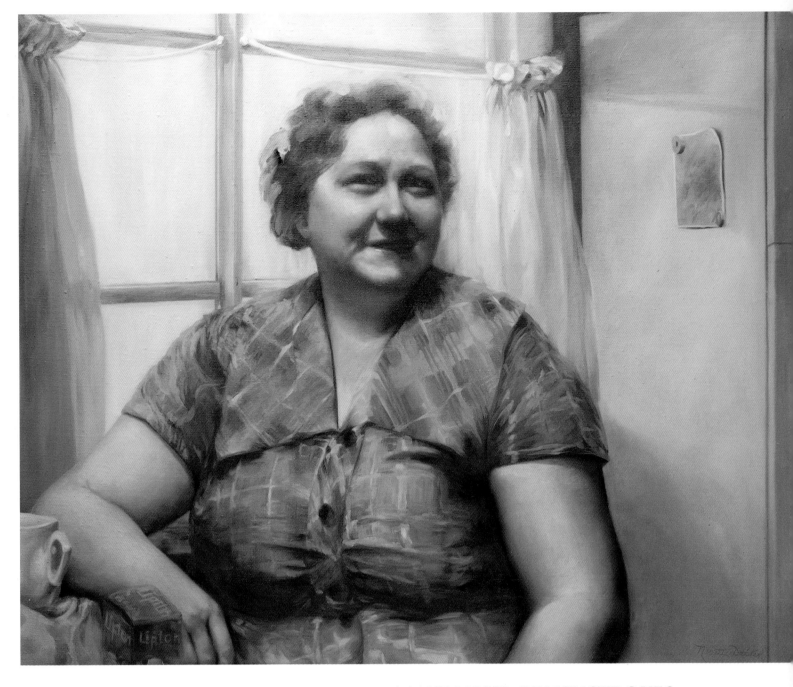

MAKE YOUR BRUSHSTROKES EXPRESSIVE

NANETTE DRISI

Leona is meant to inspire universal memories of mother and of shared moments. It shows a humble, loving woman in a modest setting. Beauty is shown in the commonplace: a quiet moment for tea, warm afternoon light streaming through a kitchen window and a snapshot of a loved one held to the side of a refrigerator with magnets. Leona's expression, with her laughing eyes and warm smile, is enhanced by free, expressive brushstrokes. The paint was applied as pure color and blended on the canvas to achieve the desired effect. The portrait, painted from a posed subject, was completed from photographs.

Leona by Nanette Drisi, oil on linen canvas, 28" x 31" (71cm x 79cm)

FIND A FRIEND WITH A "MOVIE STAR" LOOK

JOYCE PIKE

If you need models, try using your friends and family. Jeanette is the sister of my dear friend and fellow painter, Anita Hampton. Jeanette is a beautiful woman, but the thing that excited me was that she reminds me of Mae West, with her platinum blond hair and that "come up and see me sometime" look. My basic fleshtone mixtures for shadows are Winsor & Newton Permanent Magenta and Grumbacher Thalo Yellow Green, sometimes with a touch of Cadmium Red Light or Cadmium Orange. To darken the shadow I add Sap Green. For lights I use Cadmium Yellow Light and Cadmium Red Light plus white.

Jeanette by Joyce Pike, oil, 24" x 18" (61cm x 46cm)

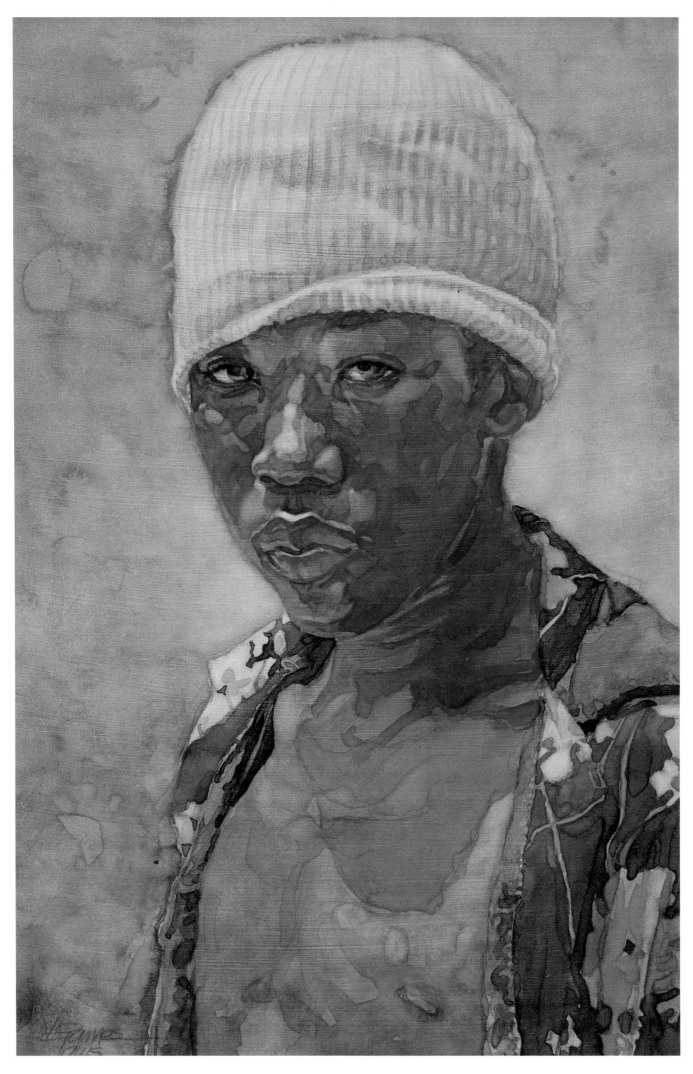

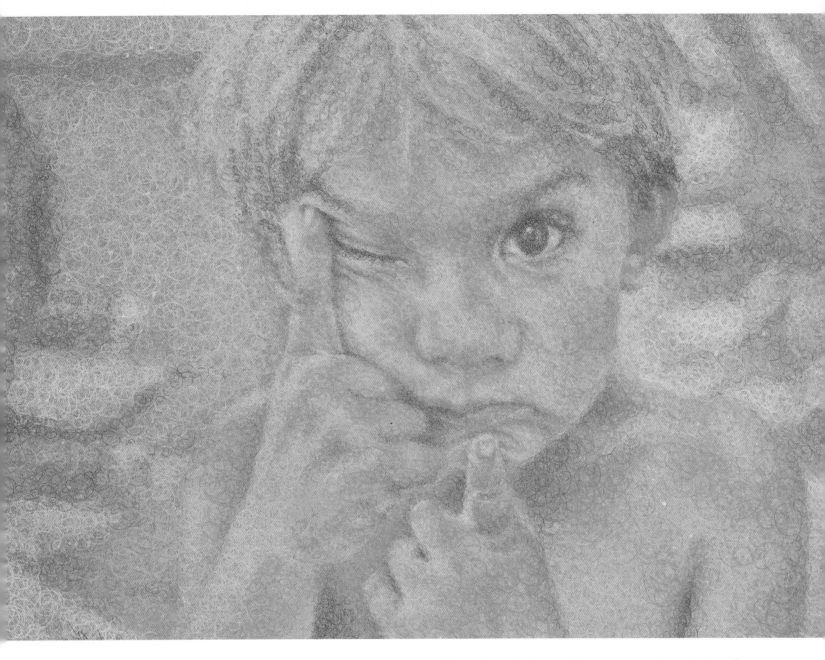

CAPTURE A "SERIOUSLY FUNNY" EXPRESSION

Maggie Toole

I was practicing taking pictures using the natural light in my studio when my three-and-a-half-year-old son, Rory, started getting creative with his poses. This image shows his "seriously funny" side, and is a great representation of who he is. I paid particular attention to that one big brown eye, making sure it would both pierce and melt the viewer at the same time . . . just like he does to me. My technique is called *Circulism*, which is the layering of color pencil circles. This method allows every layered color circle to show through and to mix right before the viewer's eyes. I always work on a color surface, whether it is an exotic wood, tinted clayboard or paper (in this case, a pale blue handmade paper). The image slowly appears, like a Polaroid picture, as I proceed to draw circles, working the whole area and alternating between building light and dark areas.

Candidly Posed by Maggie Toole, color pencil on handmade paper, 19½" x 25" (49.5cm x 63.5cm)

BRING OUT EMOTIONS WITH A WARM BACKGROUND

Bill James

One day I noticed this young man mowing a lawn and asked if I could take his photograph: I loved what he was wearing and just had to have a shot of him. Most of the time when people pose for a camera they smile, but he didn't: He just stared at me! I remember thinking this was unusual, but I did want to capture the real person. When I saw the photo I had taken, I knew I had — it looked as though he was staring right through me. To bring out the emotion on the subject's face, I made the background warm and monochromatic. I also kept it simple to bring out his beautiful shirt and so the focus would be on his eyes. I worked on a gesso-coated illustration board. After applying a warm wash of color over the whole surface, I rubbed out the lighter areas of the subject and then worked with wet-on-wet and glazing techniques to complete the piece.

Stocking Cap by Bill James, transparent gouache on gessoed board, 17" x 11" (43cm x 28cm)

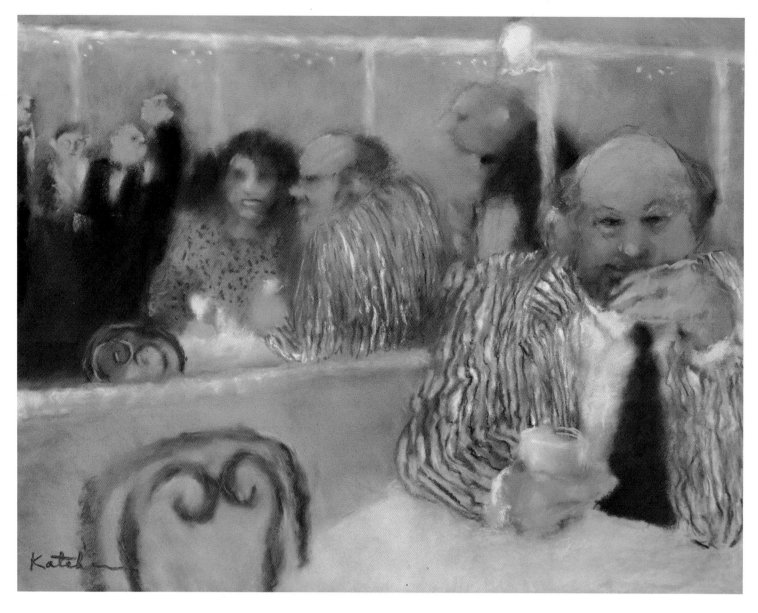

CONVEY PERSONALITY WITH EXPRESSION

CAROLE KATCHEN

This piece was commissioned by a friend who has Friday lunch with friends every week at Galatoir's restaurant in New Orleans. I focused on my friend, making him the largest figure, but instead of putting him in the center, I placed him on the right, with a mirror reflection showing his companion and the restaurant on the left. Rather than a photographic likeness, I wanted to convey his friendly, slightly mischievous personality, so the expression is more important than the actual features. Even so, people who know Bill easily recognize that this is a portrait of him. I blended the soft pastel with my fingers and the flat side of the pastels to get a hazy effect in the mirror image. The stripes contrast nicely with the smooth areas.

First Martini at Galatoir's by Carole Katchen, Sennelier pastel on La Carte paper, 19" x 25" (48cm x 63.5cm)

RECOGNIZE THE RIGHT POSE

JAMES E. TENNISON

Don't begin a portrait sitting with too many preconceived ideas. The plan for Rush's portrait was to paint her outdoors in a flower garden. As I was preparing to go outside, Rush very naturally struck this pose while she waited. Her expression and gesture captured her personality perfectly — a directness, a delight in living and a certain sparkle in her eye. One of the most helpful tips I have ever received was from the great portraitist and figure painter, Joe Bowler. He taught me to use a palette knife to carefully scrape off paint that has built up too thickly on my canvas. This enables me to control the entire painting surface and creates a wonderful underpainting to build on.

Rush by James E. Tennison, oil on Claessens Belgian linen, 36" x 24" (91.5cm x 61cm)

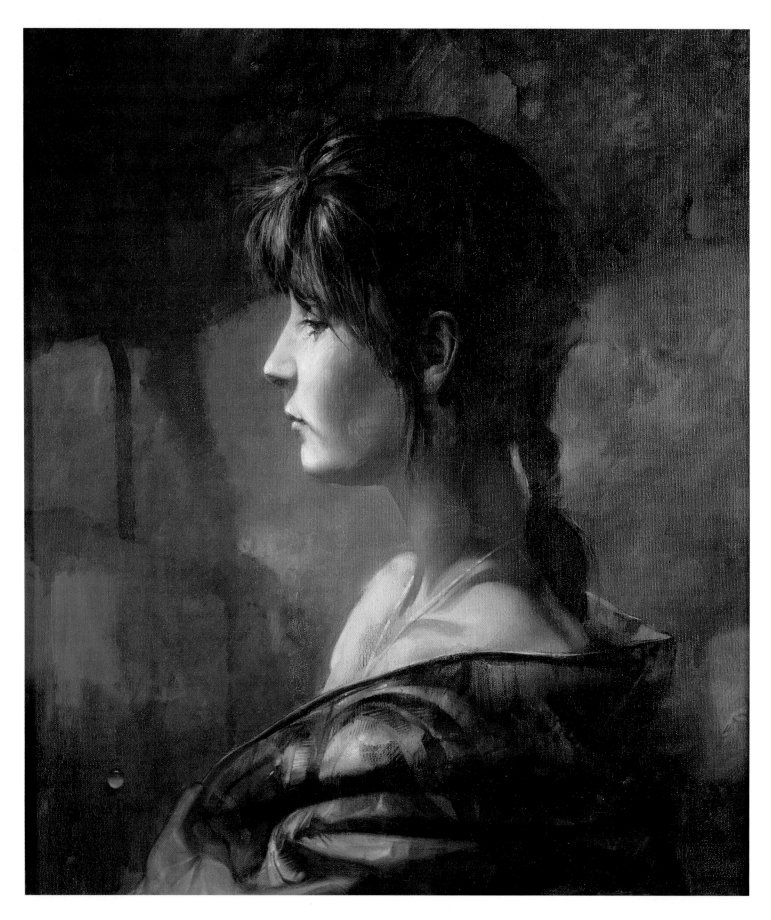

Donna by Mohamed Drisi, oil on canvas, 24" x 20" (61cm x 51cm)

BE SIMPLE, NOT SIMPLISTIC

MOHAMED DRISI

It seems profile paintings are relatively rare. Their perceived simplicity may be a threat to the name and reputation of unsuspecting artists. And not all subjects are endowed with aesthetically satisfying profiles. Donna's face, however, revealed a humble but genuine beauty, scrubbed of artificiality. I saw a profile that had a precious universal appeal. My task was to underline all that I saw in it while taking care not to exaggerate or diminish the modesty of her natural beauty. Simplicity is good; simplistic is dreadful.

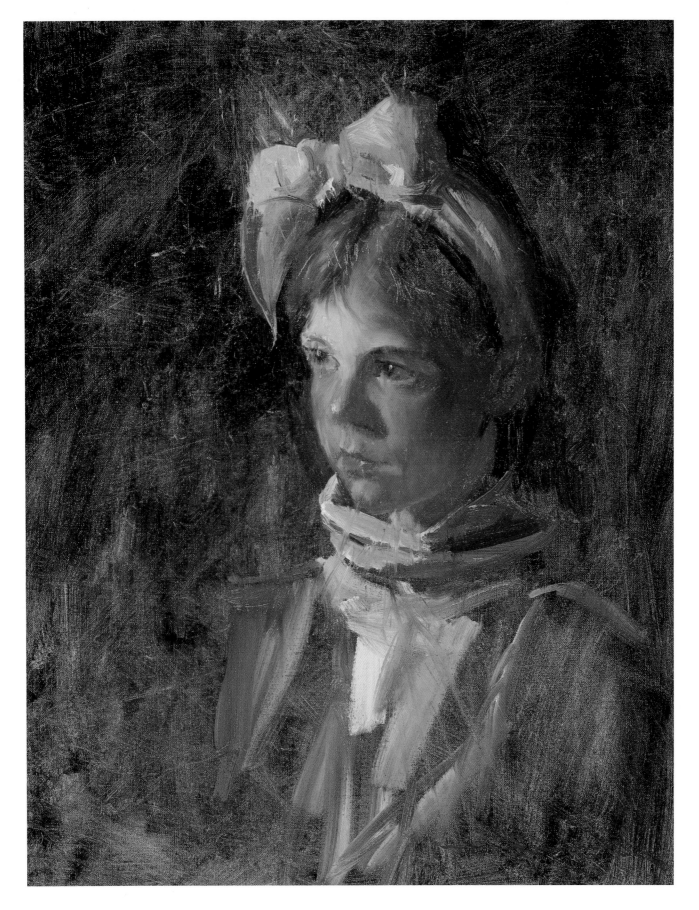

TRY PAINTING A CHILD FROM LIFE

CHARLES WARREN MUNDY

Jessica is my eleven-year-old niece who was visiting our home for a day. She is one of eight children in a family and lives in a humble, Christian atmosphere. Jessica's opalescent face, coupled with the bow in her hair and the informal collar, was the inspiration. The beautiful innocence of children is a great treasure. This three-hour, from-life study was quite a challenge in discipline for Jessica. Value and lost and found edges are to me the most crucial aspects in a painting. Using color and proper relationships of smooth and rough brushstrokes, I try to paint masses and cut out the "fluff and duff."

Jessica by Charles Warren Mundy, oil on portrait linen, 20" x 16" (51cm x 41cm)

ENHANCE YOUR SUBJECT WITH

COLOR

Don't limit your colors to typical "fleshtones." To make the most of this model's rich, chromatic skin tones, Anne Marie Oborn contrasted the reds in the model's face with the greens in her sweater, heightening the drama even more with the light background.

Cecile by Anne Marie Oborn, oil on untempered Masonite prepared with Liquitex Gesso/modeling paste, 14" x 18" (35.5cm x 46cm)

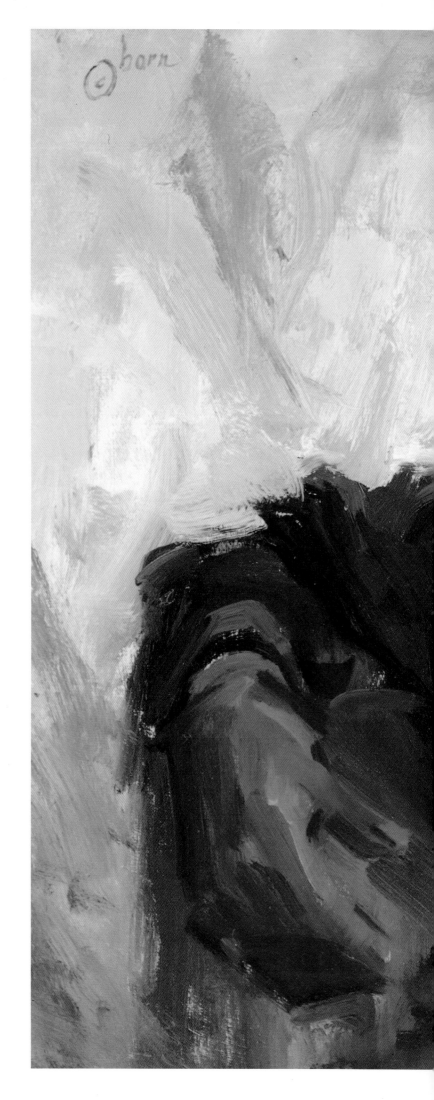

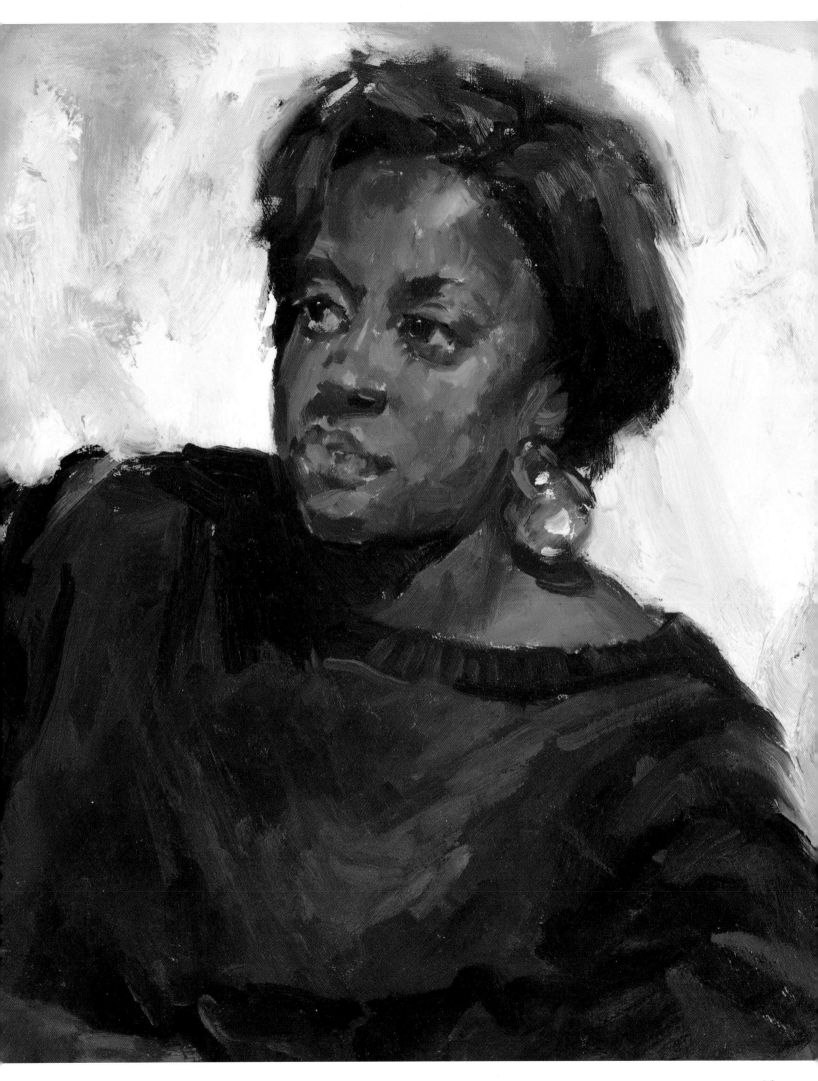

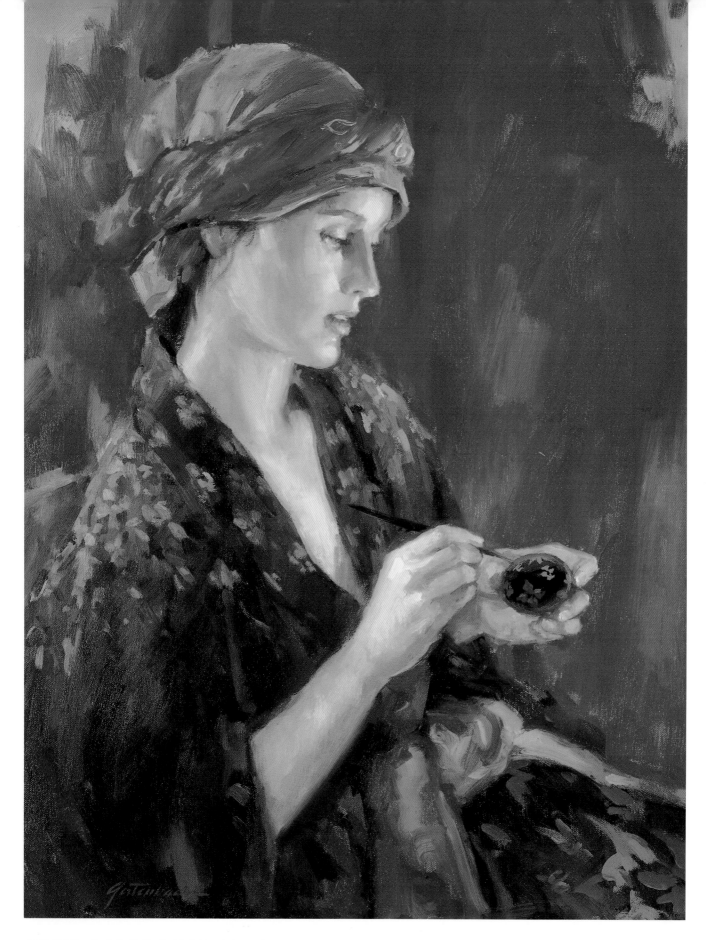

RICH COLORS FOR AN OLD-WORLD FEELING

LYNN GERTENBACH

My friend and model, Bonnie, is of Ukrainian heritage; together we came up with her costume. I was excited about the red background, which created a warm old-world feeling and set off the rich colors in the handpainted egg. Red is a dominant color, so I needed the strength of the darks and the other pure colors for weight and contrast. I lit her face to create a candlelight effect and to stay within the warm-color hues. My skin tones are determined solely by the colors surrounding the subject. In this painting I wanted to evoke the warmth, intimacy and tradition reminiscent of turn-of-the-century Russian masters.

The Ukrainian Egg by Lynn Gertenbach, oil on linen canvas, 24" x 20" (61cm x 51cm)

USE COMPLEMENTS TO CREATE "VIBRATION"

CARON TUTTLE

Erinn by Caron Tuttle, oil on oil-primed linen, 14" x 18" (35.5cm x 46cm)

Subjects attract me on a purely emotional level, but to convey my original vision I concentrate on design, drawing and the true colors of light. I apply masses of color washes to double-oil-primed linen canvas to see color relationships. Mixing paint minimally to create brilliant effects, I place complementary colors next to each other to create "vibration." I vary my techniques with the use of both impasto and thin washes, changes in brushstrokes, areas of bright broken colors and sharp or soft edges.

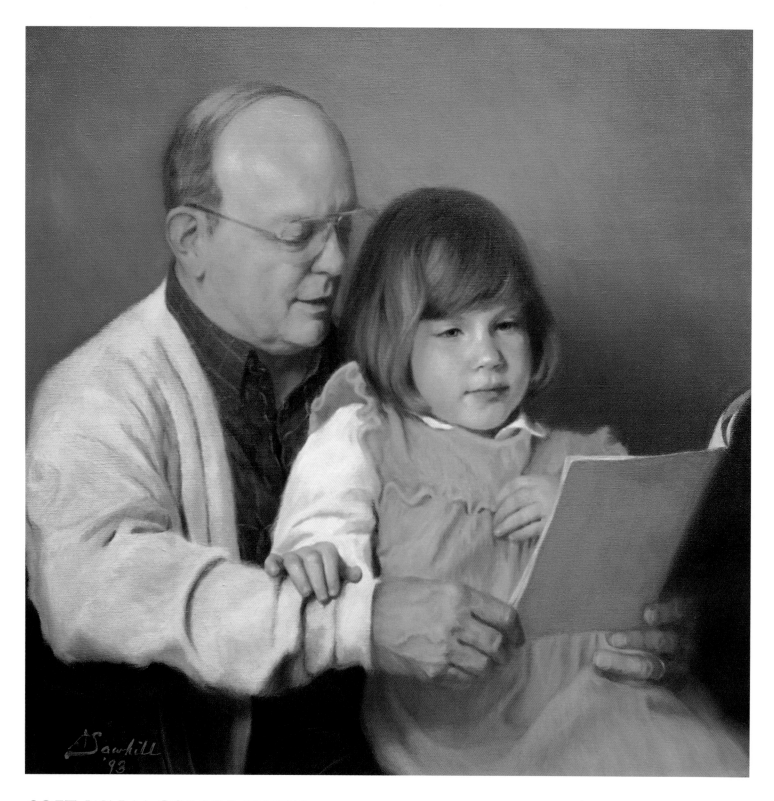

SOFT, WARM COLORS SHOW INTIMACY

Dona R. Sawhill

This composition really created itself, as it was so natural for our granddaughter Katie to be sitting in "Papa's" lap to hear a story. I wanted to capture that warm relationship between them and show her completely enthralled with the book. Enveloping the two figures in delicate, warm skin tones, even in the background, creates an endearing, intimate portrait. Because Katie was so pleasantly occupied, I was able to sketch and take photos. When Katie wasn't available, my husband held a large, dressed-up panda bear while I painted!

Storytime for Katie by Dona R. Sawhill, oil on linen, 24" x 24" (61cm x 61cm)

STUDY OUTDOOR COLOR FOR STUDIO PAINTING

Carl J. Samson

Color is an enticing aspect of any painting. I've found that through painting and studying outdoor color relationships and atmospheric effects, I am better equipped to take on color's subtleties inside the studio. I took special joy in painting Amanda's dress. Arranging it in the chair, I was able to carefully study the wonderful interplay of warm and cool color vibration that comprises everything we see.

Amanda by Carl J. Samson, oil on linen canvas, 42" x 36" (107cm x 91.5cm)

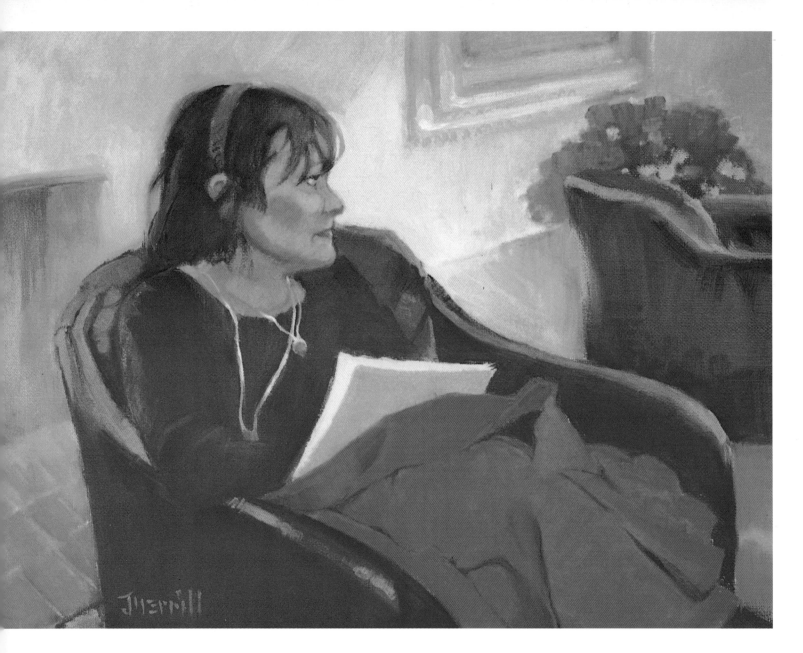

STRONG COLORS CAN MAKE A STRIKING IMAGE

JUDITH MERRILL

In Nedra Matteucci's Gallery in Santa Fe, my eye was caught by a girl with very black hair in a black dress set off by gold chains and a flaming red coat. The visual image was so striking that I asked her permission to take a photograph. The happy conclusion to this chance meeting came several months later when she bought the painting. I wanted to paint the vivid colors as strongly as I saw them. I used Ivory Black, Cadmium Red and Cadmium Red Light to achieve the vibrancy in the coat. The color was so strong that I had to heighten the girl's coloring and halo her head lightly with a warm tone so she would not be overwhelmed by the black and reds.

Girl With the Red Coat by Judith Merrill, oil on linen, 11" x 14" (28cm x 35.5cm)

DON'T LET YOUR BACKGROUND COMPETE WITH YOUR SUBJECT

BILL JAMES

At a Chinese festival in Miami, a children's musical program was presented. One little girl was so nervous that she constantly looked down at her mother, who was coaching her. I took several photographs of her, and chose this one because she was holding a beautiful green mask close to her face. The background in the photo was mainly blue, with red and yellow designed shapes; the effect was very busy, so I omitted the colorful shapes but kept the Ultramarine Blue. First I applied a blue and green wash to the surface of the pumice board with designers' gouache. I then drew in the subject using colors complementary to the final colors. In certain areas I glazed one color over another. The finished painting, with its loose, color-separated technique, is impressionistic in appearance.

The Green Mask by Bill James, pastel on pumice board, 29" x 19" (74cm x 48.5cm)

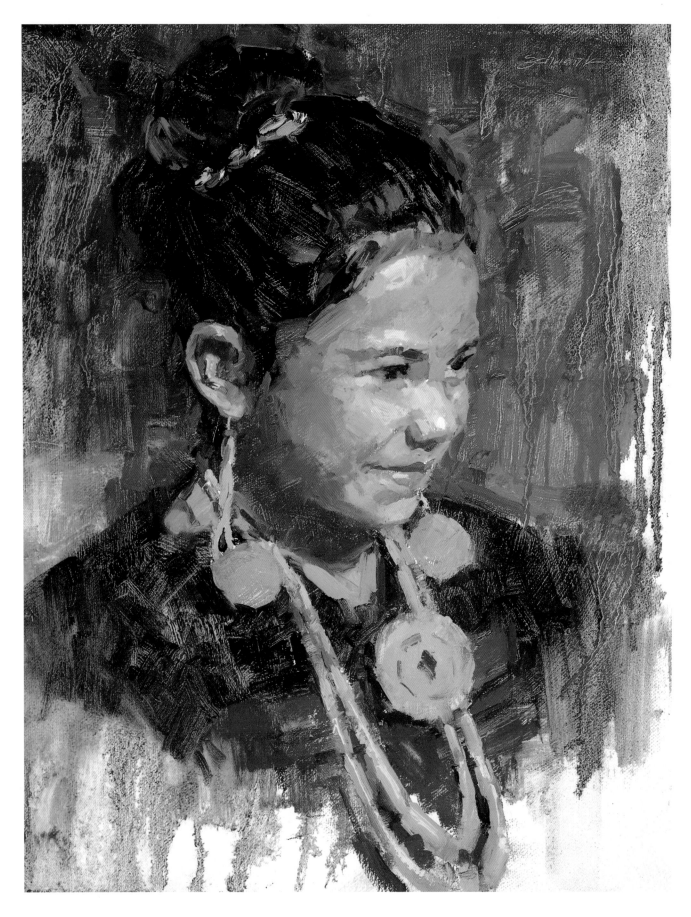

Pueblo Beauty by
Mary Beth
Schwark, oil on
canvas, 14" x 11"
(35.5cm x 28cm)

PAINT THE EARTH COLORS OF THE SOUTHWEST

MARY BETH SCHWARK

Pueblo colors are deeply rooted in the American Southwest. The earthy colors of the costumes and ornamentations complement Native American skin tones. *Pueblo Beauty* is a portrait of a young, fresh-faced girl donning traditional turquoise jewelry. To create the lively textural background in this portrait, pigment, mineral spirits and a bit of sun-thickened linseed oil were loaded onto a no. 11 bright brush and applied liberally. A clean, broad sable brush with fresh mineral spirits was used to achieve the dripping effect.

CONTINUE COLOR AND PATTERNS INTO THE BACKGROUND

MIKKI R. DILLON

Nigerian Dreaming by Mikki R. Dillon, pastel on Ersta Starcke sanded paper, 27" x 21" (69cm x 53.5cm)

This model, so obviously dignified and proud of her heritage, really intrigued me. I love to paint textures and found her clothing particularly interesting and challenging. I toned my sanded pastel paper with Nupastels in warm colors, using mineral spirits in a wash. The portrait was completed using various brands of soft pastels. The problem of background solved itself in the wonderful fabrics the model was wearing: I simply continued some of the pattern and colors into the area surrounding her profile.

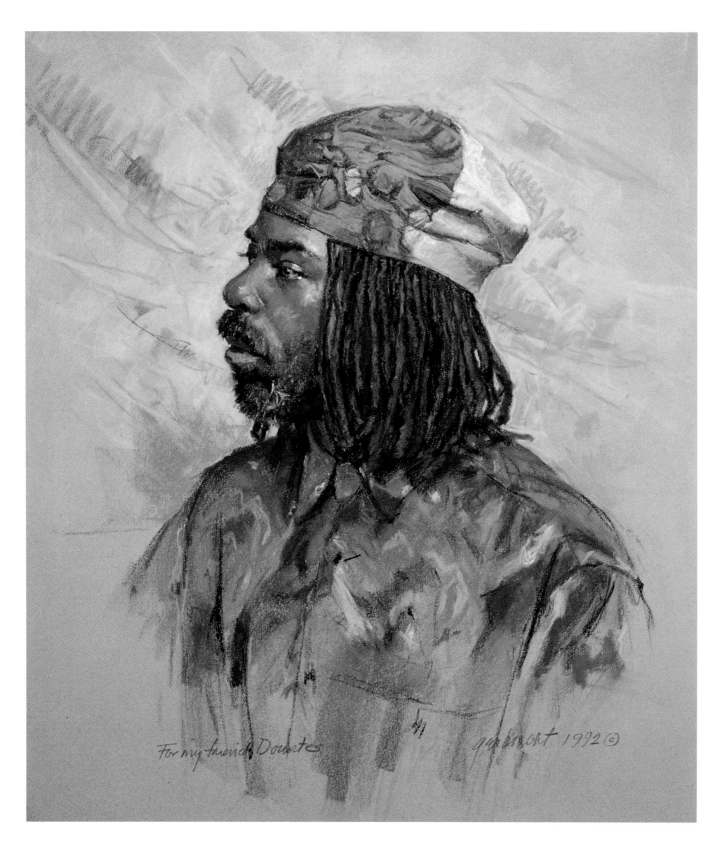

LET PERSONALITY FLOW INTO THE BACKGROUND

BOB GERBRACHT

I always look for uniqueness in people, and Dountes had too much to pass up! The picture was painted from life. I started with a plain yellow drape on the wall behind the model, but as I worked I found that to capture Dountes' colorful appearance and his lively spirit, the background needed decoration as well.

Dountes by Bob Gerbracht, pastel on Canson Mi-Teintes paper, 25" x 19" (63.5cm x 48.5cm)

DON'T OVERLOOK A BLACK-AND-WHITE COLOR SCHEME

PAUL F. WILSON

To get portrait commissions, I needed a model for a sample piece. Jennine was a close friend and quite beautiful. After trying two ensembles, we decided on this dress because black and white were the colors she was most comfortable in and also because of my fondness for the portraits of Rembrandt and Frans Hals. This simple color scheme enhanced her rich fleshtones. I painted from dark to light in opaque paint, repeating this process many times and continually building up the values. Backgrounds are always a challenge, and I have literally copied them from paintings that I like to help me develop ideas.

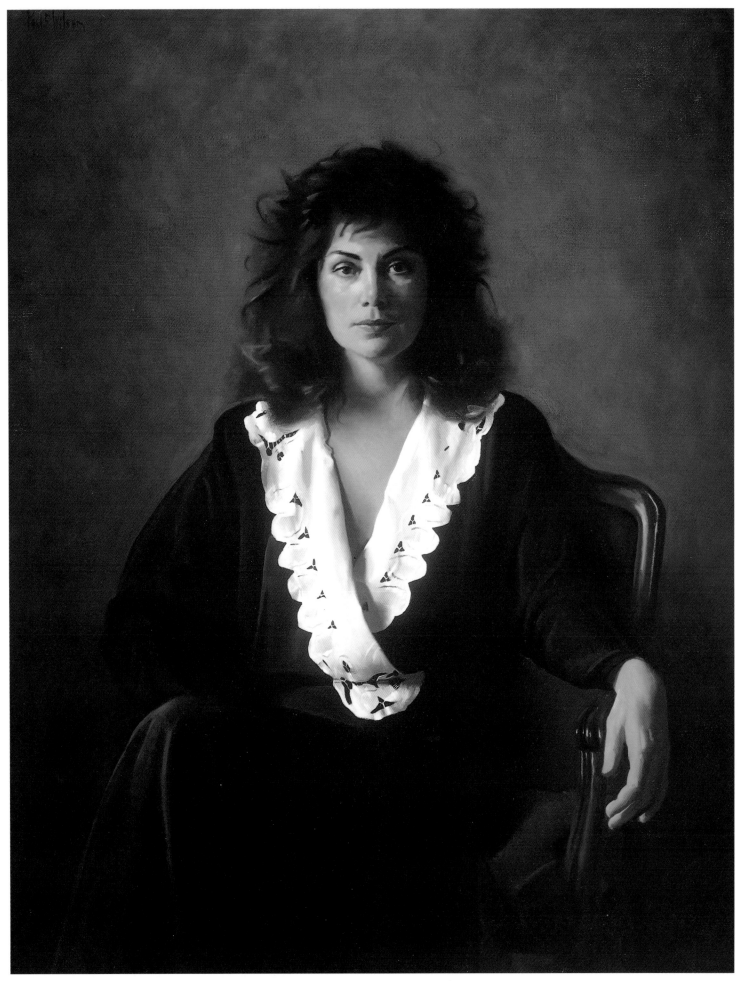

Jennine by Paul F. Wilson, oil on linen, 48" x 34" (122cm x 86.5cm)

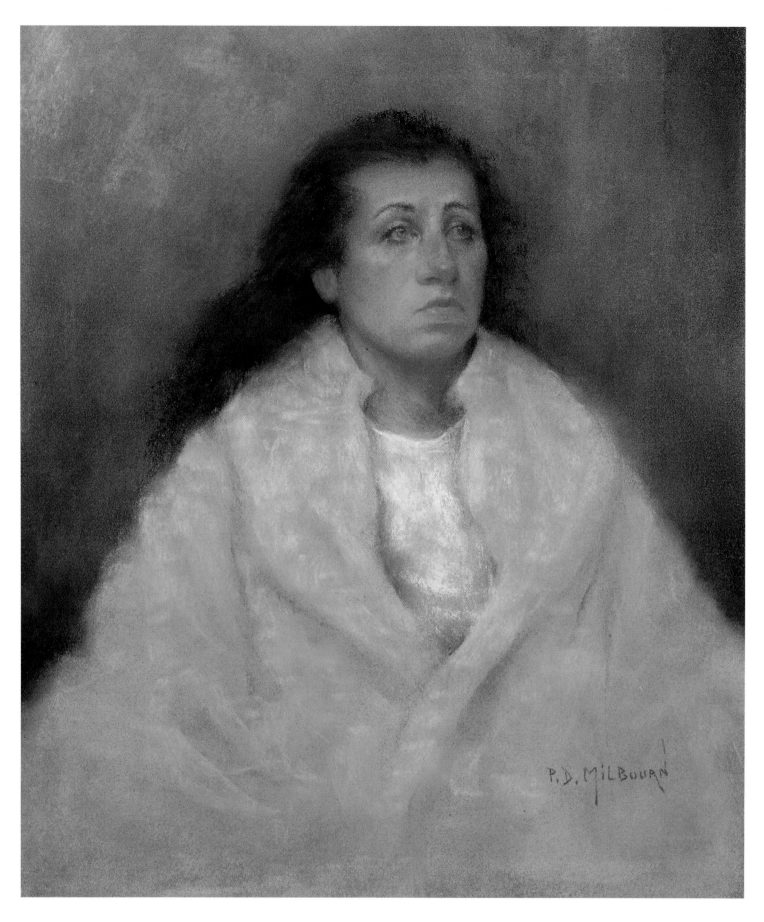

The Yellow Jacket by Patrick D. Milbourn, pastel on French Grey pastel paper, 16" x 12" (41cm x 30.5cm)

FEATURE ONE FLAT COLOR

PATRICK D. MILBOURN

The yellow jacket worn by the subject was an important contribution to the development of this painting. Limiting the background allowed this huge yellow overcoat to flow and disappear outside the boundaries of the paper. I kept the color of the jacket fairly flat, to avoid detracting from the actual portrait, but chose a textured paper to give the illusion of the rugged fabric of the coat. The model was visually compelling — long black hair, dark rough skin and dark brown eyes. Her demeanor fed the feeling I wished to convey. She was intense, yet had a spiritual presence — very silent, very strong.

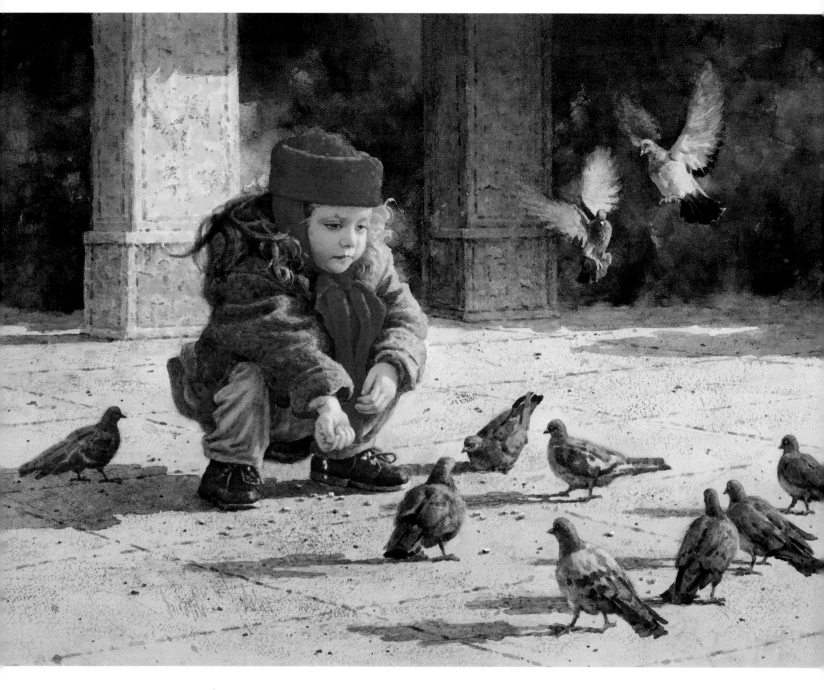

ADD FOCUS WITH A SPLASH OF BRIGHT COLOR

JOSEPH S. BOHLER

This little girl, with her face surrounded by red, was my inspiration. As I watched her feed the pigeons in the afternoon sunshine on Piazza San Marco in Venice, I thought of Rembrandt, who sometimes used a splash of bright color to bring life and focus to his subjects. The little girl was looking at the birds, but also looking beyond them in quiet, pensive glances. This is what I wanted to bring to the viewer. Normally I work from live models, but this painting required a couple of quick photos. For the skin tones, I used Winsor Yellow and Permanent Rose. A Cobalt Blue wash was painted over the fleshtones to suggest the influence of the blue sky.

Afternoon Sunshine — Piazza San Marco by Joseph S. Bohler, AWS, transparent watercolor on Arches 300 lb. cold-pressed watercolor paper, 22½" x 29½" (57cm x 75cm)

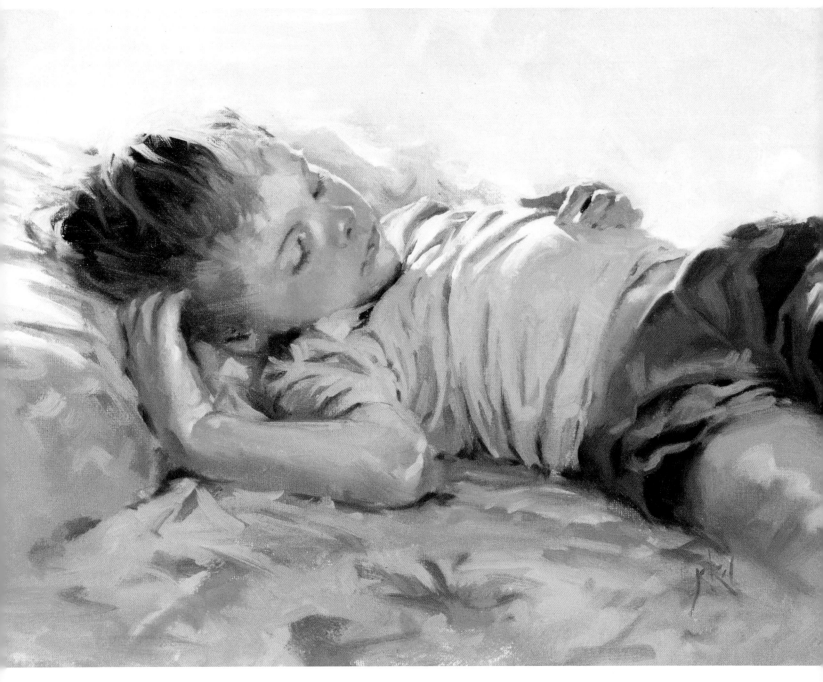

SUBTLE COMPLEMENTS CREATE A RESTFUL MOOD

BRIAN JEKEL

Whether in full gallop or at rest, a child's world is full of possibilities. I've done many paintings of children sleeping or playing on their beds. Colorful pillows, quilts and toys of all sorts add visual interest and often a storyline. In this piece, Jordan is taking a nap; warm sunlight caresses the upper and back edges of his head, back and arm. This piece is a study of subtle complementary colors and modeling. One of the most satisfying ways to paint is the direct method, where the artist simply starts with paint and develops the painting — beginning at the center of interest and working out from there. Try to get each stroke as correct as possible and then leave it alone. The end result is a rewarding balance between a painting of high finish and a spontaneous sketch.

Jordan by Brian Jekel, oil on linen, 12" x 16" (30.5cm x 41cm)

EXCITING COLORS WITH OILS

ANNE MARIE OBORN

I am inspired by the variety of ethnic forms in the cultures of the world. The innocence and vulnerability of this model in her native Korean costume seemed in sharp contrast to the war-torn history of her country. In a successful portrait, the spirit of the model must be communicated. For me, color is everything. No colors are as exciting as those that can be achieved with oils. Painting from a live model, as this portrait was, allows you to see firsthand the variety in the skin tones.

Remnants of Korea by Anne Marie Oborn, oil on untempered Masonite prepared with Liquitex Gesso/modeling paste, 16" x 12" (41cm x 30.5cm)

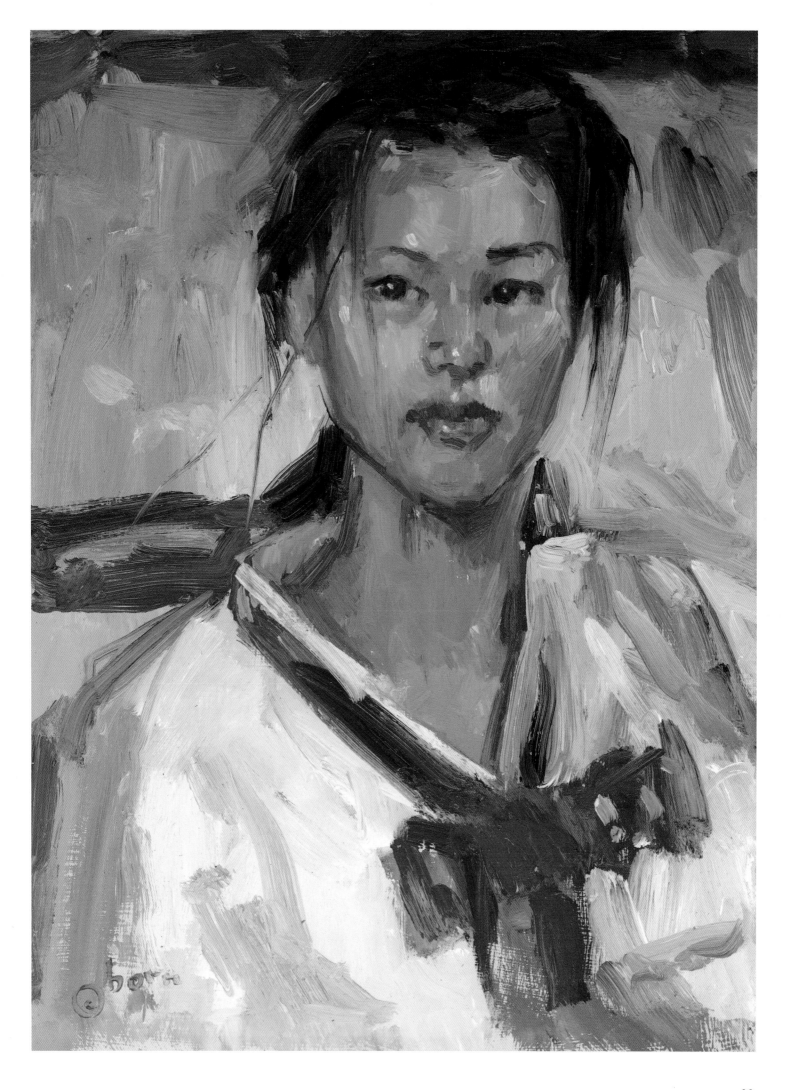

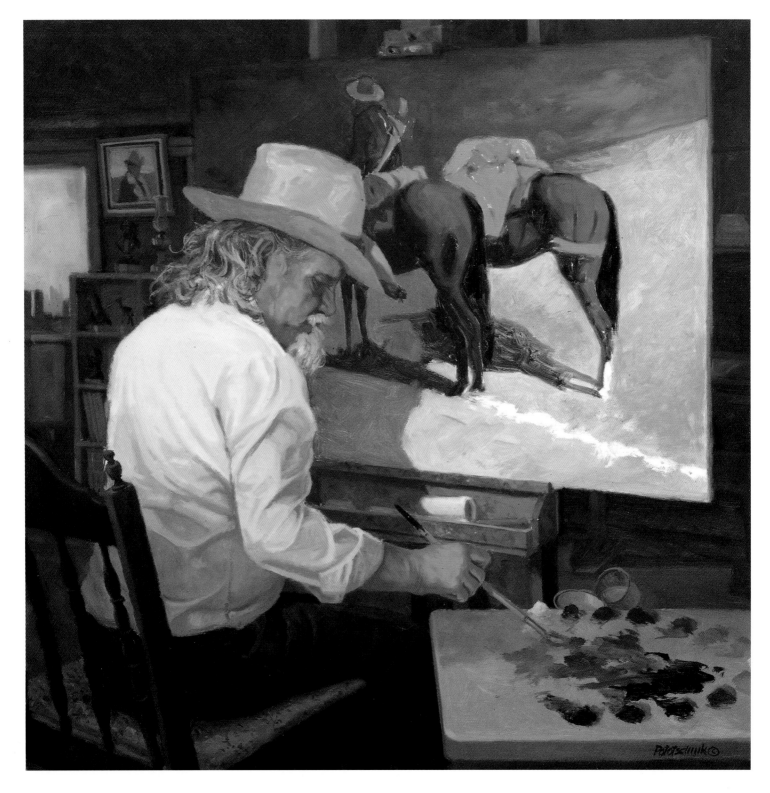

TRY USING A LIMITED PALETTE

JOHN POTOTSCHNIK

My friend, Bob Tommey, is all that the title of this piece implies. His advice to me as a fellow artist has always been helpful. Noted for his teaching of the color wheel, it's only recently that I've gained, with his help, a new level of understanding of color. Using only three colors — Alizarin Crimson, Ultramarine Blue and Cadmium Yellow Pale — plus white, Bob mixes all the complementary and tertiary colors to complete the twelve-part color wheel. This portrait not only portrays his physical appearance but also was done using his palette, subtly expressing his teaching.

Painter, Sculptor, Teacher, Friend by John Pototschnik, oil on Masonite, 23" x 23" (58.5cm x 58.5cm)

EXPLORE THE VARIETIES IN ONE HUE

OLGA J. MINICLIER

Initially this model sparked my interest with her extraordinary beauty, delicacy and serenely spiritual personality. The concept for this particular portrait came to me during a model break: No pose during several previous studies felt so right in describing her humanity. Exploring the warms and cools in light and shadow triggered such excitement that it was easy to sustain the concentration to complete this painting in one sitting. I started *Jamaican Red* with a thin wash of Burnt Sienna, which served as a unifying tone throughout the painting. It facilitated a loose treatment for the opaque and transparent whites in the blouse. For reds in the skin tones, I mixed Cadmium Orange with Permanent Rose to achieve greater subtlety and a broader variation of hues.

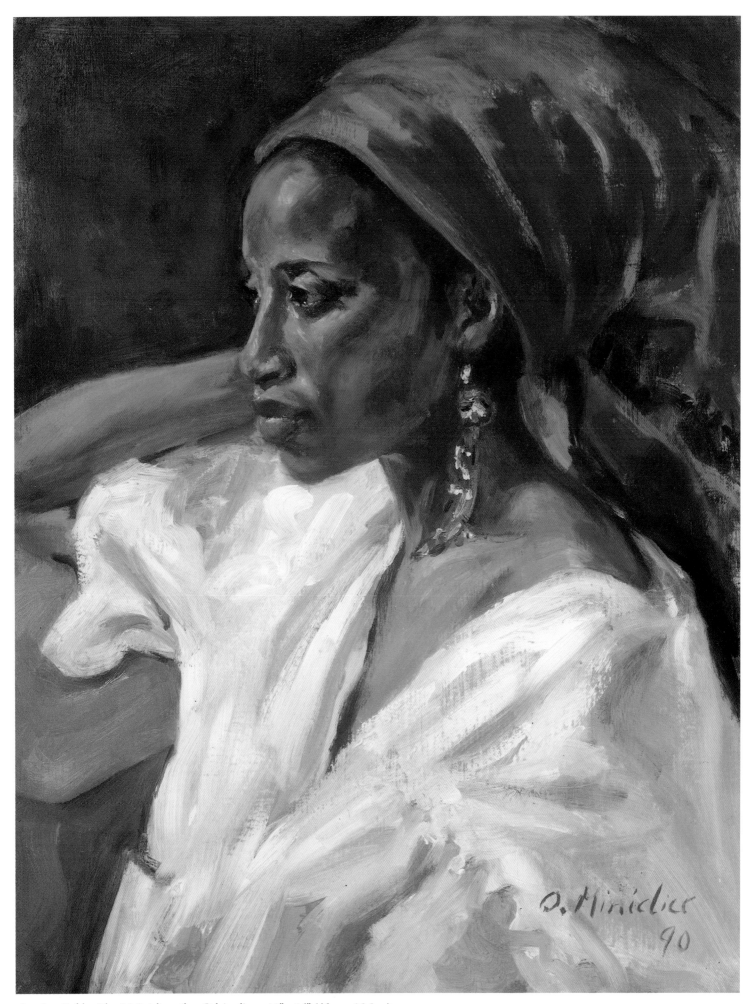

Jamaican Red, by Olga J. Miniclier, oil on Belgian linen, 18" x 14" (46cm x 35.5cm)

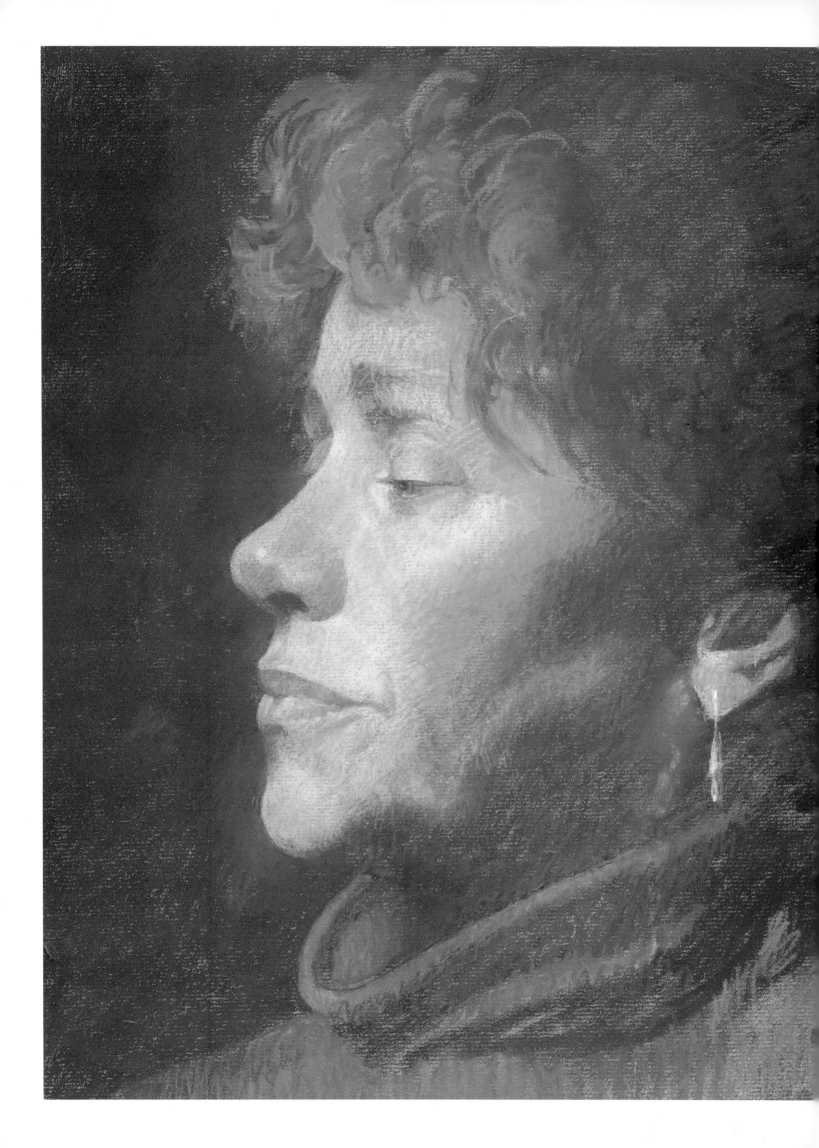

MOOD OR EMOTION

Envision a portrait from the inside out — an approach both spiritual and emotional. When Anatoly Dverin first saw her, he thought Clementine had a face that lit up from the inside. The strong features of her profile and her thick red hair made a deep impression on him. Because the subject seemed to be deep in thought, he deliberately half-closed her eyes and surrounded her with darkness. To visualize the inner self of a sitter takes more than pure technique, but good technique is still necessary to bring the work to a fruitful conclusion.

Clementine by Anatoly Dverin, soft pastel on middle-gray Canson paper, 16 ½" x 18 ½" (42cm x 47cm)

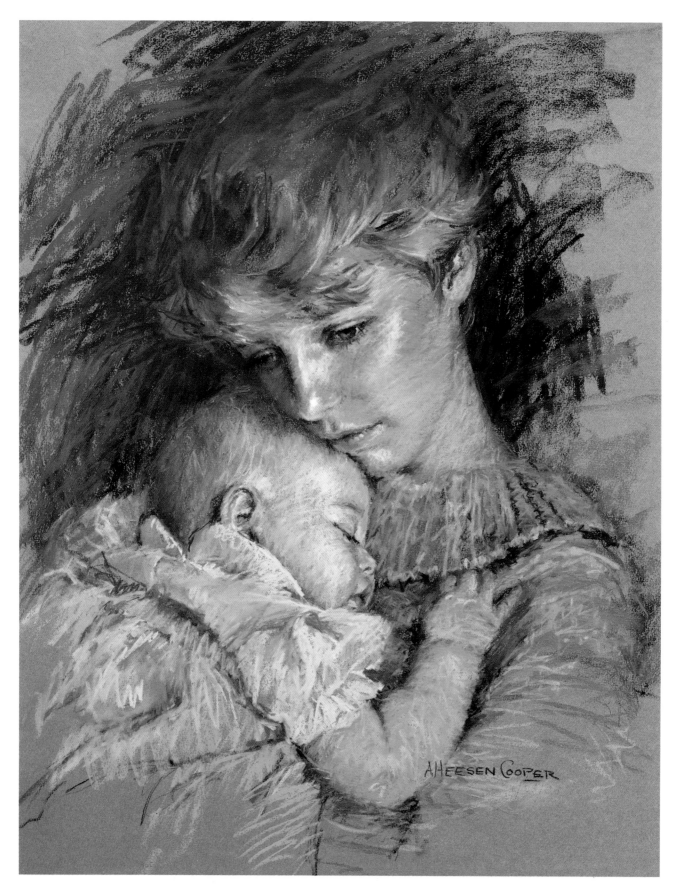

EXPRESS YOUR FEELINGS FOR YOUR SUBJECTS

A. HEESEN COOPER

Linda is my daughter, and the baby is my first grandchild. Because this was not a commissioned portrait, I was free from the usual restrictions that go with commissioned work: The color of hair or eyes didn't matter; the clothes didn't matter; I didn't need to bring out the best features or show full frontal or three-quarter views. Nothing mattered but the intense emotion I felt for both of my subjects. Having painted many hundreds of portraits in pastel, I painted intuitively, with no thought of technique. Grayed or muted colors are achieved by layering pure warms and cools, rather than by using grays. I never smear the pastel, so each color remains fresh and clear.

Linda & Baby
by A. Heesen
Cooper, soft
pastel, 24" x 18"
(61cm x 46cm)

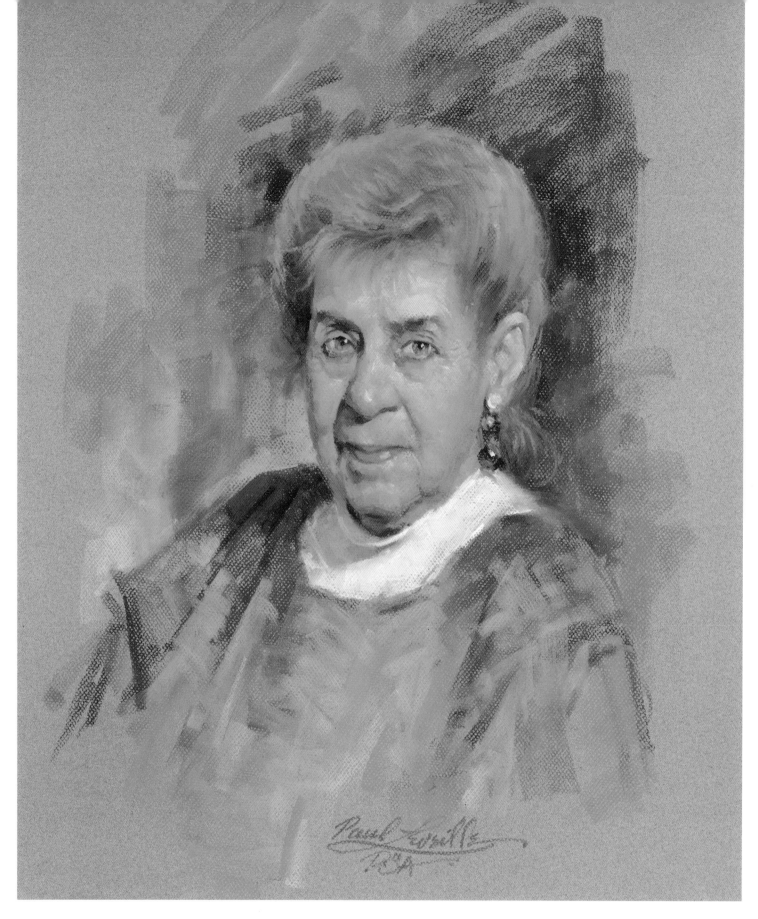

Anty by Paul Leveille, pastel on Canson Mi-Teintes, 22" x 17" (56cm x 43cm)

MATCH YOUR MEDIUM TO YOUR MOOD

PAUL LEVEILLE

When I was a young boy, I spent many wonderful "Huck Finn" summers with my cousin Gary at his small waterfront cottage. My cousin's mother and her best friend, "Anty," did their best to keep us on the straight and narrow. Now, at age eighty-seven, Anty exhibits the same spunk and sense of humor that she dispensed to us while we were growing up. Pastel felt like the right medium to use for this portrait — perhaps because the spontaneity and loveliness I find in pastels is similar to Anty's personality. The rough side of a gray sheet of Canson Mi-Teintes was used for this portrait; to me, the rough texture appearing now and then lends a fresh look to the work.

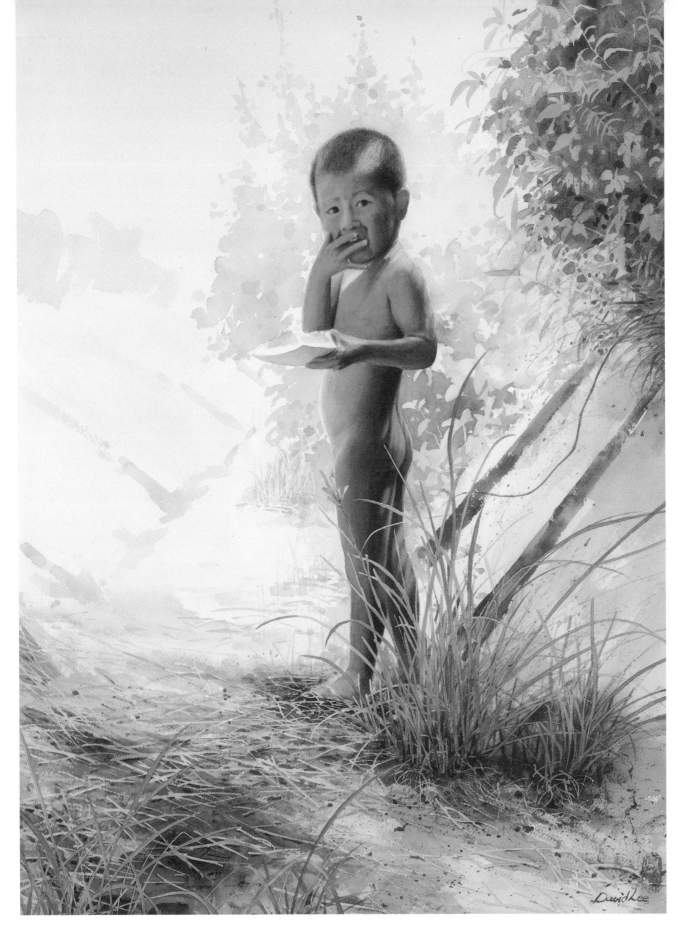

RECALL FEELINGS OF YOUR OWN CHILDHOOD

DAVID LEE

I was inspired to paint this piece by the little boy's ambivalent facial expression and body language. This innocent boy stares at you with both shyness and curiosity. I also wanted to capture the boy's character through his healthy, firm, suntanned skin. As I painted this piece, I became quite emotional because I began to reminisce about my childhood village. I hope the viewer will experience a similar feeling. Warm colors and lush vegetation in a simplified background are used to convey a watermelon field on a hot and hazy day; masking fluid was used for details in the leaves and straw.

A Boy in the Field by David Lee, watercolor on cold-pressed watercolor paper, 29½" x 21½" (75cm x 55cm)

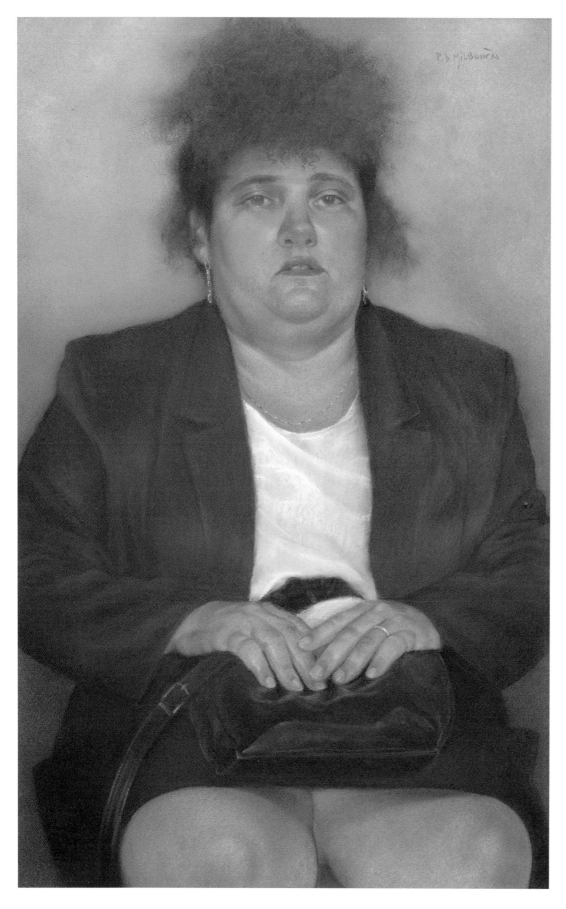

AN UNEASY POSE CREATES TENSION

PATRICK D. MILBOURN

The Interview by Patrick D. Milbourn, pastel on French Grey pastel paper, 24" x 20" (61cm x 51cm)

I get inspired by the features of an individual as well as their moods. In *The Interview*, the subject's red hair was frenzied, yet framed her face. Her uneasy pose and her basic black accessories all contributed to the tense mood. The figure dominates the foreground. The background is subtle to emphasize the character of the model. On color or pastel-toned paper, I develop the surface with many combinations of colors in cloudlike formations. I interpret forms and textures not by copying them, but by coaxing them out of the medium, and I will even keep a smear or smudge that suggests a mood.

CAPTURE THE GLOW OF A FLEETING MOMENT

LOUIS ESCOBEDO

I don't paint people — I paint emotion. I'm not interested in a likeness; instead, I try to evoke a visual response. I use oil as a medium because of its luminosity and its moldable texture. In this painting I was trying to capture the glow I saw at a certain moment of the day.

Garden Flowers by Louis Escobedo, oil on canvas, 16" x 20" (41cm x 51cm)

ADD A TOUCH OF HUMOR TO A FORMAL PORTRAIT

JOSEPH MANISCALCO

I had been asked by the Lamparters to introduce a touch of humor into their portrait. I loved the idea. Rather than painting them sitting together, I painted her sitting comtemplatively in front of a framed portrait of her husband. He is holding a bouquet of eleven roses, which are spilling over the frame; she holds the twelfth rose, which she has evidently plucked from her husband's painting. After doing a finished drawing in charcoal on the canvas, I completed a full-color underpainting using transparent washes of Yellow Ochre, Alizarin Crimson and Prussian Blue. Adding Cadmium Red and Cadmium Yellow to my palette, I completed the portraits using the *alla prima* method.

Mr. and Mrs. Ronald Lamparter by Joseph Maniscalco, oil on linen canvas, 48" x 30" (122cm x 76cm)

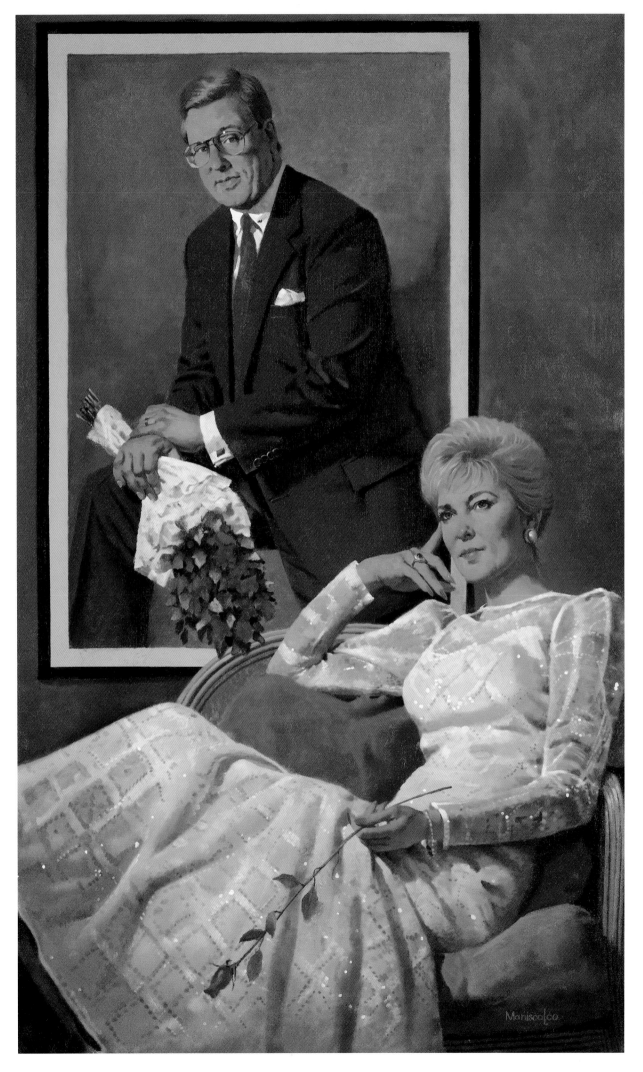

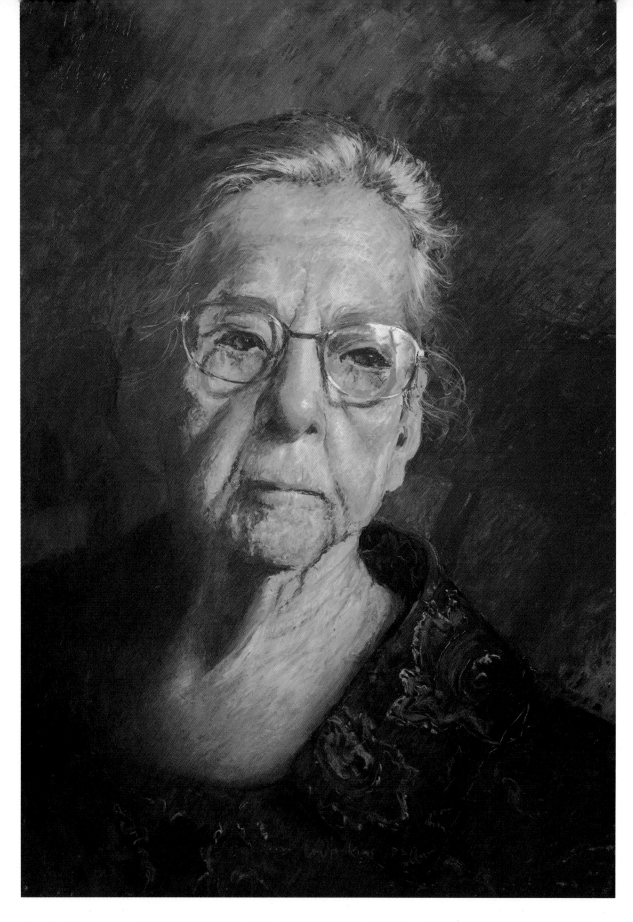

Portrait of Ma by
Claire Miller
Hopkins, PSA, KA,
soft pastel and vine
charcoal on Ersta
Starcke sanded paper,
22" x 14" (56cm x
35.5cm)

RESPONSE TO SUBJECT CHANGES DIRECTION

CLAIRE MILLER HOPKINS

My encounter with "Ma" — who was in her nineties — occurred after she experienced a loss that, to me, would seem unbearable. I felt connected to her, as I had recently lost my mother and brother. My desire to paint her came from a purely emotional response to her quiet dignity and stoicism. This painting came on the heels of an intense period of intellectual work focusing on design and spatial elements. Painting Ma moved me back into emotional involvement with my subject. The single source of light on Ma defines form and heightens drama. Wrinkles are formed with tones rather than line, much as you would paint the folds in cloth.

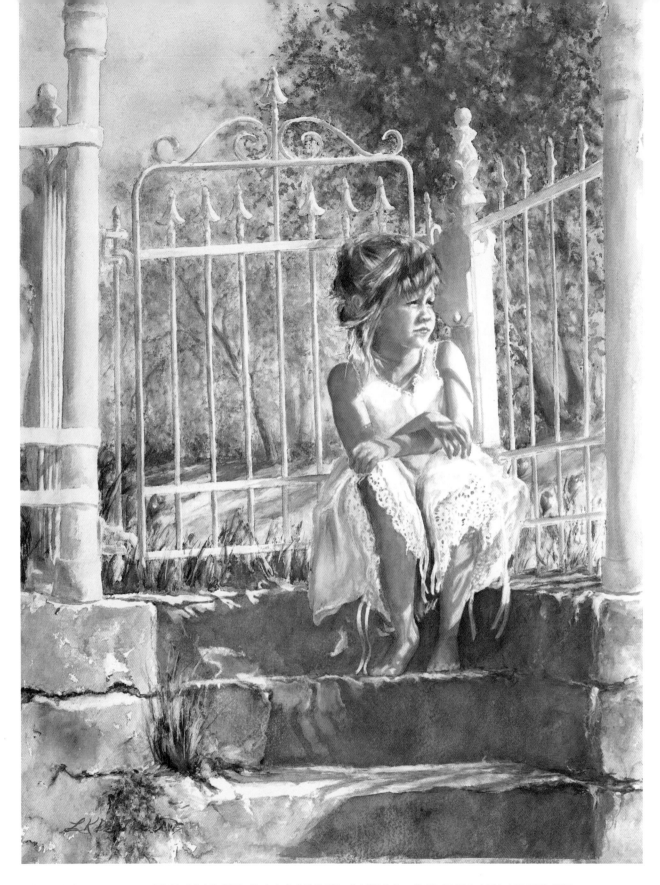

The Seventh Summer
by L. Kathy Deaton,
watercolor on Arches
300 lb. cold-pressed
watercolor paper, 30"
x 22" (76cm x 51cm)

DRAW FROM YOUR WELL OF REMEMBERED EMOTIONS

L. KATHY DEATON

As the last hour of sunlight danced toward the western horizon, a barefoot little girl sat alone on an old stone step . . . A long-forgotten memory stirred within me as I watched, powerful and familiar, yet vague and indefinable, emotions wash across the face of my granddaughter. In that moment, time peeled away and another seven-year-old girl was experiencing a youthful rite of passage. With the realization that carefree summer days could not last forever, the veil of childhood innocence had begun to lift. To give solidity of form beneath translucent skin tones, apply alternating washes of delicate warm and cool tones, allowing the paper to dry completely between each application. Layer as many glazes as needed to achieve the desired value.

REFLECT A STRONG PERSONAL PRESENCE

ANTHONY A. GONZALEZ

This model is appealing because of her quiet inner spirit. I have used her many times in my work because I look for a strong personal presence. I prefer a painterly quality, showing the workings of the brushstrokes: Painting in this manner frees me from painting tightly or rigidly and allows the painting to have a flowing quality that expresses the mood I want. This portrait was painted directly from life, reflecting an immediate spontaneity.

Pensive by Anthony A. Gonzalez, oil on Fredrix Antwerp linen, 10" x 8" (25.5cm x 20.5cm)

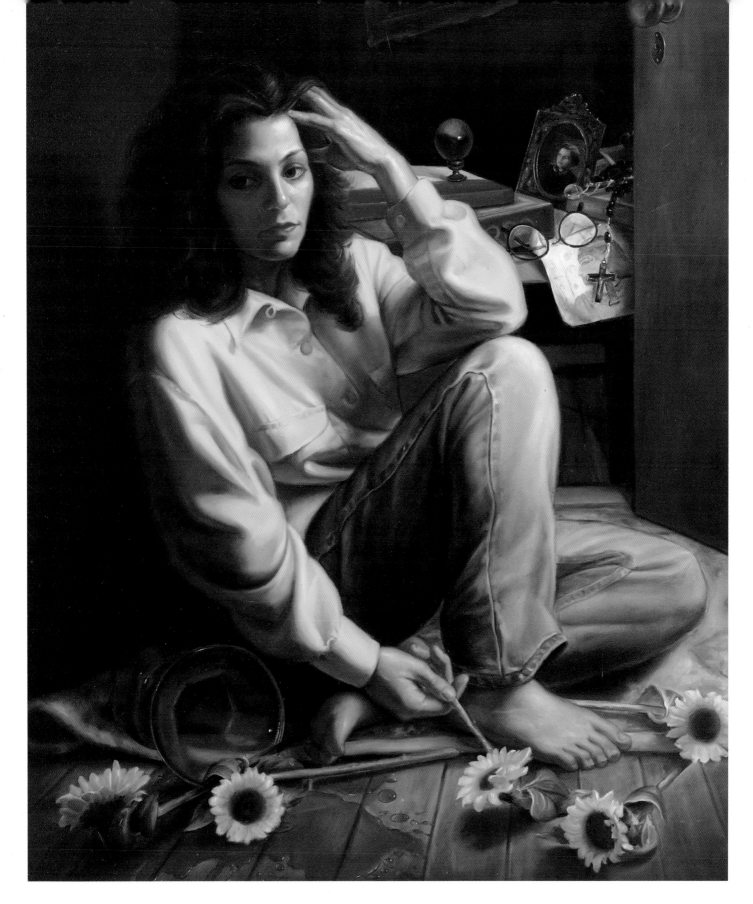

EVOKE THE CHARACTER OF AN INTIMATE SUBJECT

BRUNO SURDO

My Twin by Bruno Surdo, oil on primed linen, 42" x 35" (107cm x 89cm)

The unique experience of having a twin inspired me to paint this portrait. My twin sister, Mary, is a profound individual whose cultural interests are expressed in the objects and metaphorical images surrounding her. Rendering her facial features, I saw my own appearance emerge, making me truly see our genetic parallel. The composition encompasses an enclosed environment that reflects Mary's introspective nature. I wanted to communicate her sensitive character while also expressing my feelings toward my sister, thus creating an evocative, thought-provoking piece. The technique I used incorporates layering glazed transparent and semitransparent colors over an opaque monochromatic underpainting on fine portrait linen, using sable brushes.

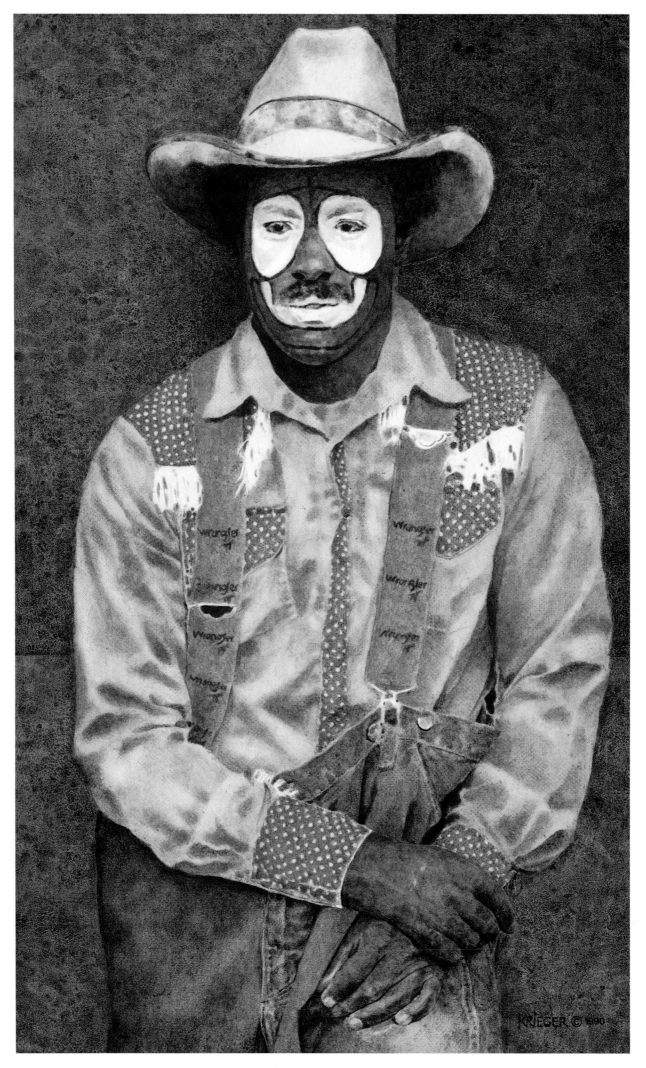

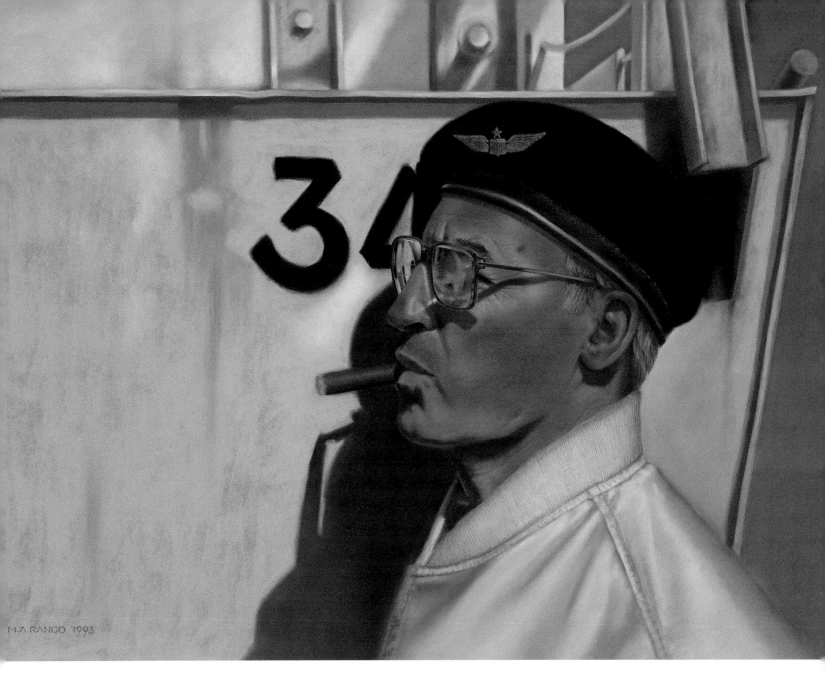

SEPIA TONES CREATE A PENSIVE MOOD

BUTCH KRIEGER

A portrait should not only capture a physical likeness but also reveal the individual's unique personality. In my portrayal of rodeo clown Leon Coffee, I wanted to expose the serious person behind the humorous makeup. We selected a serene, reflective pose rather than something comical or witty. This is, after all, an intelligent, sober man with a very serious job — protecting dismounted cowboys from rampaging bulls. For the same reason, I did this portrait in sepia tones, rather than the actual garish colors of my subject's costume. I didn't want anything to overpower my portrayal of the face behind the facade. Over a black-and-white acrylic underpainting, I layered transparent oil glazes of Greenish Umber and Oxide Red. The result is a warm, earthy brown timbre that intensifies the pensive mood of the subject's pose.

Serious Business by Butch Krieger, acrylics and oils on Masonite, 31⅜" x 19⅝" (79.5cm x 50cm)

LIFT THE VEIL OF A PERSON'S SOUL

MARILYN-ANN RANCO

About a year after my mother died, I felt an urge to paint a portrait of my father, Joseph-Antoine Ranco. Almost from the start, I sensed my mother's presence at my side. She was an amazing artist, a true inspiration in my life. Thus, painting that portrait was a mystic experience, almost a pilgrimage into the secret garden of the man my mother loved all her life. Creating a portrait is about lifting the veil concealing the soul of the sitter.

A Pair of Wings on the Dock by Marilyn-Ann Ranco, PSA, soft pastels on La Carte medium-gray pastel paper, 19½" x 25½" (49.5cm x 65cm)

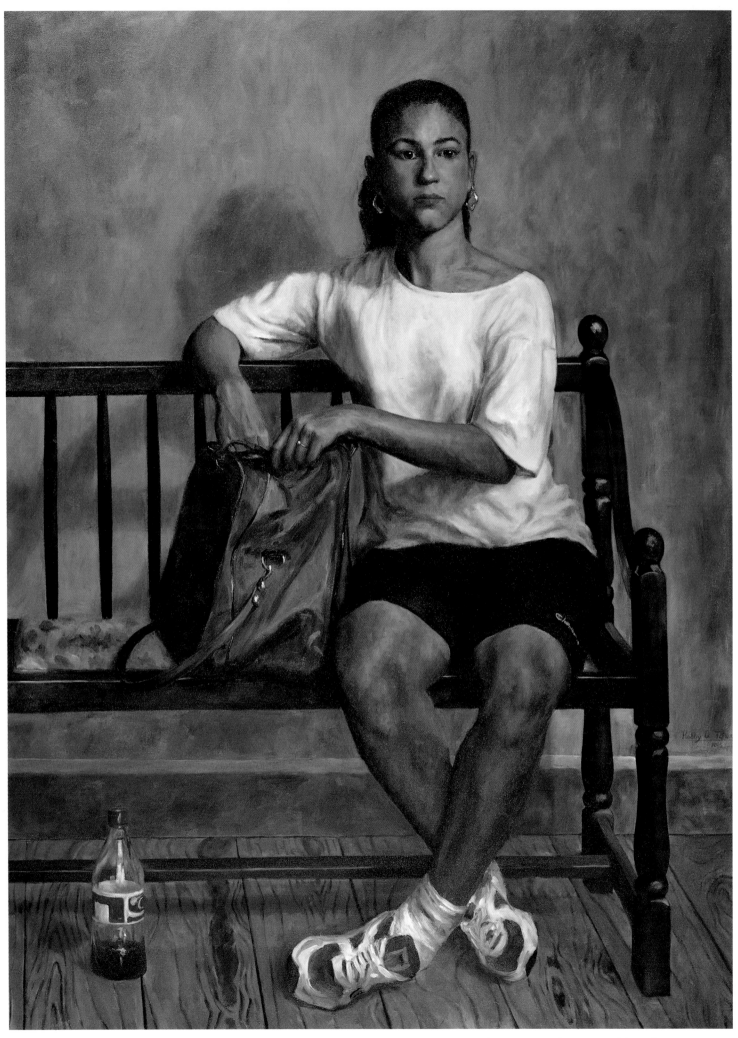

Waiting by Robby D. Tatum, oil on canvas, 40" x 30" (102cm x 76cm)

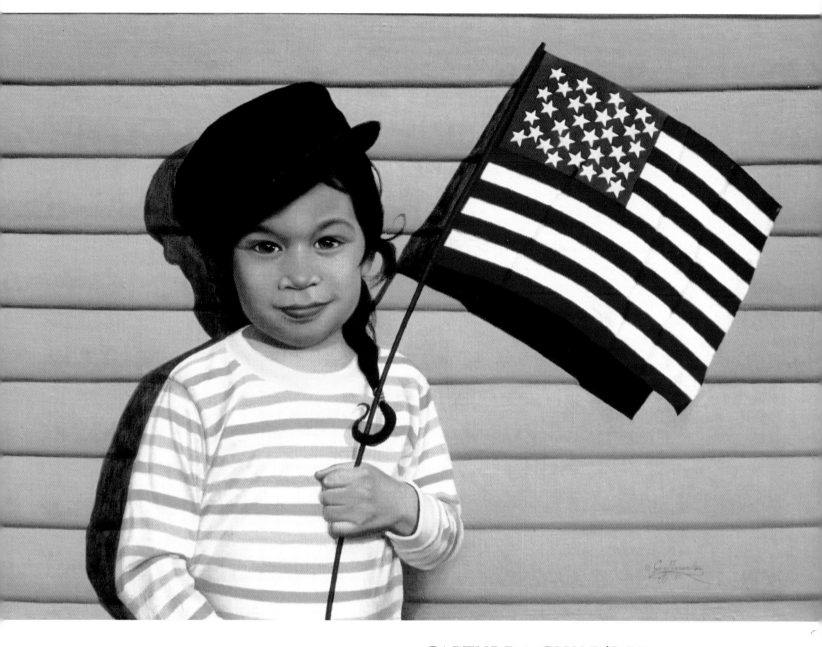

CAPTURE A CHILD'S PRIDE AND JOY

GARY J. HERNANDEZ

I got the idea for this portrait of Maggie when she and her family came to visit one Sunday afternoon. They had just attended church; at Bible study they gave the children little American flags as keepsakes. She was very proud of her new flag, waving it as she walked around the house. I wanted to capture the spirit of that moment: perhaps innocence, the first feeling of patriotism or just a happy little girl with a new toy. The smooth surface of the linen enhances the effect of the crisp shadows and stripes. I painted the shadows thin and transparent and the lights thick and opaque. This technique gives the portrait a dimensional quality.

Maggie Holding the Stars and Stripes by Gary J. Hernandez, oil on Belgian linen portrait canvas, 20" x 28" (51cm x 71cm)

TELL A STORY BY MANIPULATING ART ELEMENTS

ROBBY D. TATUM

This scene captivated me, although changes were necessary to some of its elements to create a painting. I positioned the model off-center and turned the drape behind her into a wall. I invented the baseboard molding with its mismatched color scheme of Alizarin Red vibrating against the wall's Turquoise Green and added an aged plank floor with a half-empty soda bottle for visual balance. These changes establish a distinct mood — and perhaps tell a story where none existed before.

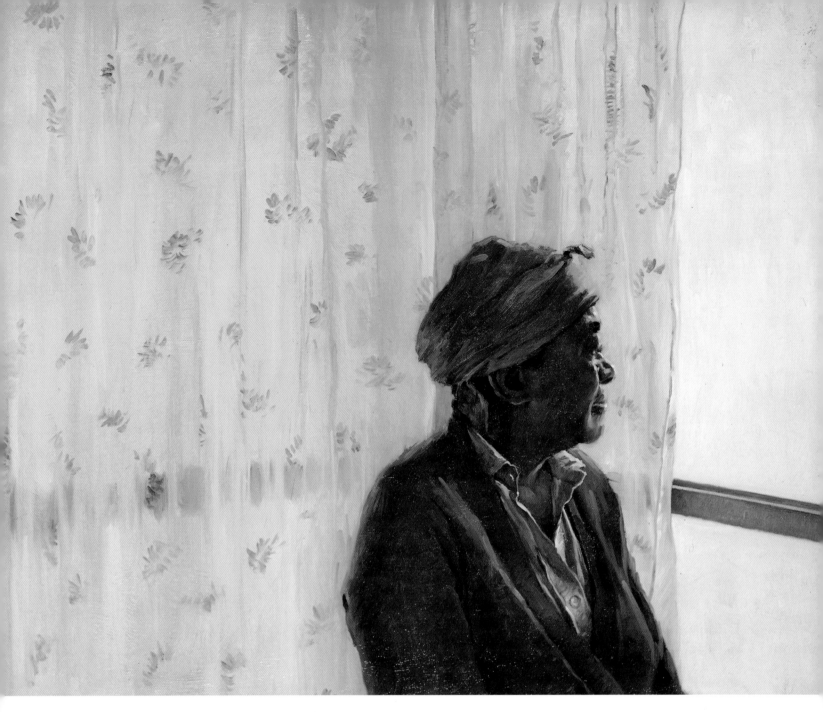

TELL THE TRUTH IN A PERSONAL MOMENT

RON McDOWELL

Shirley is a portrait of my mother. My feelings about this painting run very deep, for obvious reasons. As she gazes outside, one senses a certain aloneness and separation, which everyone experiences at some point in life, and an internal acceptance of whatever is to come — typical of Shirley, a woman of great character. This is a very familiar setting: at her kitchen table in the home where I grew up. I portrayed her truthfully as I saw her at the time, in a very intimate, personal moment. *Shirley* was painted on linen canvas, sized with rabbitskin glue, grounded with white lead that I painstakingly applied by hand and then textured. To me, 90 percent of the painting's success depends on how the canvas surface *feels*.

Shirley by Ron McDowell, oil on canvas, 24" x 30" (61cm x 76cm)

CREATE A VISUAL DIARY OF YOUR FAMILY MEMBERS

BRIAN JEKEL

The bond between mother and child is no doubt one of life's most tender relationships: This painting of my wife and daughter is an attempt to capture that feeling. The difficulty of this piece mainly resulted from trying to distance myself emotionally from the subjects and treat them objectively. I've used all my family members at one time or another in creating a visual diary, much in the tradition of William Merritt Chase, Frank Benson and Joaquin Sorolla y Bastida. Portraits of this nature capture not only a likeness, but also a mood.

Marlene and Lacey by Brian Jekel, oil on linen, 24" x 12" (61cm x 30.5cm)

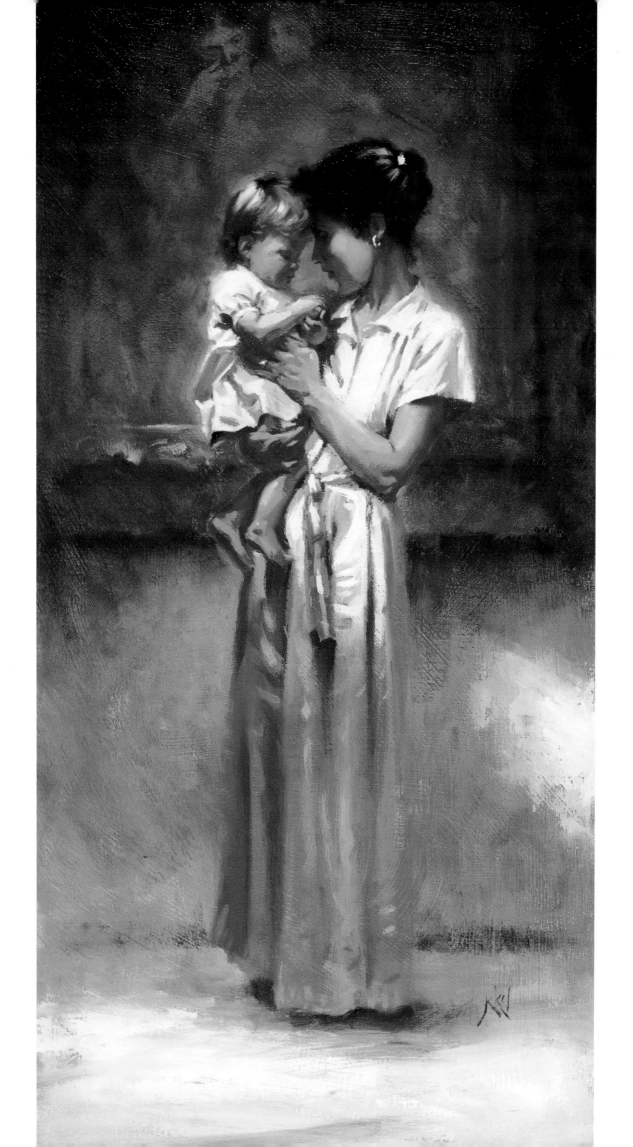

4

PORTRAY MEANING WITH

SYMBOLISM

Symbolism can be used to express a universal theme in your painting, or private symbols can be used to convey aspects of your subject's personality or life. When Monica Acee first saw Gilley Newell, he was out in a field turning the newly mown hay with a pitchfork, testing for dryness. Unaware of her presence, he stopped, leaned on his pitchfork and admired the view. At that moment he became to Acee the epitome of a hardworking American farmer. The red, white and blue silo roof in the background mirrors her theme.

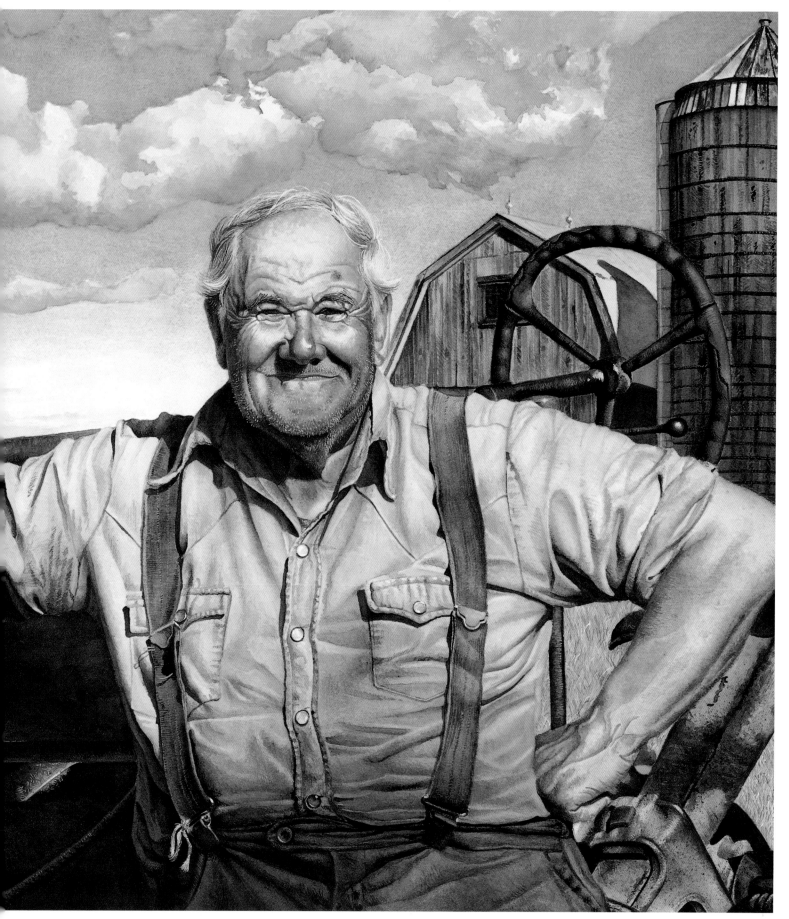

Portrait of an American Farmer by Monica Acee, watercolor on Arches 140 lb. cold-pressed watercolor paper, 21" x 29" (53.5cm x 74cm)

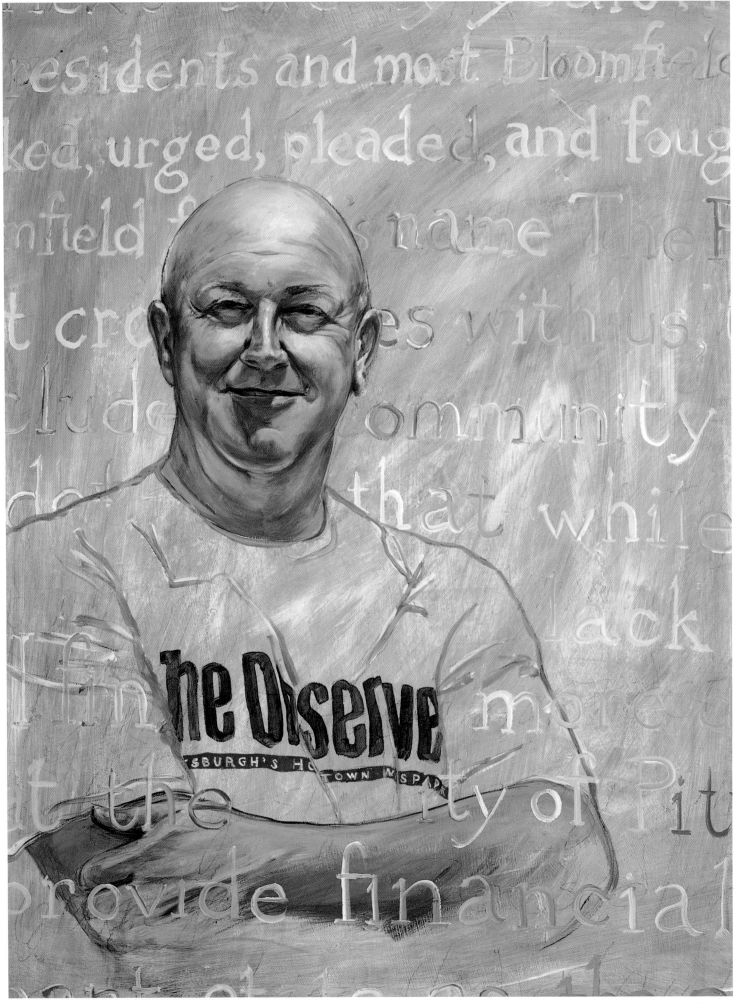

Mike Romanello by Mary M. Mazziotti, acrylic on birch plywood panel, 32" x 24" (81.5cm x 61cm)

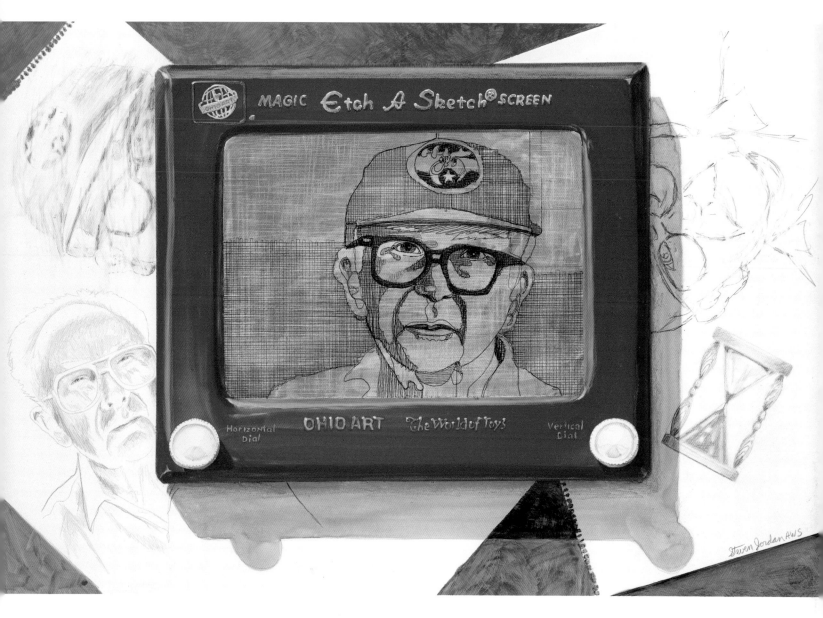

DRAW ON YOUR IMAGINATION

STEVEN JORDAN

Drawing Near the End was painted as a tribute to my father, who was in the final stages of Alzheimer's disease. The Etch-A-Sketch is a symbol of impermanence — life is as fleeting and temporary as the image on the magnetic screen. The sketches of my father are like pages of his life that cannot be replaced. One of the sketches symbolizes his life being erased; the hourglass represents the end drawing near, thus the title. Metallic silver simulated the screen of the Etch-A-Sketch. The lettering was masked before applying the red, then painted with gold metallic watercolor.

Drawing Near the End by Steven Jordan, watercolor, acrylic and pencil on hot-pressed board, 20" x 30" (51cm x 76cm)

FIND A VISUAL REFERENCE TO YOUR SUBJECT'S PERSONALITY

MARY M. MAZZIOTTI

Mike is the editor of our hometown newspaper. It was easy to find a visual reference for his personality — words just spill out of him. The printed words that fill the background and swim over Mike's image are from one of his editorials. I often mix visual symbols of the subject's personality or profession into the painting, in the same way that Renaissance artists used coded symbols to add dimension to their work.

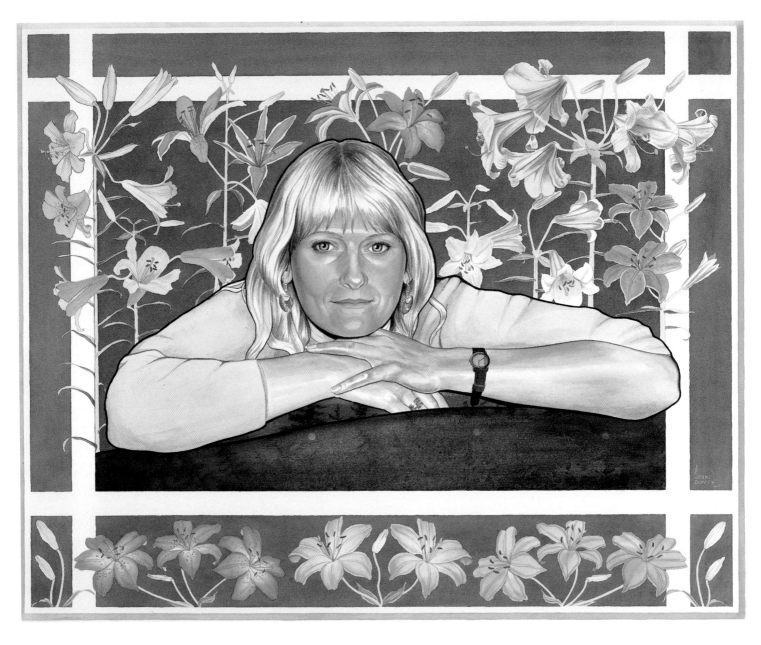

DESIGN SYMBOLS INTO YOUR BACKGROUND

JEANE DUFFEY

During unhurried meetings with my sitters, I discover their interests, favorite colors and birth signs, and collect information about their family, pets and so on for possible inclusion in the background design. Susannah means "lily" in Hebrew, giving me the idea for the background. The sofa design incorporates the moon for her birth sign and conifers for her forester husband. The watch setting is the approximate time of her birth, the rings include an inherited ruby — her birthstone — and the lapis-lazuli earrings are favorites, similar in color to her eyes. Interesting conversation usually leads to quite unconscious and natural poses. When this happens I say "hold it" and use my camera, take notes and make small sketches. The best images are transferred to a photo CD, which then plays on a TV screen near my easel. This portrait was painted in Cobalt, Raw Sienna, Naples Yellow, Light Red and Indigo.

Susannah by Jeane Duffey, watercolor on T.H. Saunders cold-pressed watercolor board, 30" x 24" (76cm x 61cm)

SYMBOLIZE THE HOPES AND DISAPPOINTMENTS OF LIFE

D.J. DiMARIA

My life has given me a deep empathy for those that are not outwardly beautiful or joyful. I can sense through a person's eyes how life has been to them. This is what I tried to capture in the painting *Waiting*. It is about a lonely woman in midlife who had expected the "Prince Charming" promised to her in the fairy tales of her youth. Her eyes stare into the distance, telling the viewer that she has not given up hope. The silk party dress and bare feet represent the lingering promises of youth. The rocking chair symbolizes aging; the black umbrella represents the ultimate death that hangs over us all. Drama is created with value changes from light to dark, using a limited palette.

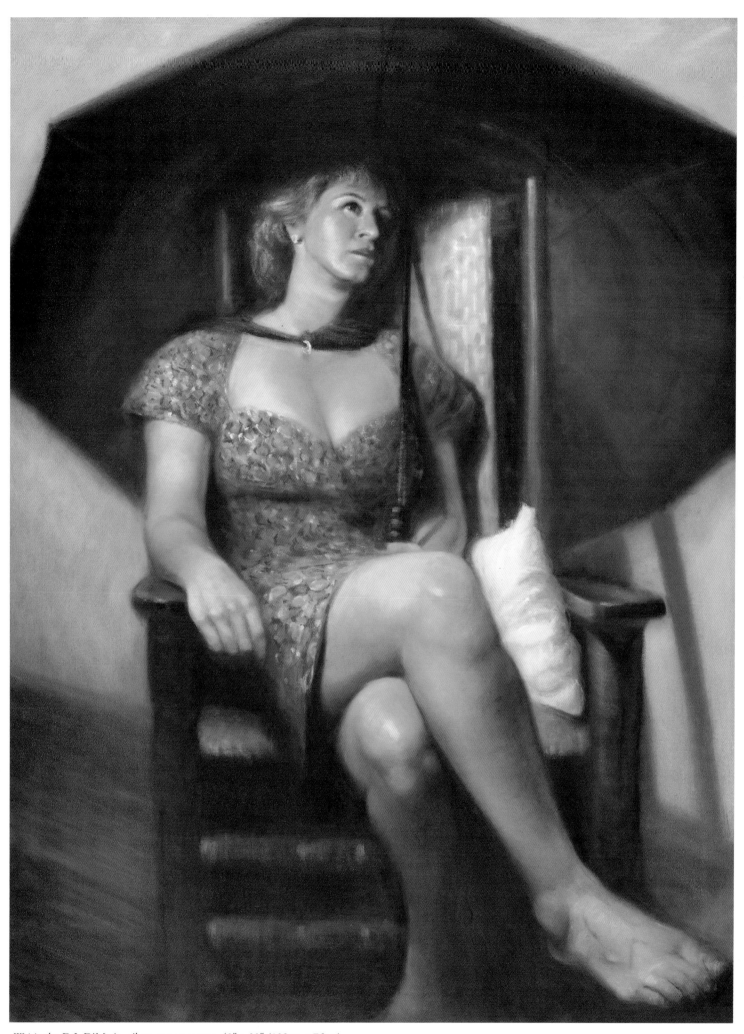

Waiting by D.J. DiMaria, oil on cotton canvas, 40" x 30" (102cm x 76cm)

USE CLASSICAL SYMBOLS

ALEKSANDER M. TITOVETS

I have always been inspired by Ancient Greece. *Ebb Tide — Persephone* creates an image reflecting magical light amidst the harshness and darkness of the Greek legends. Persephone symbolizes the eternal cycle of renewal: day and night, spring and autumn, life and death. Thus, twilight is beautiful but brief and poignant, for darkness will soon follow. My work consists of large brushstrokes in impasto style using a variety of smooth and rough surfaces that, together with rich colors, create an impression of semiprecious stones.

Ebb Tide — Persephone by Aleksander M. Titovets, oil on cotton canvas, 30" x 40" (76cm x 102cm)

COMBINE TWO SYMBOLS FOR ONE MESSAGE

JOHN POTOTSCHNIK

Vanishing Resources is an expression of appreciation for older people and the invaluable resource of wisdom and experience that they are. It also expresses a note of sadness that things are always changing, aging, decaying and moving on. This truth is echoed in the distant barn, once of value and constantly used — now deserted, overgrown with weeds and of little value. My special neighbor, Al Monroe — a wise, caring thoughtful man of sound character — allowed me to photograph him for this painting. Using photo reference from another location for the background, the two subjects were combined to tell the story.

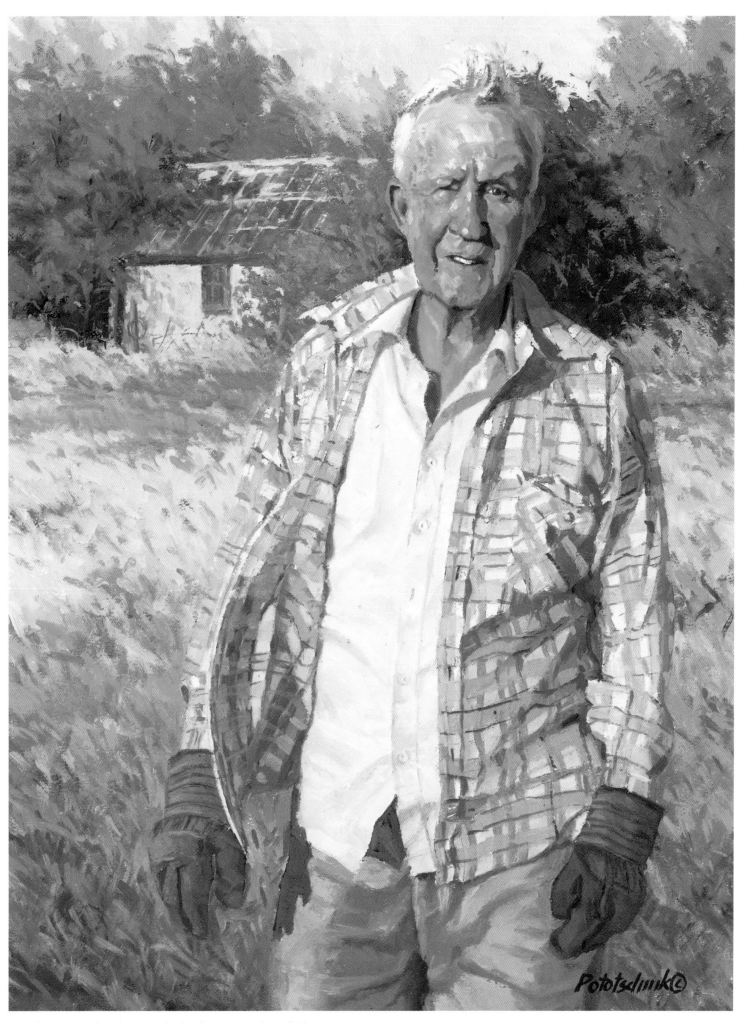

Vanishing Resources by John Pototschnik, oil on paper, 16" x 12" (41cm x 30.5cm)

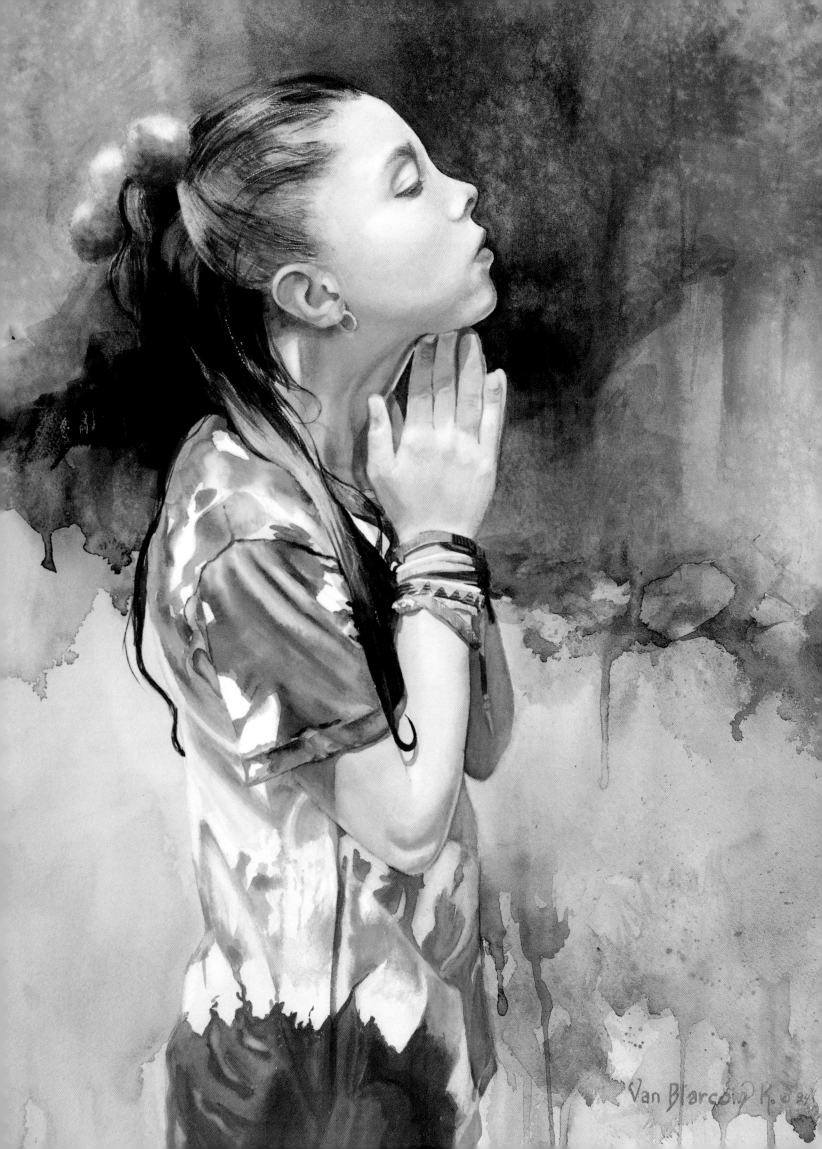

PERSONIFY THE SPIRIT OF YOUTH

ANNE VAN BLARCOM KUROWSKI

When Naomi appeared from the creek, wet and barefoot, her hair and tie-dyed shirt still dripping, I immediately wanted to capture that moment. The bright colors she wore echoed the intensity of the playfulness and the directness of her youthful spirit. Watercolor was particularly suitable because it allowed me to create an atmosphere of spirituality by merging the loose, free background with crisp realism in a seamless transition. The background is basically abstract and mimics the drips in Naomi's hair and shirt; textural areas result from spraying water on a wet surface.

Naomi by Anne Van Blarcom Kurowski, transparent watercolor on Arches 300 lb. cold-pressed paper, 30" x 22" (76cm x 56cm)

PROVOKE CURIOSITY WITH ABSTRACT SYMBOLISM

SHARYNE E. WALKER

The delicate imagery and wildly abstract concept of *The Crimson Palette* provoke curiosity. The intense colors beckon from the canvas, inviting the viewer into a subliminal world of beauty, passion, perfection, serenity and delight. The figure's light and dark patterns were blocked in and the painting was done from the background to the foreground; the figure tackled last. Symbolism and dream imagery in the surroundings convey the story of this individual.

The Crimson Palette by Sharyne E. Walker, acrylic paint on canvas, 36" x 36" (91.5cm x 91.5cm)

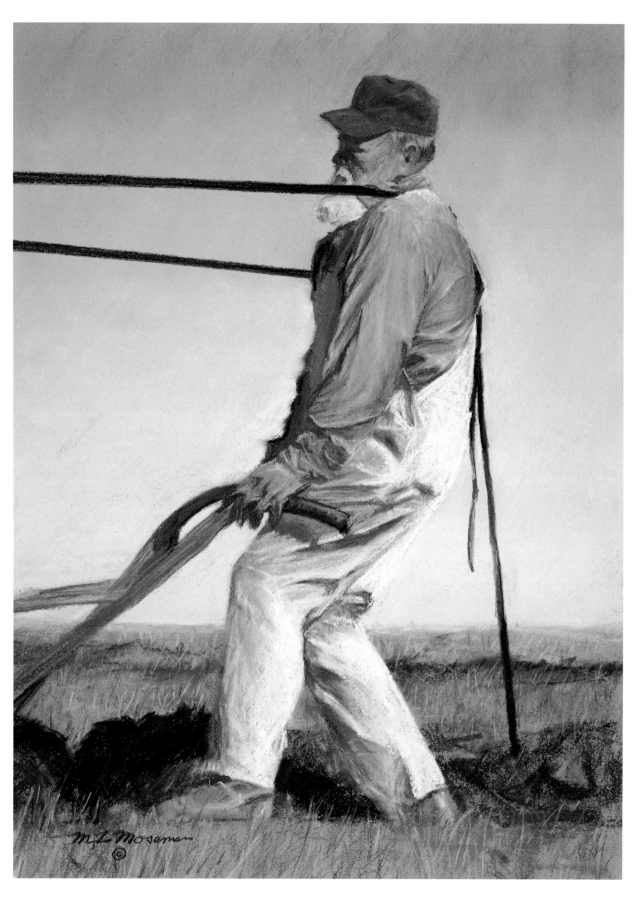

Plowman by M.L. Moseman, pastel on Canson paper, 16" x 12" (41cm x 30.5cm)

POINT OF VIEW CAN ENHANCE YOUR THEME

M.L. MOSEMAN

Growing up on a farm, I came to admire rural workers in harmony with the land. To express this, I portrayed a farmer connected to the earth by his horse and plow. The National Agricultural Hall of Fame has allowed me to photograph plowing competitions: Having raised horses, I felt comfortable kneeling among them to take hundreds of snapshots. Kneeling as I painted caused me to look up, adding strength to the plowman's character. In the final composition, this was further emphasized by lowering the horizon and eliminating visual clutter. Cool pastels over a warm paper (Canson 384) give a sparkle to the outdoor setting.

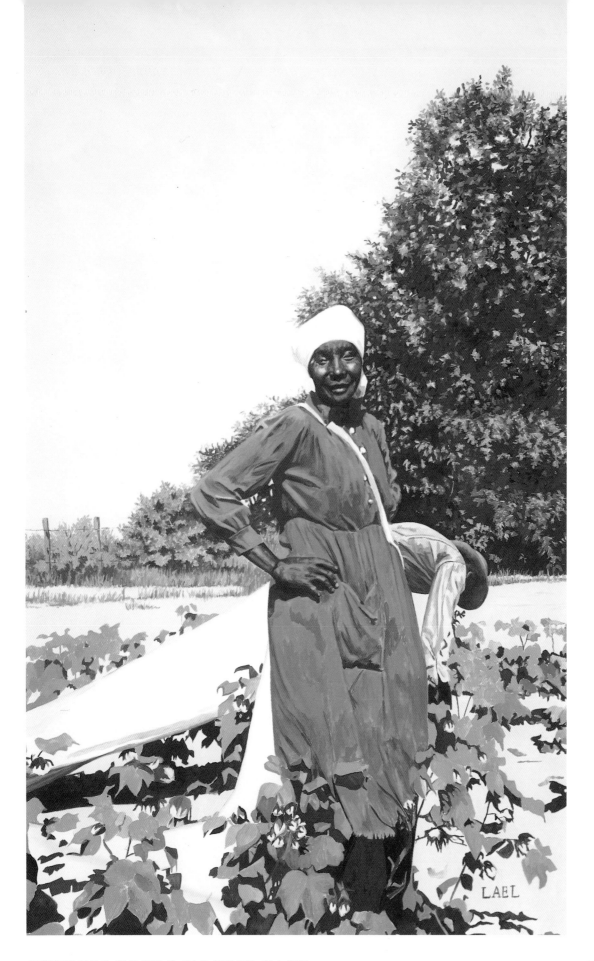

EXPRESS PRIDE IN THE PAST

LAEL NELSON

100% Cotton is a picture of life in days gone by. As a child, I went to the fields with my parents to pick "King Cotton." My aim for the portrait was to bring forth from the past a young Southern woman and show her strength of character and pride in her work. The sunshine on her red dress shows the warmth of the sunny day as the figure momentarily pauses from labor. I use my watercolors as a paste, as in oils. The values are done first in Burnt Umber before the colors are added.

100% Cotton by Lael Nelson, opaque watercolor on Arches 300 lb. cold-pressed paper, 31" x 19" (79cm x 48.5cm)

USE PERSONAL SYMBOLS TO DESCRIBE YOUR SUBJECT

Ms. Ramona Tumblin by Holly Hope Banks, oil on Belgian linen, 50" x 44" (127cm x 112cm)

HOLLY HOPE BANKS

For this portrait I wanted to utilize lighting similar to that of Van Dyck and reminiscent of the great English portrait painters of the seventeenth century. My goal was to give the sitter dignity and elegance, but with a sense of her warmth as well. The cherished books, favorite flowers and antique fan carefully clasped in her hands described the sitter's personality. This portrait was painted entirely from life in approximately twelve sessions. A skylight provided a bathed-in-light effect.

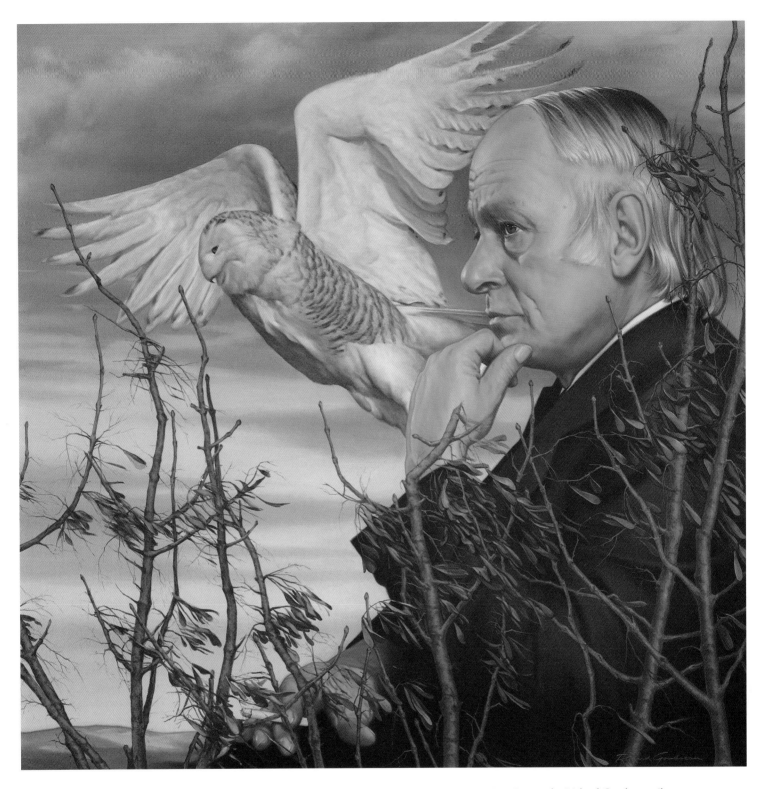

PORTRAY THE VISION OF A HISTORIC FIGURE

René Lévesque by Richard Goudreau, oil on canvas, 36" x 36" (91.5cm x 91.5cm)

RICHARD GOUDREAU

After having read the biography of Quebec's former Prime Minister, the late René Lévesque, I was moved to paint the portrait of this historically fascinating visionary. Even today, the association of Lévesque with the white snow owl — the symbol of Quebec — is inevitable. To symbolize the man and his dream of independence, all the elements of the painting were chosen for their underlying meaning. The white owl (Quebec) flies in the same direction as Mr. Lévesque's forward vision of the future; the breeze displaces the clouds (obstacles) and the seeds of the maple tree (a symbol of Canada) in an opposite movement. Lévesque was rarely seen without a lit cigarette and another in reserve — this detail adds authenticity.

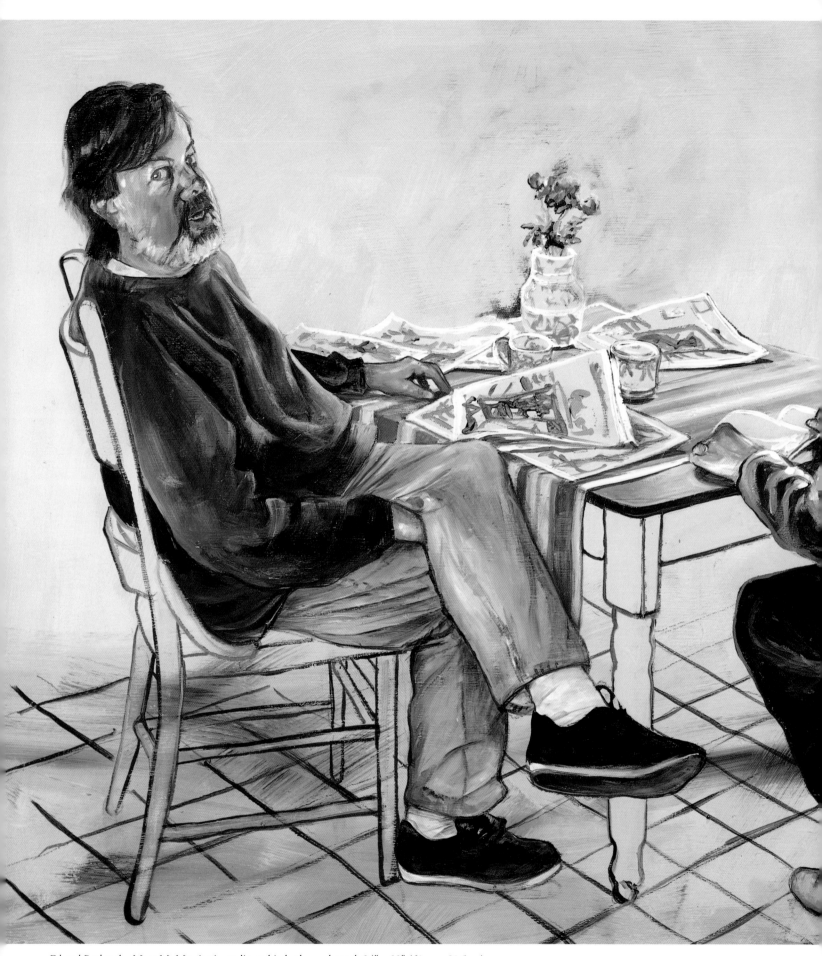

Ed and Barbara by Mary M. Mazziotti, acrylic on birch plywood panel, 24" x 32" (61cm x 81.5cm)

Photo by D. Albrecht

DESIGN AND COMPOSITION

No amount of fine rendering will make up for a weak design, but a strong design can stand as a work of art even with unfinished details. Part of the success of this double portrait lies in what was left out of the scene. By eliminating a distracting background and only sketching in the table, newspapers and chairs, greater focus is given to the finished figures. The triangle formed by Ed's head, his foot and Barbara's head keeps your eyes moving around the painting, adding to its vitality.

Portrait of Martha McInnish by Lisa Fields Fricker, oil on linen, 40" x 28" (102cm x 71cm)

COMPOSE TWO VIEWS OF YOUR SUBJECT

PHIL KANTZ

The best start of any work of art is an intelligent, sophisticated composition; if that's under control, even a weak pencil drawing will hold together. Sometimes two or three different compositions are equally appealing, and you can't make up your mind. Unless you create three separate works, you have to eliminate two equally fine ideas. Or you can take a chance, split the panel and paint two views, as I did with this piece. *Double Study* is painted from life on a canvas panel that has a couple of scraped down old paintings underneath. This way I can create certain textures that fresh surfaces cannot yield. I prefer creamy opaque pigment to define light on form, and use only bristle filbert brushes.

Double Study by Phil Kantz, oil on canvas panel, 12" x 16" (30.5cm x 41cm)

DON'T TAKE SHORTCUTS IN DESIGNING A PORTRAIT

LISA FIELDS FRICKER

There are many steps to "capturing a person's soul" on canvas. To achieve a true connection with my subject, I paint from life as much as possible. I did several oil sketches to portray aspects of Martha's unique appeal. These sketches help clients visualize the finished portrait, and help me validate my perceptions. Working from life, I got to know Martha while recording her coloring. I then shot black-and-white film (for comparison with the life sketches). The possibilities for lighting became the spark that ignited my imagination. I employed a cool red (Acra Violet) and a warm yellow (Cadmium Medium) throughout, adding Ultramarine for the greens. I completed the portrait with another life sitting.

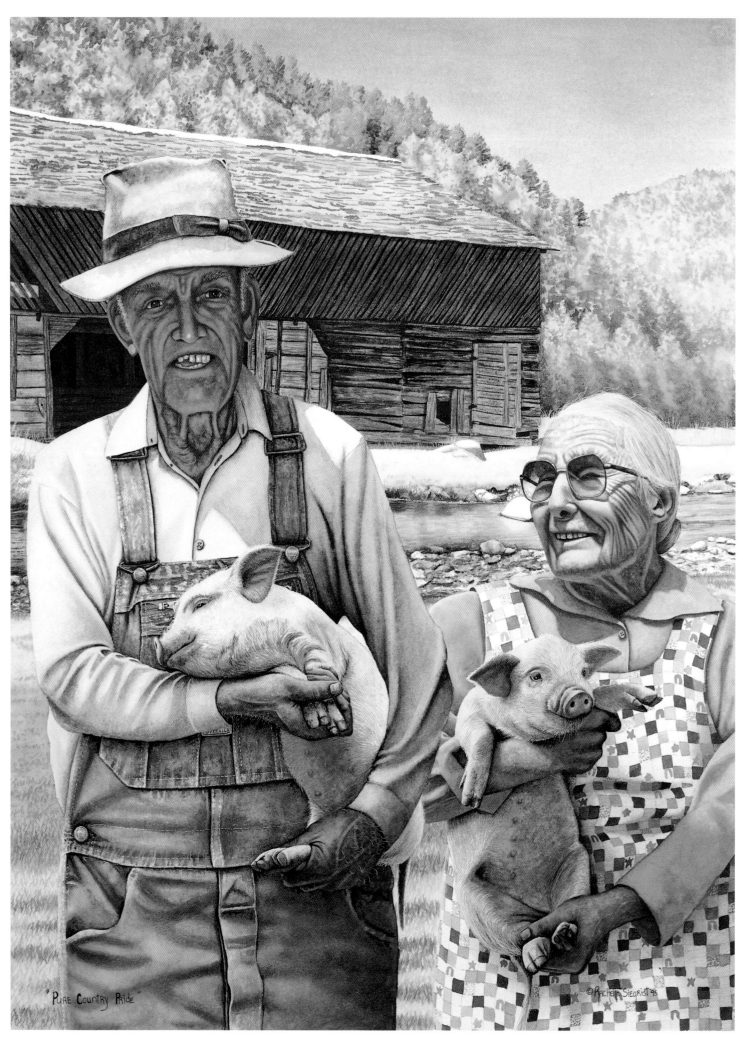

Pure Country Pride by Rachelle Siegrist, watercolor with white gouache on Arches 300 lb. cold-pressed paper, 30" x 22" (76cm x 56cm)

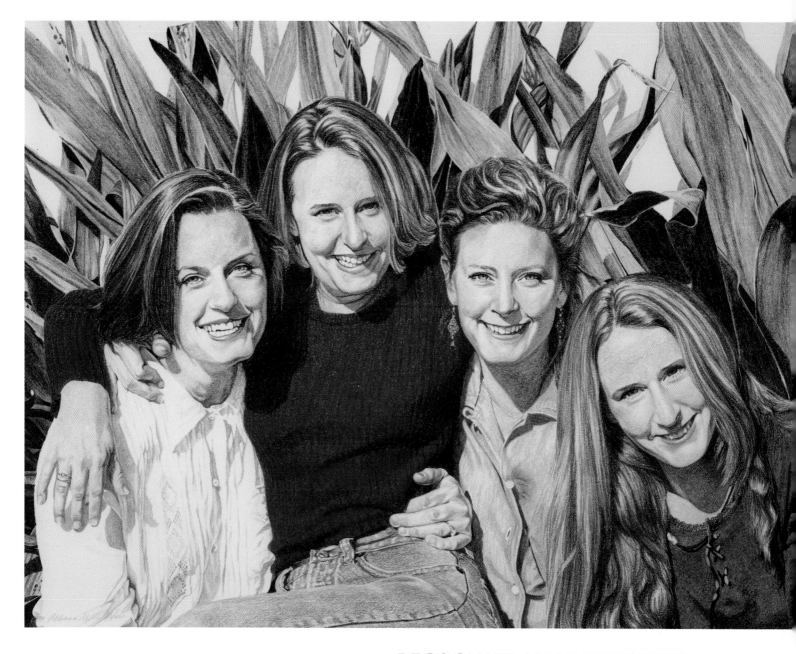

RECOGNIZE AN UNEXPECTED GOOD COMPOSITION

MELISSA MILLER NECE

Knowing the difficulty in getting four people to pose together, I originally planned to do this commission as four separate portraits to be framed as one. After shooting individual photos of each young woman, I suggested they squeeze together for the two remaining exposures. The playful, affectionate interaction in those two shots made them the best. One sister had her eyes closed in the otherwise better photo, so I used her head from the second picture. While the greenery nicely offset their clothing, the lighting made this scene especially striking and provided distinctive shapes that actually made doing the drawing easier.

Sisters by Melissa Miller Nece, CPSA, color pencil on Strathmore illustration board, 16" x 20" (41cm x 51cm)

BE CAREFUL WHEN COMBINING SEVERAL PHOTOS

RACHELLE SIEGRIST

The challenge of this composition was combining separate photos of my great-aunt Belle, her son Herbert, the pigs and the barn to achieve a believable setting. Working from these reference photos, I started by adding salt to the initial skin-tone wash. Using detail brushes, I continued building facial features from dark to light with semi-opaque colors. I expressed my relatives' joy in the simple things of life by adding adorable piglets, down-home attire and an inviting stream and barn.

Pamela by James E. Tennison, oil on Claessens Belgian linen, 32" x 22" (81.5cm x 56cm)

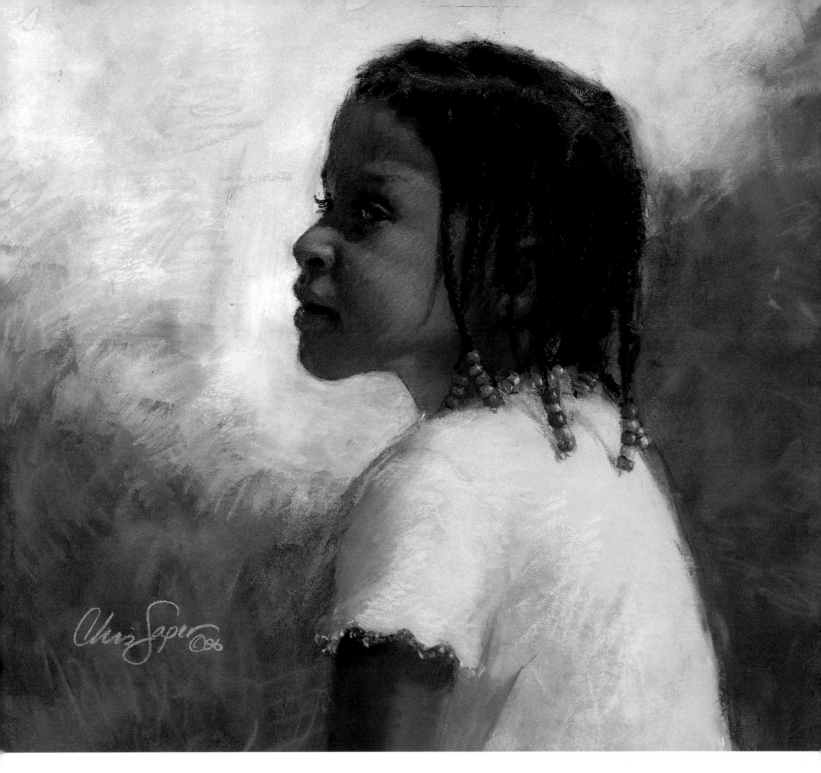

DESIGN A BEAUTIFUL PAINTING ANYONE CAN ENJOY

James E. Tennison

My first contact with Pamela was the day I answered my phone and was charmed by a small voice saying, "Mr. Tennison, will you please paint my portrait?" Pamela's mother, who commissioned me to paint her daughter, gave me a great deal of artistic freedom. She said, "I want a beautiful painting with a portrait of Pamela in it — a painting that anyone can enjoy, whether they know her or not." I felt the painting was a success when I received another call from that small voice saying, "Mr. Tennison, I really like my portrait!" Good materials are so important to good painting: This is one area where I don't economize. I prefer Winsor & Newton oil paints, filbert bristle brushes and Claessens #13 oil-primed linen.

DESIGN LENDS MOOD AND EMOTION TO YOUR PAINTING

Chris Saper

Virtually every portrait is a design problem waiting to be solved, and it's often the nature of that solution that lends mood and emotion to a finished painting. To this end, I am diligent in composing a light and dark "passage" for the eye, keeping in mind that staccato rhythms convey energy, while gentle "eye loops" suggest serenity. For me, background serves only one function: to support the design of the painting through value shifts and color harmony. My subject, Jesse, possesses a strength and grace usually reserved for those much older, and it was this sense that influenced this painting of her from start to finish. The paper I use has a marvelous tooth, which allows me to build the strong, accurate shadow structure necessary to properly support color and light. I build dark to light and cool to warm.

Jesse's Braids by Chris Saper, pastel over watercolor on Wallis pastel paper, 16" x 18" (41cm x 46cm)

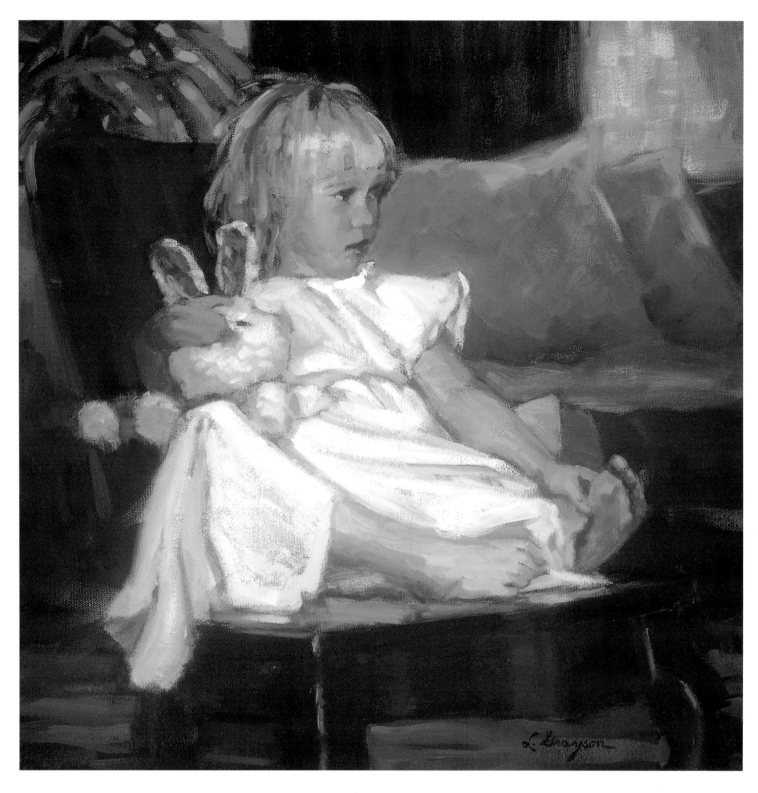

Emily by Louise Grayson, oil on canvas, 18" x 18"
(46cm x 46cm)

LET YOUR SUBJECT DESIGN HER OWN POSE

LOUISE GRAYSON

After dressing my granddaughter, Emily, in her great, great grandmother's dress, I followed her around for an afternoon, snapping photos whenever I caught her in unselfconscious positions. Three rolls of film and four hours later, I selected one in which she had, by chance, seated herself quietly in an antique chair and become so absorbed in the television that she forgot my presence. The white dress, along with Emily's light hair and golden-pink skin tones, form a stable but dynamic triangular shape that stands out beautifully against the intense but dark color shapes in the background.

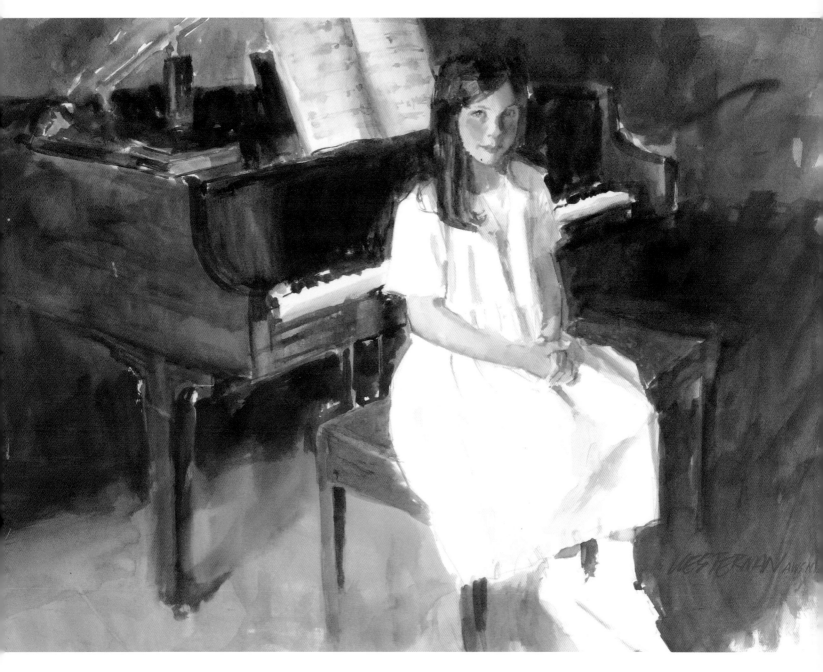

UNDERLYING DIAGONALS CAN ADD EXCITEMENT TO A SERENE PORTRAIT

Hilary at the Piano by Arne Westerman, AWS, NWS, watercolor on Lanaquarelle hot-pressed paper, 21" x 29" (53.5cm x 74cm)

ARNE WESTERMAN

Wearing a white dress and looking as beautiful as a young Elizabeth Taylor, Hilary happily posed seated at the piano with the window light washing highlights in her face. The background is painted in intentionally warm colors to contrast with the white outfit and to suggest Hilary's inner warmth. The design of the painting uses opposing diagonals to add an underlying excitement to the serene portrait. The main diagonal runs from the music at the top through the body and out the gently defined feet at the bottom of the painting. The other diagonal runs through the angle of the piano. I chose Lanaquarelle hot-pressed paper for its texture and washability. I can always wash off or modify offending values or colors, so I mix "heavy" or go straight from the tube to hit the intensity first thing.

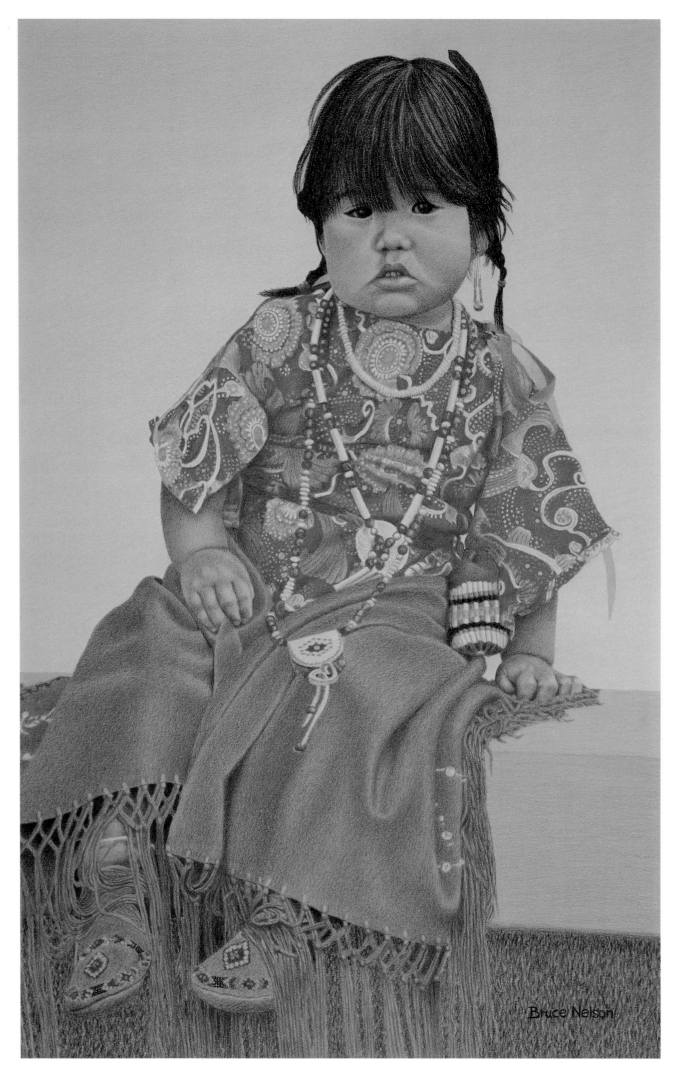

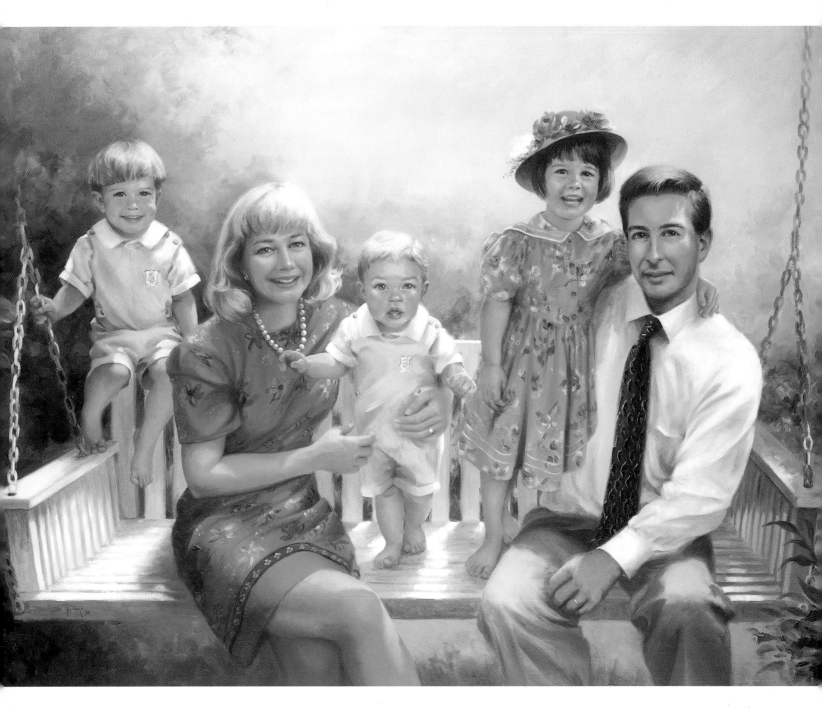

TAKE ON THE CHALLENGE OF A COLORFUL PATTERN

BRUCE J. NELSON

While attending a Fourth of July celebration in a small western town, I saw this pretty little girl sitting on a bench. I was taken with her cuteness and the brilliance of her costume. I took several candid shots with a 35mm camera equipped with a telephoto lens. The layout was done with a light-gray Verithin pencil and the help of a slide projector. The drawing was accomplished by viewing the slide through a 9x loupe. I layer the lights over the white paper first, then the darks over that. All white seen in the drawing is paper. The magenta color was made with nonfading Berol Verithin Lavender and Rose pencils shaded with Blue Violet.

Indian Girl #4 by Bruce J. Nelson, color pencil on Strathmore Bristol 5-ply, medium surface, 24" x 15½" (61cm x 39.5cm)

KEEP THE CAMERA CLICKING

FRAN DI GIACOMO

When this delightful family commissioned me to paint them on this swing, the challenges were many. I had to make each person's proportions, age and fleshtone relate perfectly to the rest of the family (the baby not too pale, golfer Dad not too dark). The background foliage had to relate differently to each person, create movement and composition and be the glue that held it all together. Because they had requested a horizontal painting, both adults had to be seated — I had to arrange the level of the heads in a pleasing manner and follow the rules of good composition with the swing. Paint and technique cannot save a weak composition or bored expressions. When painting children, start with a camera and keep the shutter clicking. Put yourself on their level. I get lots of different expressions and closeups. This family portrait was put together like a jigsaw puzzle. If I needed a certain pose, or a foot or hand position, to keep the composition interesting, it was in a file. A brief session with each subject for fine-tuning finished the painting.

The Kleinert Family by Fran Di Giacomo, oil on linen, 36" x 50" (91.5cm x 127cm)

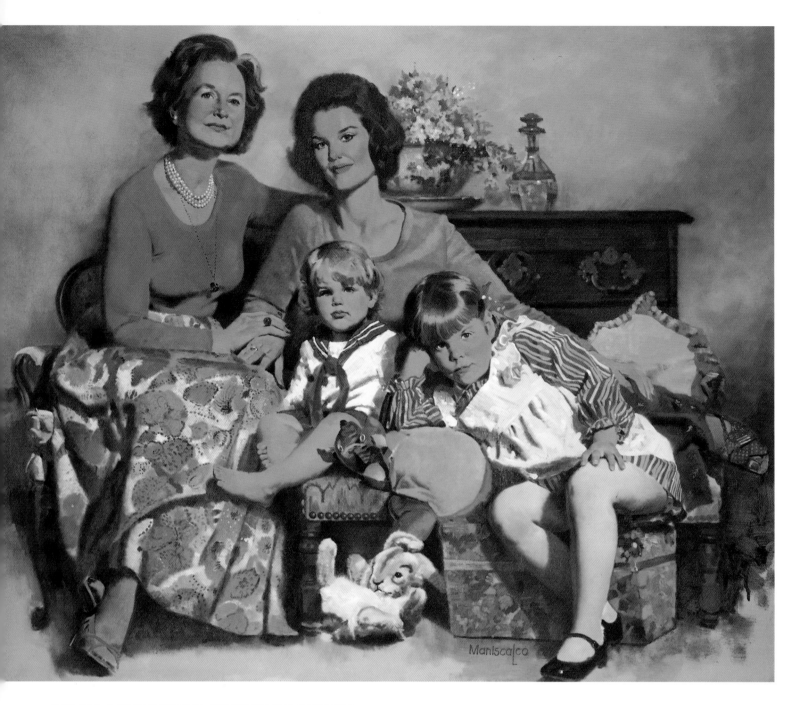

LINK MULTIPLE FIGURES WITH RHYTHM AND COLOR

JOSEPH MANISCALCO

To produce a portrait of a grandmother, a mother and two grand-children, all beautiful, was a joyful challenge. The object was to capture the family in an exciting and interesting composition with dynamic movement, characterization and color. To avoid stilted and unrelated poses, I make my subjects feel comfortable, creating a relaxed mood. In addition to doing a complete compositional sketch in full values and color, which permitted me to attack the canvas with confidence, I painted a small head study of each subject from life to ascertain coloring of hair, eyes and complexion. I tried a variety of poses to choose the most suitable for creating a composition in which the contours of the figures interlock and link cohesively and rhythmically.

Three Generations by Joseph Maniscalco, oil on linen canvas, 30" x 40" (76cm x 102cm)

ALTERNATELY ATTEND TO THE WHOLE AND TO DETAILS

SHUQIAO ZHOU

This was my first painting as Visting Artist at Occidental College. Mr. Pennington sat for two to three hours a day for two weeks as I demonstrated my methods for advanced drawing and painting students. I was passionately excited by the fresh experience of painting a portrait of a Caucasian. I found it necessary to retouch the eyes again and again. When the model dozed off occasionally, I reminded myself not to neglect relationships of the whole composition while indulging my fascination in these focal elements. Throughout your work, alternately establish the whole composition and then attend to details; return again to the whole and finally integrate all of the elements that express the character of the subject.

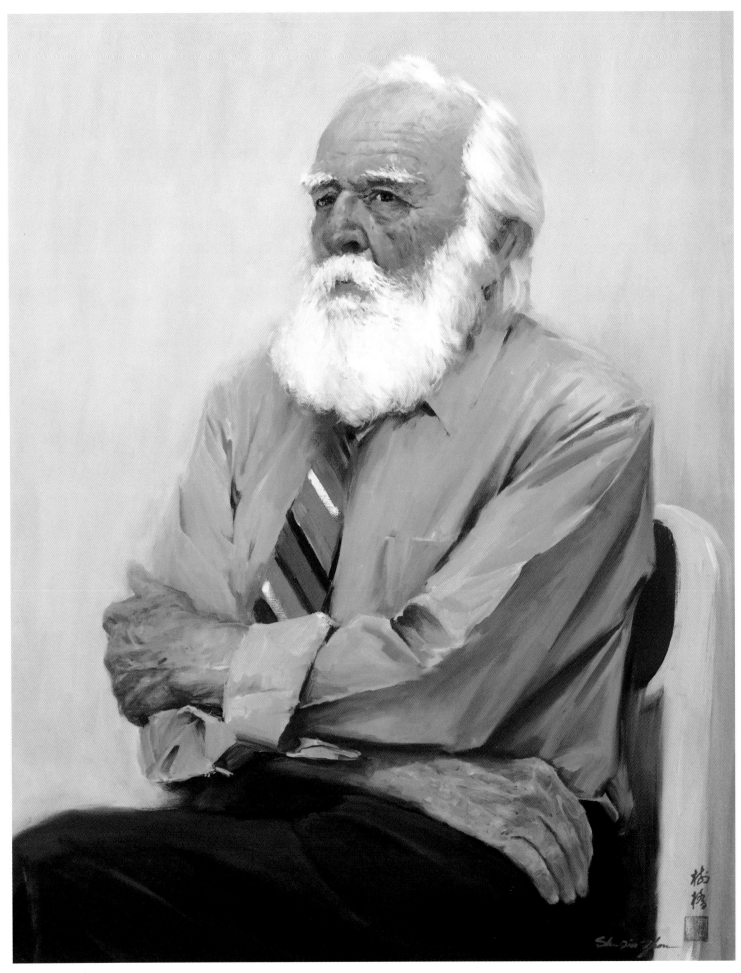

Mr. Pennington by Shuqiao Zhou, oil, 30" x 24" (76cm x 61cm)

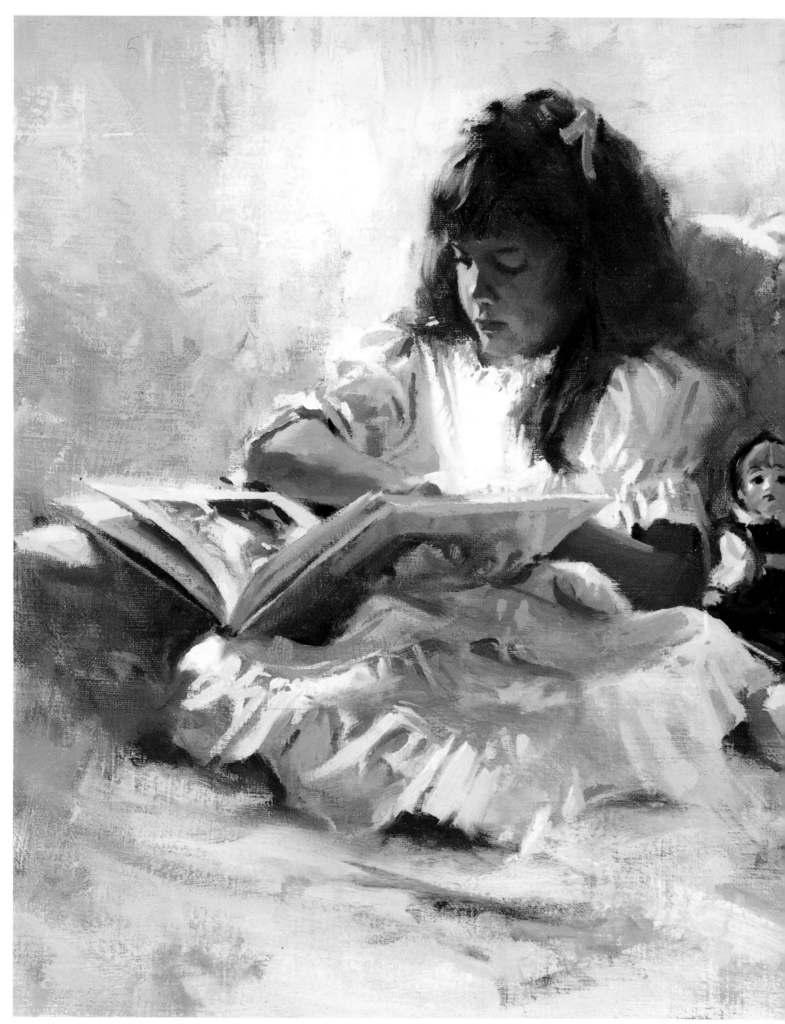

Abbie by Brian Jekel, oil on linen, 14" x 18" (35.5cm x 46cm)

TURN THE VIEWER ON WITH

LIGHT

Make light your partner in creating exciting portraits. This painting of Abbie is not a portrait in the traditional sense of focusing in on the face. It is about light creating beautiful forms around this little girl and what she is doing. The brushwork and palette knife work are loose, but accurately describe the light, shadow and form. The paint handling and the high key-palette are reminiscent of the Impressionists.

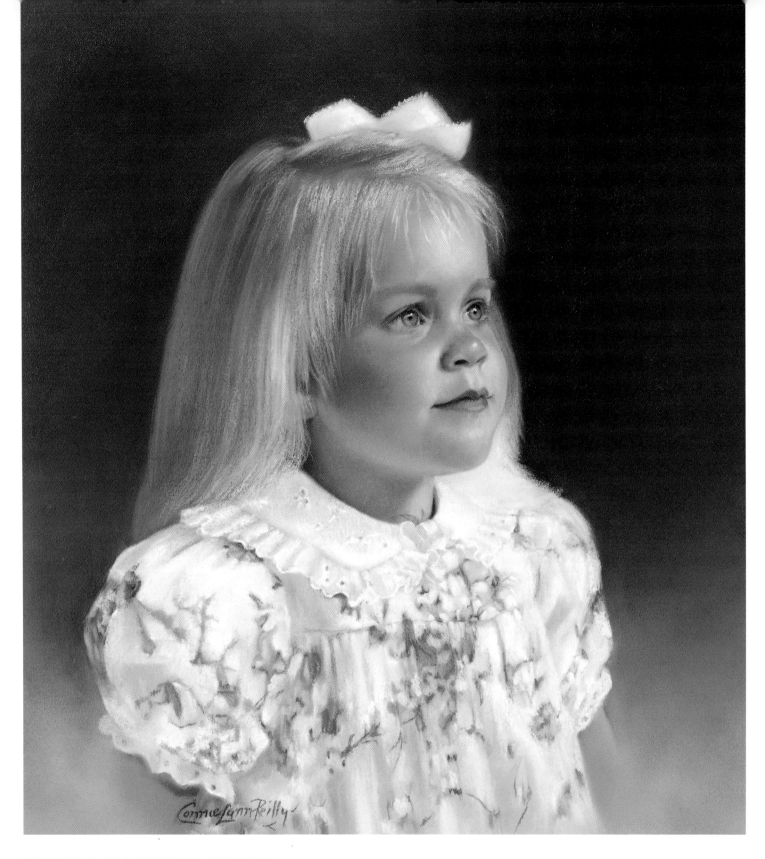

REVEAL AN INNER LIGHT

CONNIE LYNN REILLY

It has been said that "the light of the body is in the eye." The purpose of this portrait was to show the brightness of Christine's spirit and her soft, near-angelic quality. This required using natural light at the proper time of day, as well as choosing the proper pose and getting just the right expression from Christine. Dark and middle tones in large simple shapes and colors created a solid foundation on which to build three-dimensional form, saving the light tones for last. I blend and layer Rembrandt pastels until the desired realistic look is achieved.

Christine by Connie Lynn Reilly, pastel on Canson Mi-Teintes pastel paper, 24" x 18" (61cm x 46cm)

GOLDEN HIGHLIGHTS WITH PASTELS

KATHLEEN PUTNAM NEWMAN

This painting was inspired during a camping trip my sister and I took with our small children. On this particular morning I was explaining to my daughter why the raccoons might have taken the bracelet she left outside the night before. After mapping out the shapes and patterns of light with black Prismacolor pencil, I completed the watercolor and then, using pastel lightly on the surface, created texture and recaptured golden highlights in the hair, setting up more contrast with the dark background.

Linzie by Kathleen Putnam Newman, watercolor and pastel on Arches 140 lb. cold-pressed paper, 14" x 10" (35.5cm x 25.5cm)

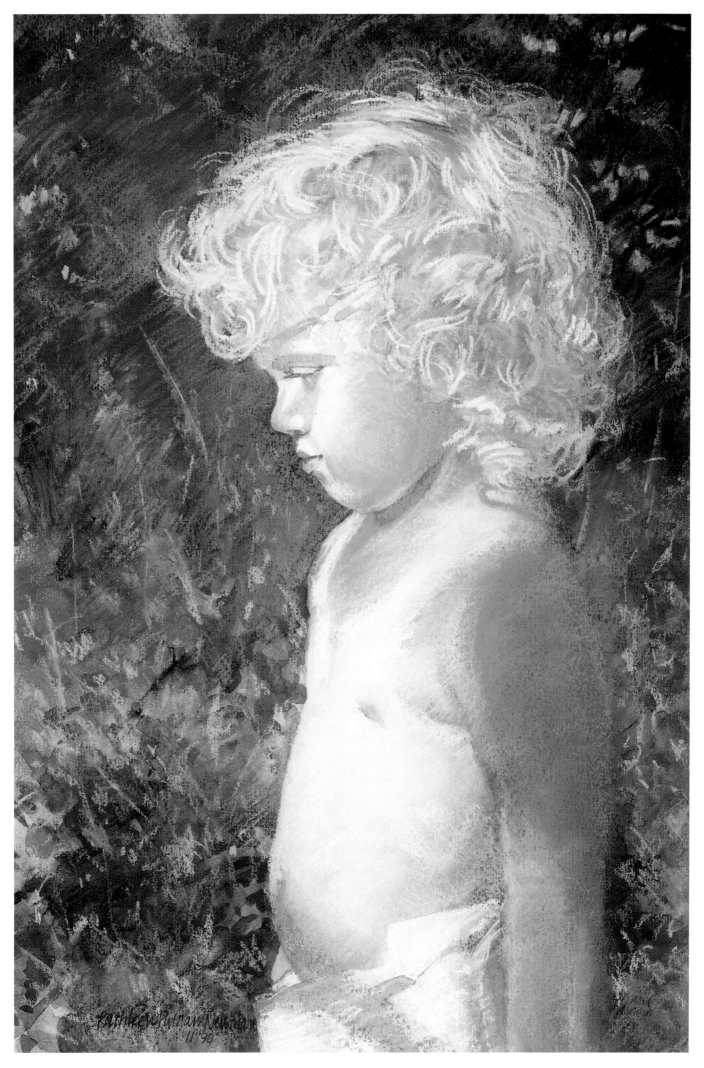

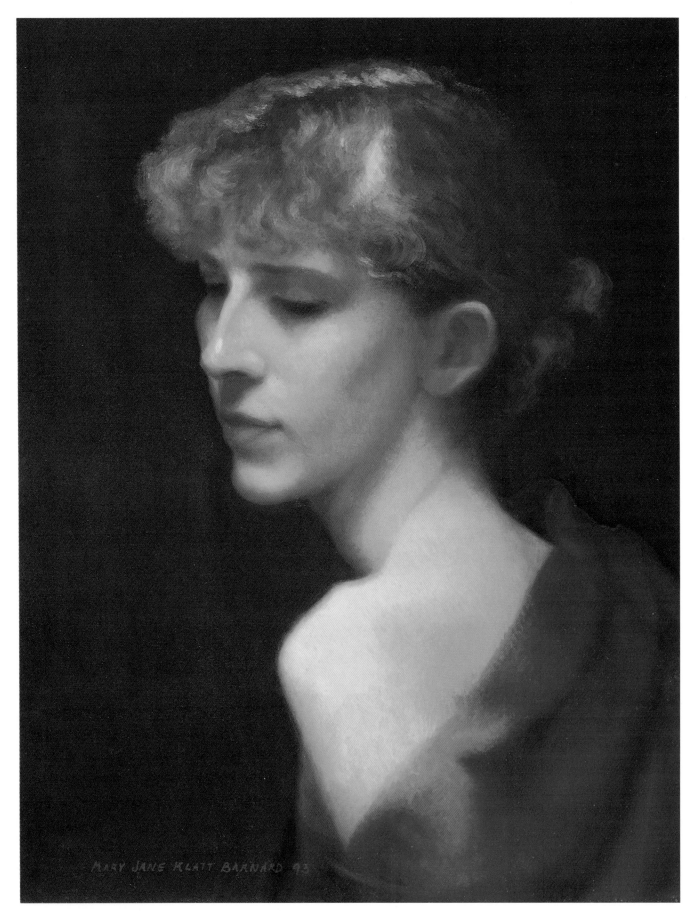

SQUINT TO SEE MASSES OF LIGHT AND DARK

MARY JANE KLATT BARNARD

When Katherine, a model, posed for a group of figure-drawing students, I stood outside their semicircle to paint this head study. I painted the red drapery from a mannequin. My goal was to capture the serene mood and classical lighting of the pose. While developing the large masses of light and dark, I squinted to see the overall visual impression. Later, shapes, colors and values were refined, eliminating unnecessary details.

Katherine by Mary Jane Klatt Barnard, oil on linen canvas, 15" x 12" (38cm x 30.5cm)

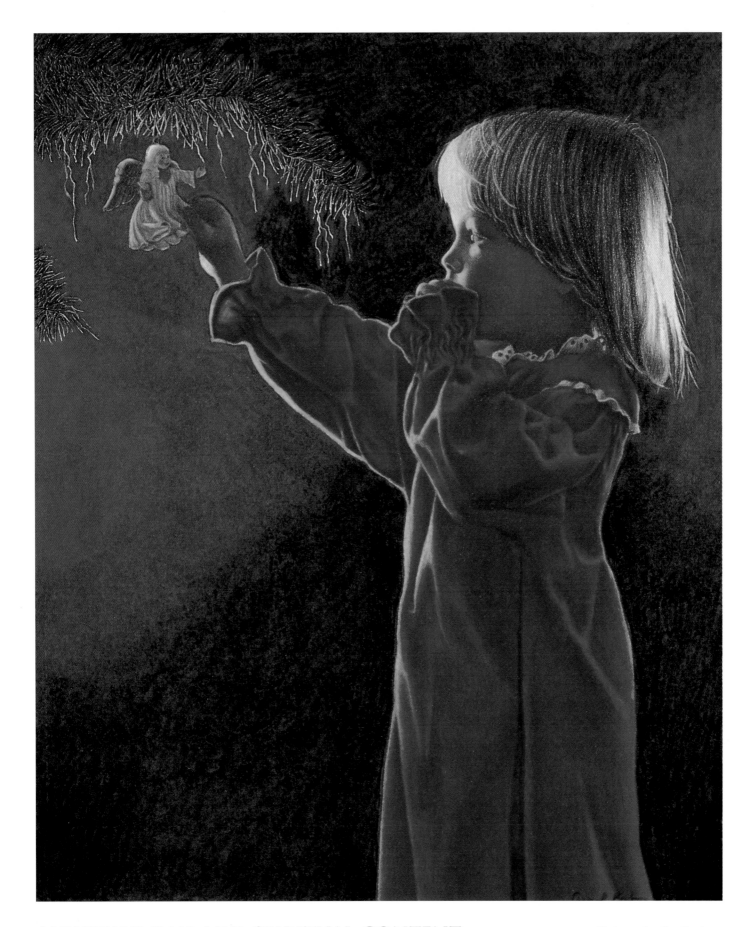

LIGHTING CAN ADD SPIRITUAL CONTENT

CAROL BAKER

For the holidays, a local gallery scheduled a "Works of Faith" show. Remembering a black-and-white photo of a friend's daughter beholding an angel on the Christmas tree, I asked to borrow it. The photo was spiritually and emotionally moving, and the lighting was extraordinary. It was reminiscent of the wonder I had about Christmas as a child. Using Berol Prismacolor pencils on a soft cotton rag paper, I can create rich, saturated color. The soft, waxy colors are easily blended, and by burnishing over layers you can create a smooth, velvety surface.

Christmas Angel by Carol Baker, Prismacolor on Rives BFK 250 printmaking paper, 20" x 18" (51cm x 46cm)

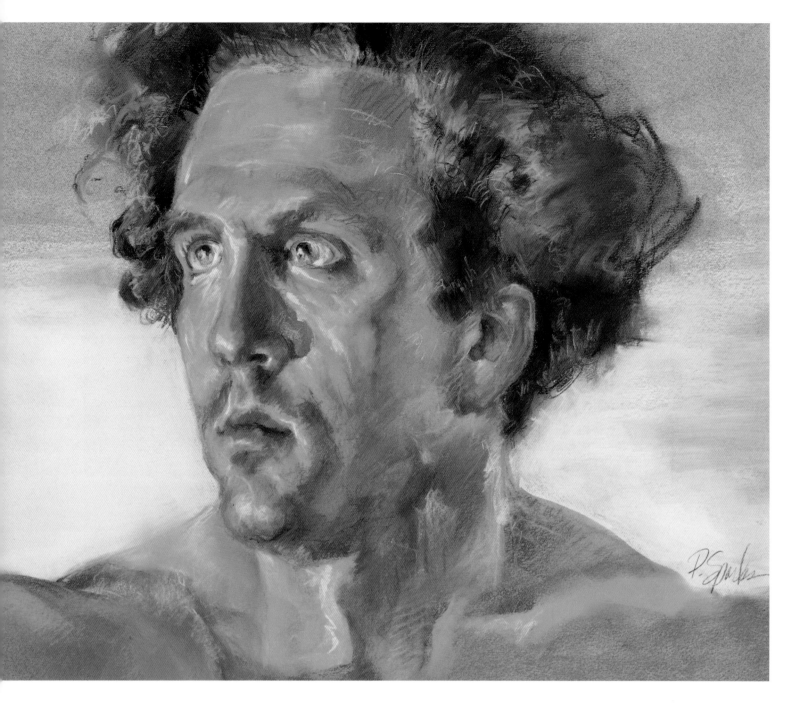

Alexander Was Here by Perri Sparks, Nupastel and Grumbacher pastel on Felt Gray Canson Mi-Teintes paper, 15" x 19" (38cm x 48.5cm)

DRAMATIC RESULTS WITH A SINGLE FRONTAL FLOODLIGHT

PERRI SPARKS

A career as a surgical illustrator provided a foundation of tight, realistic imagery; however, my work is now an emotional response to the subject. I scheduled one three-hour session for this subject and used a single strong, frontal floodlight with diffuse, cool, reflected fluorescent room light. The intensity and motionless concentration of this model permitted me to relax and be creative with the warm and cool tones overlaid on my basic value blocks. When I use a particular color in one section, I make sure it appears in at least two or three other areas. I keep my palette limited, working best when constrained by time and the immediacy of a live model.

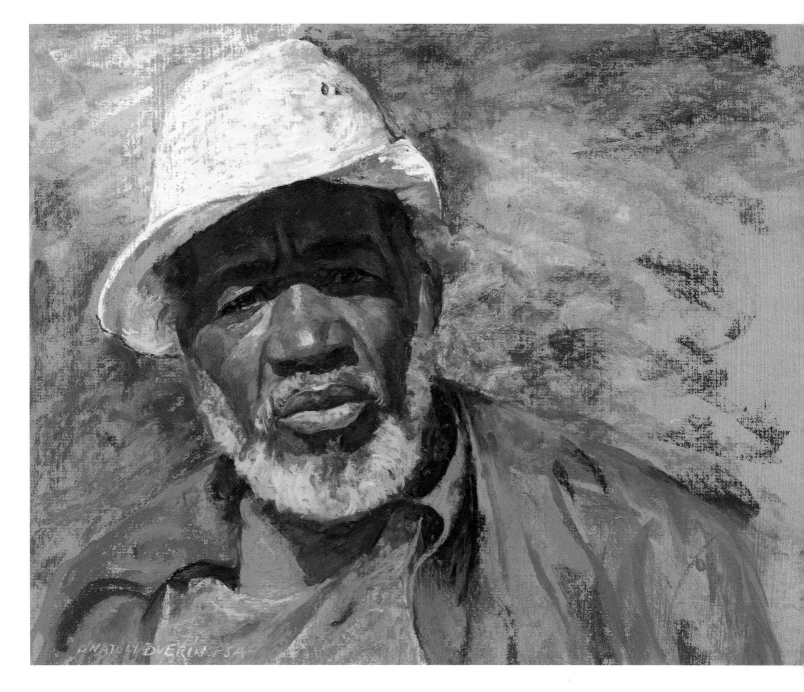

LET SOME OF YOUR SURFACE SHOW FOR A SENSE OF FLICKERING LIGHT

Anatoly Dverin

Moses is a local fisherman I saw on the lake near my house. The chocolate color of his face, the play of light and shadows, his bright blue jacket and stark white hat all combined to create some very striking contrasts. With his permission, I did some sketches and took a few photographs. Back at my studio, I composed a preliminary sketch and then invited Moses over. I posed him outside to reproduce the same lighting conditions as by the lake. As I began drawing, I kept much of the board visible. This helps to create a sense of flickering light and to produce good eye movement. I worked much deeper into the face, concentrating particularly on the eyes and mouth, as they allow us to see inside the person. I let blues and violets be reflected in the shadows to help dramatize the warm tones of the face. To keep the eye focused on the rich, warm colorations in Moses' face, I kept the background colors cool and the strokes undefined. Their unfinished quality allows for an active surface of light and movement.

A Man in a White Hat by Anatoly Dverin, soft pastel on board prepared with gesso and marble dust, 16" x 20" (41cm x 51cm)

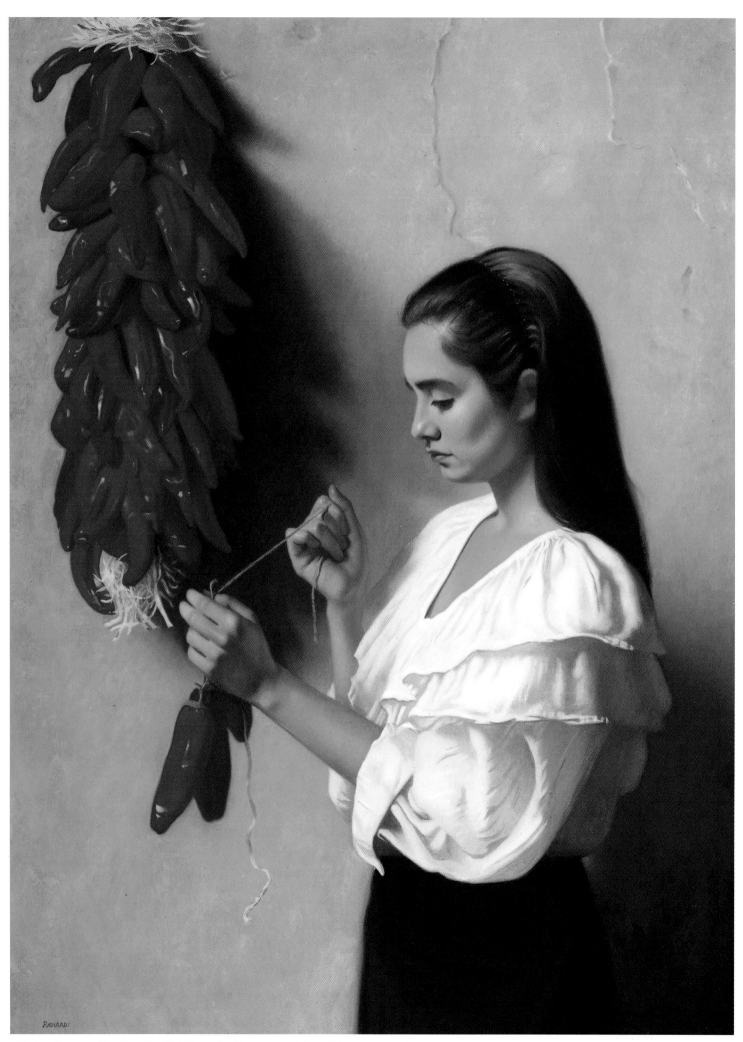

Marissa (Starting a New Ristra) by Kirk Richards, oil on canvas, 40" x 30" (102cm x 76cm)

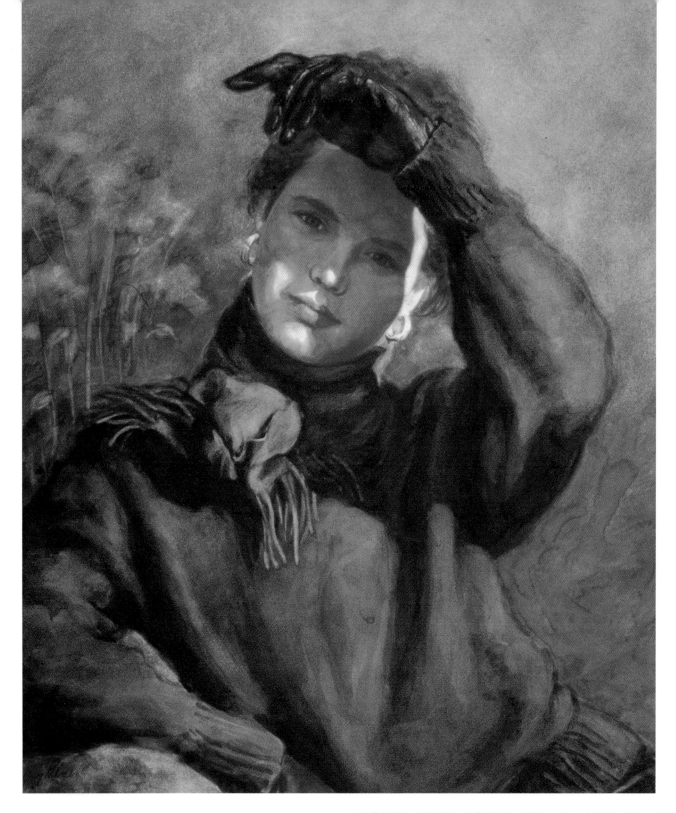

ENJOY THE SUBTLETY OF NATURAL LIGHT

KIRK RICHARDS

This portrait was an opportunity to explore part of the cultural heritage of the southwestern United States. The intent of this painting is for it to appear to have been painted outside, in front of an adobe wall, although it's actually a studio painting, with the model posing in front of an "adobe" wall of my own creation. I worked directly from life, with natural light from a north-facing skylight. The subtleties of color and value transitions as illuminated by natural light cannot be duplicated by photography. I rendered the figure very carefully, and then "textured" the wall using a combination of transparent and opaque paint, and both brushwork and palette knife work.

LIGHT EXPRESSES TIME AND SEASON

JANET PALMER

In this portrait, light is the real subject. The quality of the light expresses the time of day and year, and defines form almost without the need for detail. Colors have been reduced to basically three — skin, clothing and background. The figure is still, but there is movement in the tilt of the head and the curve of the arms and folds. To create a dialogue between sitter and viewer, the subject looks out of the picture plane and engages eye contact. Plate-finish Bristol board is a recent discovery for me. The smooth, slippery surface can be reworked almost indefinitely by painting, lifting and repainting. The drips and blobs created by the slick surface give a spontaneous look to the painting.

October Light by Janet Palmer, watercolor on Strathmore plate-finish Bristol board, 22¾" x 19" (58cm x 48.5cm)

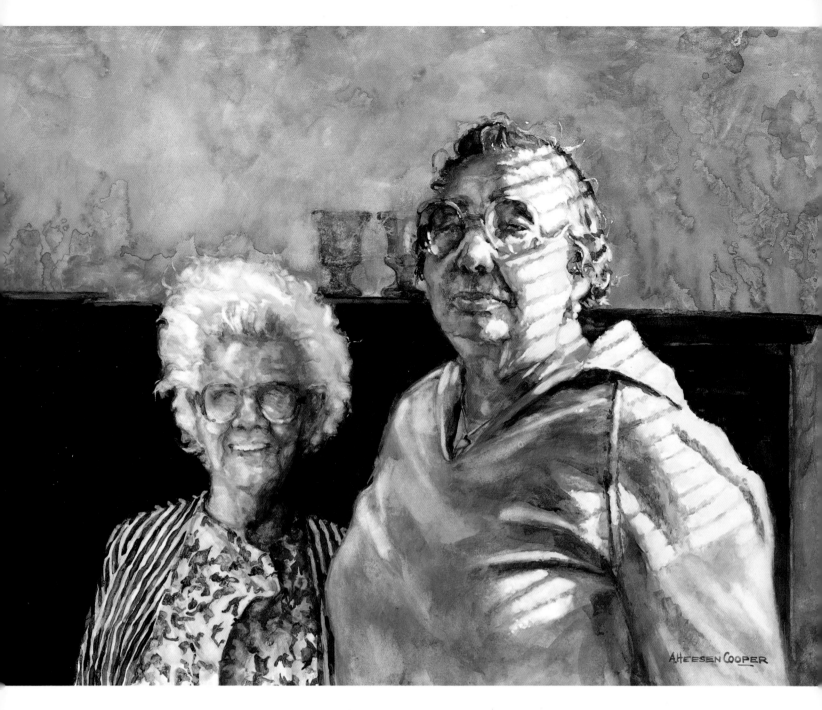

Old Friends by A. Heesen Cooper, watercolor and white designer gouache on Bristol plate-finish paper, 20 ½" x 27 ½" (52cm x 70cm)

USE AVAILABLE LIGHT TO EMPHASIZE MOOD

A. HEESEN COOPER

I love painting people. At a local senior center, I met these two old friends. I was struck by their differences: one tiny, one strong and proud. The strong light from the shaded window emphasized the indoor atmosphere. I used a watercolor method learned from Burt Silverman: This way of working starts with milky washes of small amounts of white designer gouache and watercolor on Bristol plate-finish or gesso-coated paper. It gave me the opportunity to move the color around, remove it, layer it and mess with it to my heart's content, and also to work from dark to light as well as from light to dark. This flexibility allowed me to become totally immersed in the atmosphere, the light, the patterns and the people. The two glasses alone on the shelf behind the women seemed to provide a metaphor of their friendship.

THE PORTRAIT MAKES THE LIGHT COME ALIVE

SABINE BARNARD

This particular painting did not originate as a portrait. I was primarily focused on the illumination on the tree, with its few remaining leaves lit up like lanterns. My daughter was standing under the tree, wearing her Halloween Fall headdress, adding to the interesting light play, but I regarded the portrait aspect as secondary to the light. It wasn't until I was well into the drawing that I discovered I had to do an exact likeness of her. The setting portrayed her perfectly, happy and at ease, surrounded by nature and light. At that point she became the reason for the composition, because she made the illumination come truly alive. I worked with strong contrasts of highlighting, backlighting and shadows, using a purely transparent palette to achieve a luminous quality.

Klein at Home by Sabine Barnard, NWS, transparent watercolor on Arches 300 lb. cold-pressed watercolor paper, 22" x 22" (56cm x 56cm)

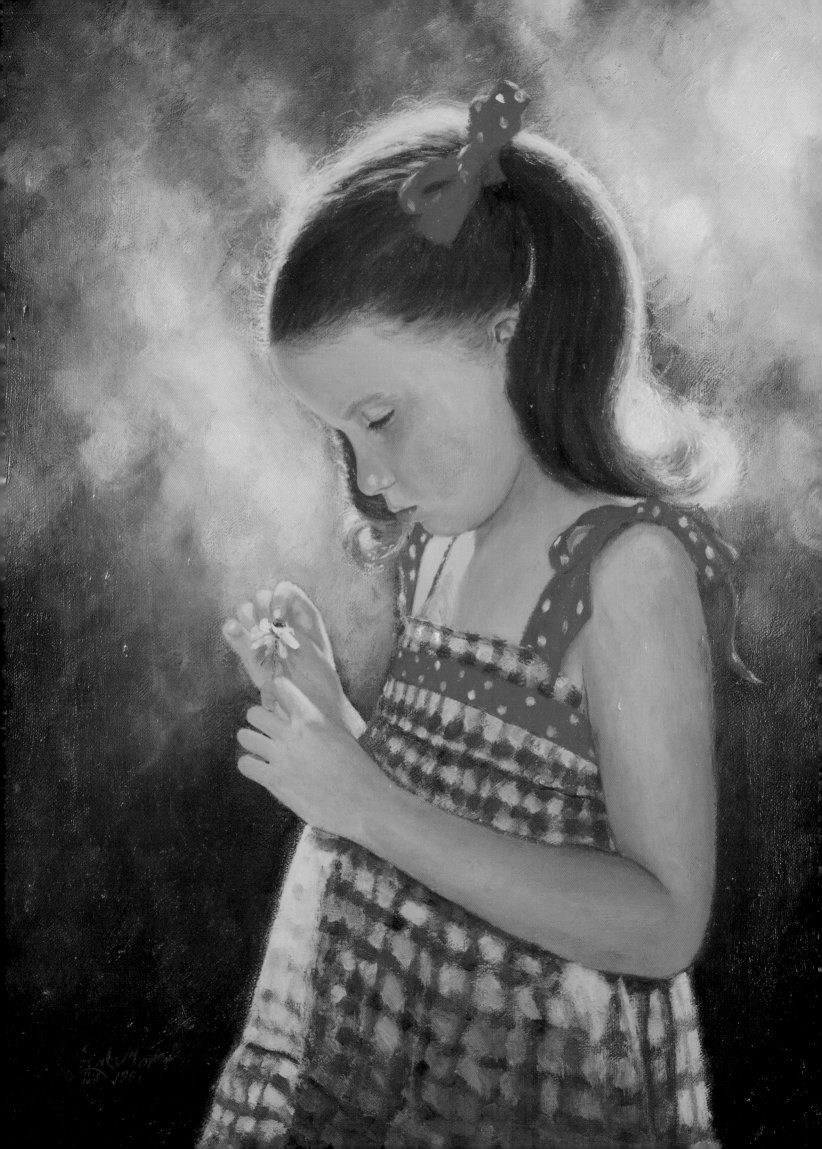

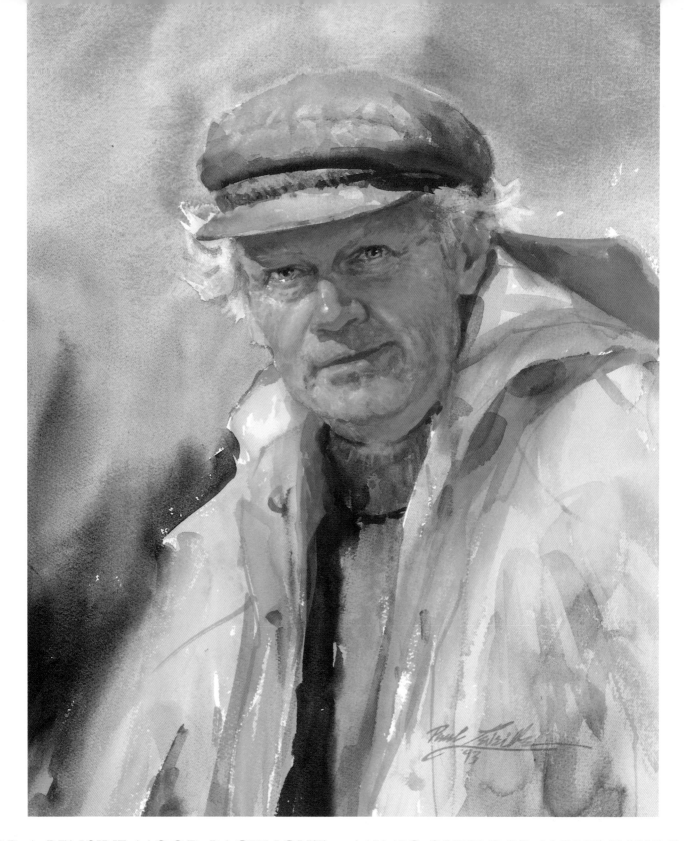

FOR A PENSIVE MOOD BACKLIGHT

EARL MOTT

This portrait was painted from a photograph. I was intrigued by the strong contrast of the shadowed figure and the halo effect of the light around the head and shining through the front of the dress. I wanted to capture the pensive mood of a little girl in a reflective moment. Placing the girl's face and body in shadow helps to create this mood. The background was painted soft and blurred to enhance the dreamy, thoughtful mood of a little girl unaware of anyone watching. After quickly blocking in the painting, I refined the portrait with several overpaintings using white sable brushes.

Girl With Flower (Elizabeth Taylor) by Earl Mott, oil on canvas, 18" x 14" (46cm x 35.5cm)

MIMIC OUTDOOR LIGHT INSIDE

PAUL LEVEILLE

Len is a close friend and an artist. I never tire of painting his face. The weathered Greek fisherman's cap, which he wears quite often, inspired this painting. For a more nautical appearance, I asked him to put on a yellow slicker. By carefully arranging the lighting in my studio, I was able to create an outdoor look, with strong contrasts of light and dark. The surrounding background and clothing were done loosely to allow the viewer's eyes to easily travel to the focal point — the face. The highlights on the lower eyelid and nose were achieved by "picking" color off the paper with the corner of a razor blade.

Old Salt by Paul Leveille, watercolor on Arches 300 lb. cold-pressed watercolor paper, 22" x 17" (56cm x 43cm)

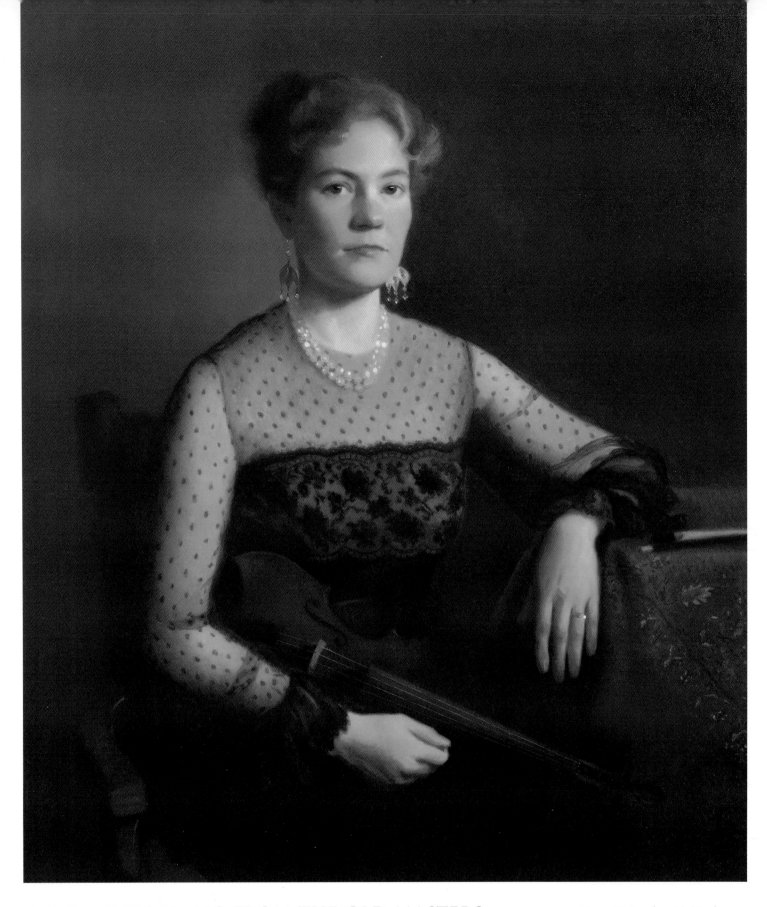

BORROW LIGHTING FROM THE OLD MASTERS

MARY JANE KLATT BARNARD

Nancy, My Daughter, My Muse by Mary Jane Klatt Barnard, oil on linen canvas, 40" x 34" (102cm x 86.5cm)

This satisfying likeness of my cherished red-haired daughter Nancy helps me feel her presence when she lives elsewhere. Life-size, it was painted from life on her visits home to enable me to see the subtleties of value and color in the structure of the face and figure. The lacy dress (posed on a mannequin in Nancy's absence), her violin, the table covering and the chair were chosen to tell a story, as well as for dramatic light and dark values, varied patterns and an expressive outline. To suggest three-dimensionality, I lightened the background next to the shadowed side of the head and darkened it on the light side.

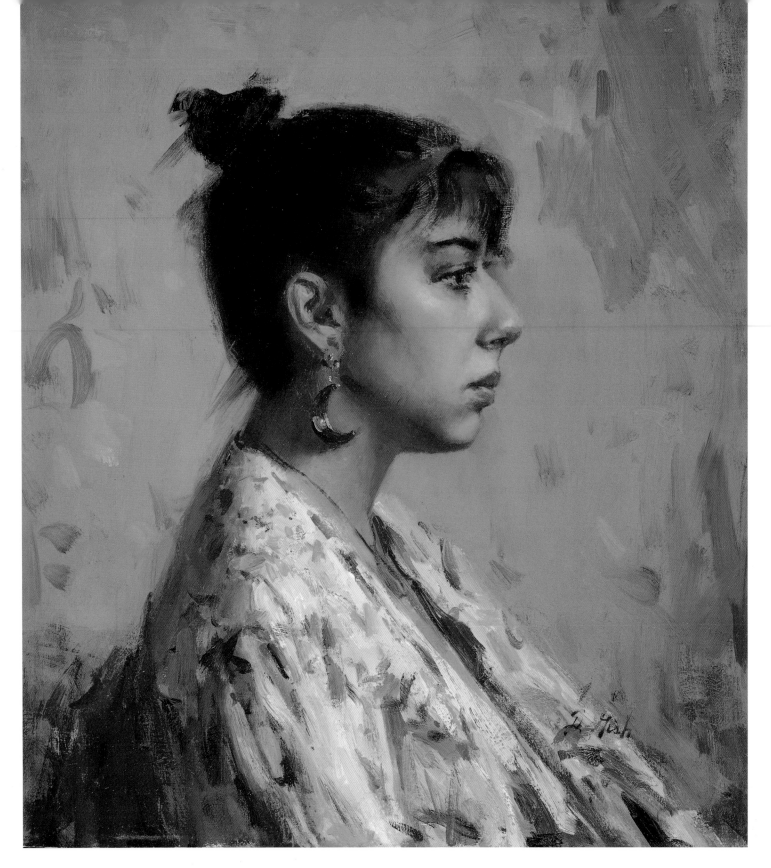

NORTH LIGHT FOR WARM SHADOWS AND COOL LIGHTS

Young Woman by Del Gish, oil on panel, 18" x 16" (46cm x 41cm)

Del Gish

The model was sitting in a studio lit with northern light, creating the appearance of warm-colored shadows and cool lights. There are four value masses: The lightest is the lit part of the face and blouse; the background is a middle-tone light; the shadows on the blouse and face are middle-tone darks; and the hair is the darkest. The painting was done in five three-hour sessions. At the second sitting I coated the entire painting with a thin layer of Liquin and continued working thinly. This way, one is always working on a wet surface and it's easier to model forms using a combination of glazing and scumbling.

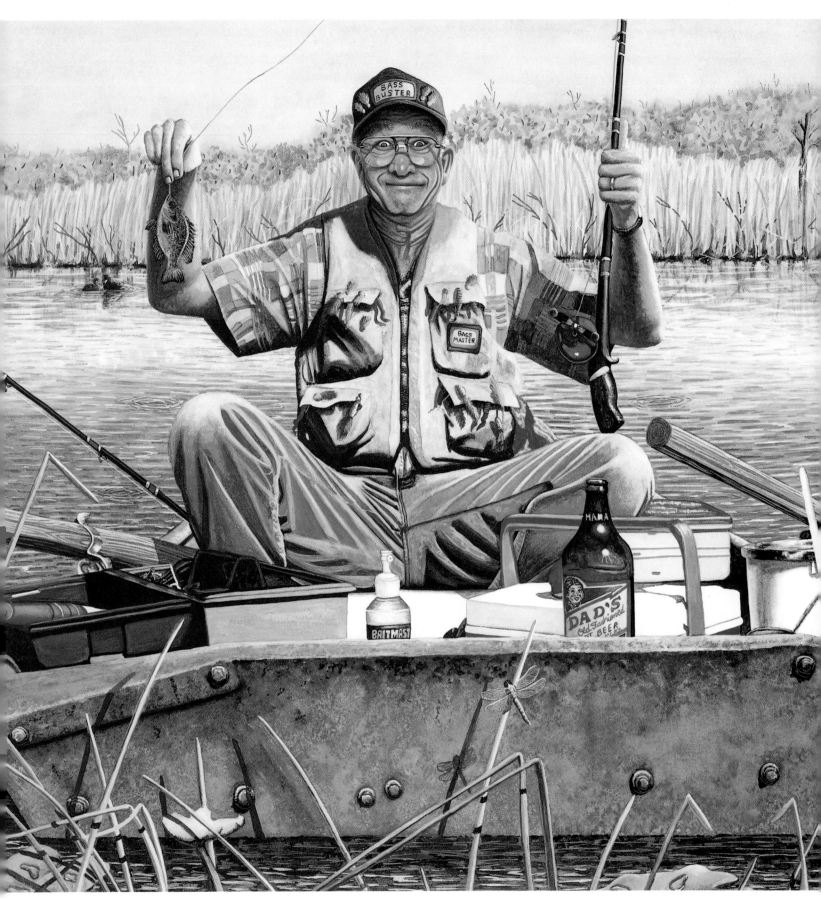

The Cradle Robber by Rachelle Siegrist, watercolor with white gouache on Cresent cold-pressed watercolor board, 20" x 30" (51cm x 76cm)

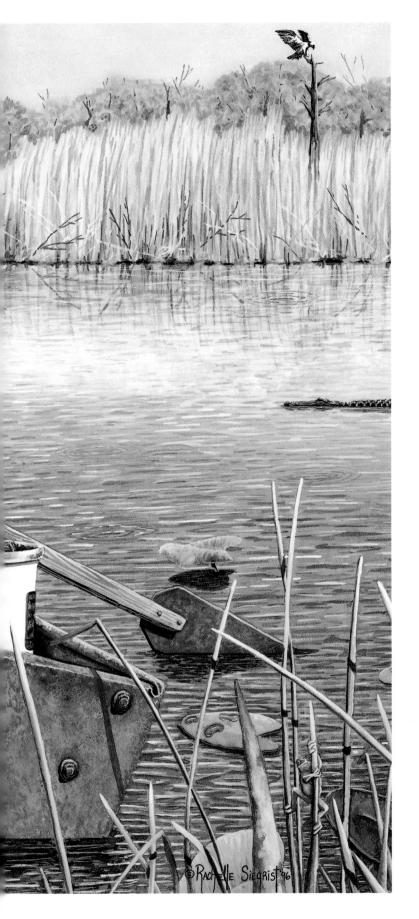

POSE OR GESTURE

A gesture or pose can be the central idea of your painting. Unlike most of Rachelle Siegrist's work, this painting originated in her head. Her friend, Jim Macumber, an avid fisherman and a genuine character, was a natural choice for the main subject. He agreed to pose holding a pole and an imaginary fish, according to her mental image. The boatload of junk is fun and adds interest and believability; the little "critters" fill the composition with life and surprises.

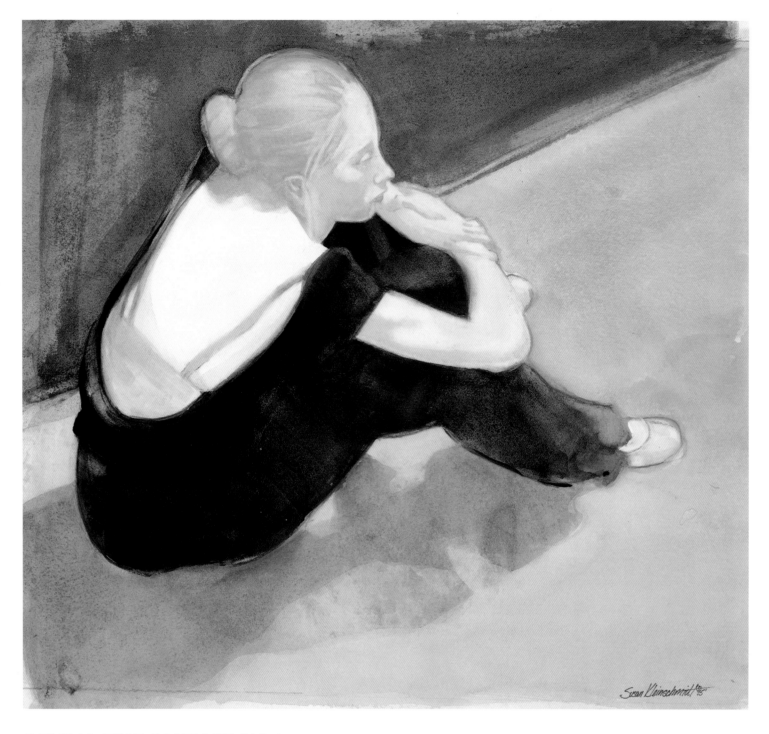

REVEAL THE ESSENCE IN A SUBJECT'S BEARING

SUSAN HOLMES KLEINSCHMIDT

The essence of a subject can be revealed in bearing as much as by facial expression. This stance caught the particular irony of Julie, who had the stage presence of an accomplished dancer and, in repose, the lanky ennui of a schoolgirl. I like to juxtapose a minimal design with the painterly application of paint. I eliminate all distracting detail and simplify the design to focus on the figure. With my limited palette, I use paint deliberately — letting the brushstrokes, drips and granulations build up on the surface. By alternating layers of transparent and opaque paint, I can achieve a wonderful, rich paint quality.

Angle of Repose by Susan Holmes Kleinschmidt, watercolor on 300 lb. hot-pressed watercolor paper, 22" x 26" (56cm x 66cm)

USE THE GESTURE OF THE WHOLE FIGURE

BARBARA ICYDA

At play, children enter their own fantasy world: It is up to the artist to capture that moment. I use the gesture of the whole figure to portray emotion, and the details of the face and hands to further reveal their tenderness. In this commissioned portrait, I suggested white dresses, which reflect the sea and sky and bring a sense of tradition and timelessness to the subjects. Yellow Ochre was used throughout to unify the composition.

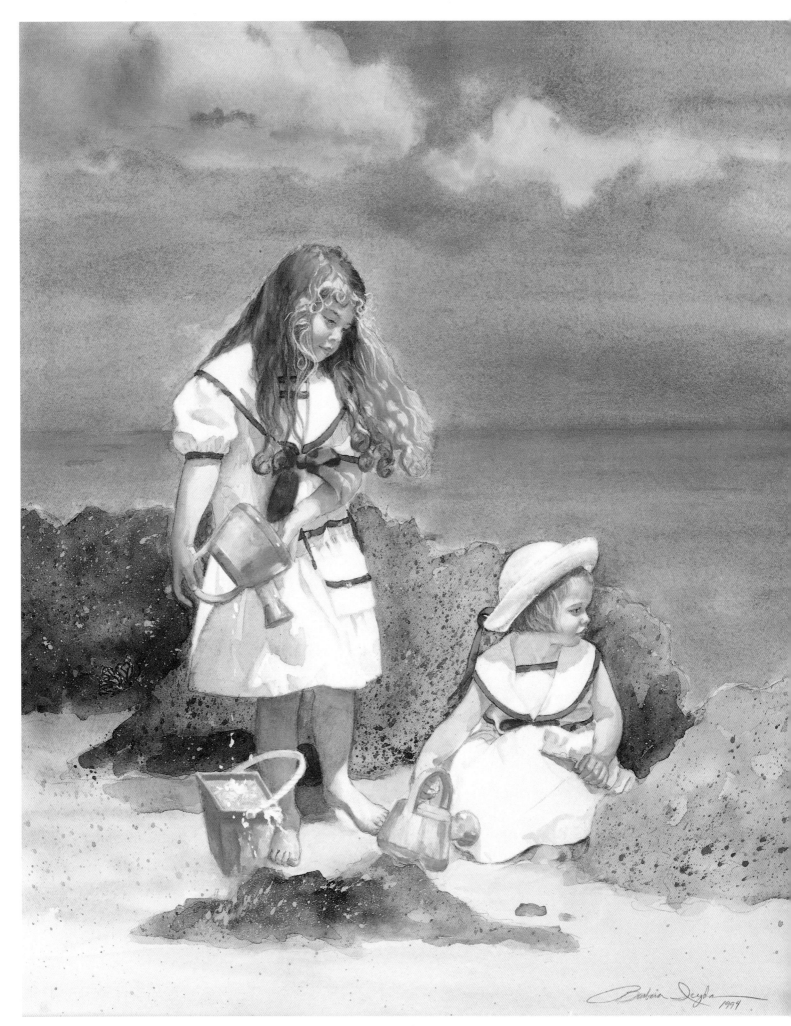

At the Seashore by Barbara Icyda, watercolor and gouache on paper, 22" x 18" (56cm x 46cm)

LET KIDS EXPRESS THEMSELVES

ARNE WESTERMAN

I think my paintings reflect my love for kids. I was in the process of working on a commissioned group portrait of the four Lathrop children when Amaya, a little jumping jack, dove onto this chair. In that gesture, she instantly exposed her impish personality, and I knew I had the stuff for a good painting. Young kids don't like to hold still. I encourage them to turn themselves into actors and to make up their own play. They will create better scenes than anything you can imagine. I follow with a camera and try to click as fast as they move. I make small color sketches on the spot as needed, and then work from the photos and sketches in my studio. An artist I know said, "Make every stroke count." Frankly, I never know what brushstroke is going to be permanent or what I'll want to wash off and replace. That's why I paint on Lanaquarelle hot-press, a paper that is very flexible and forgiving. I also like the brush textures that come with hot-pressed paper.

Amaya Lathrop on Chair by Arne Westerman, AWS, NWS, watercolor on Lanaquarelle hot-pressed paper, 14" x 20" (35.5cm x 51cm)

SOME KIDS WILL POSE LIKE MODELS

TOM BROWNING

With young children I resort to brief photo sessions for my reference materials. This little girl was only three years old but acted like an experienced model, holding poses and following my every direction perfectly. This resulted in a lot of good photos that required little alteration at the easel. When I set up this pose, I tacked a colorful poster to the wall directly behind my model. I then used these spots of color to help give direction and unity to the overall painting. With a loose technique like mine, the painting process is more fun when most of the problems are solved at the time of the photo session.

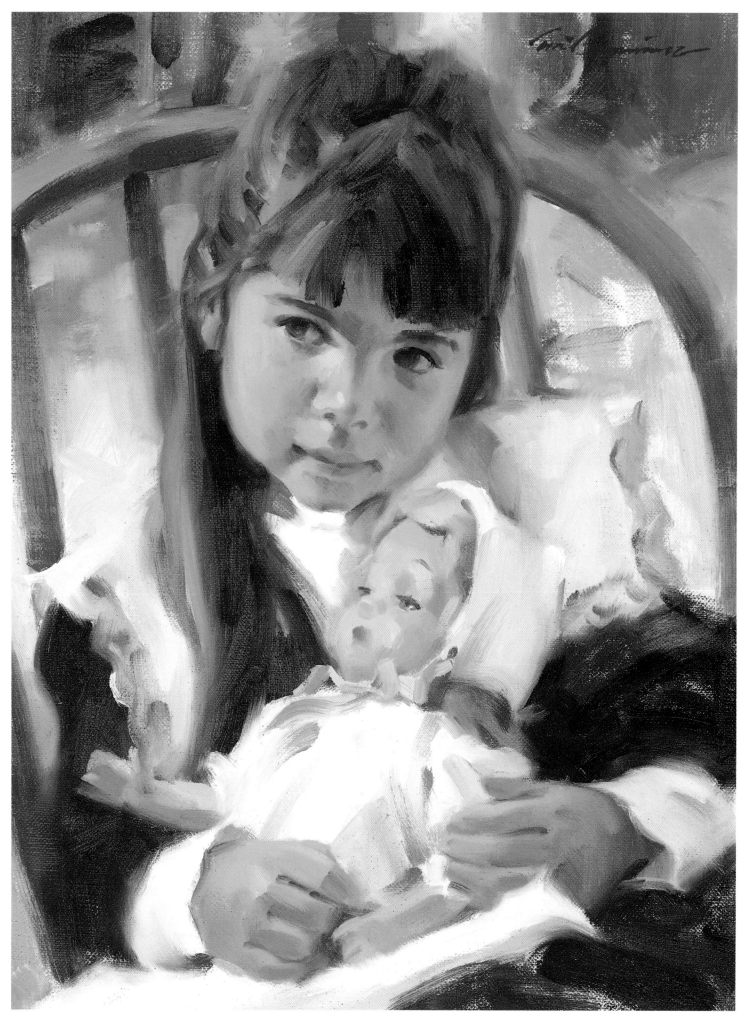

New Dresses by Tom Browning, oil on canvas, 12" x 9" (30.5 x 23cm)

Elizabeth by Corinne Baker, Berol Prismacolor color pencils on Canson Mi-Teintes paper, 20" x 13" (51cm x 33cm)

KEEP A POSE SIMPLE WHEN PAINTING MULTIPLES

CORRINE BAKER

Commissioned *Elizabeth* came with several stipulations: She is one of a photo series of three siblings, each with different lighting and a different pose. The challenge was to coordinate the three poses to be displayed together and at the same time choose the best background for each one. The rich tobacco color of the paper met some of that challenge by providing the warmth needed for the undertones of the skin and emphasizing the shiny blonde hair of all three children.

PORTRAY THE INTRINSIC VALUE OF PEOPLE

JOYCE ANN BIRKENSTOCK

Most of my time is spent on commissioned portraits, but some of my favorite endeavors are done for the sheer joy of painting people. There are many people in Haiti that capture your heart; this young girl is but one. I felt moved to portray the intrinsic and everlasting value even in the poorest of the poor. First I applied a quick-drying sculptural white, with both a brush and a knife, to the areas that provided an opportunity for textural rendering. I wanted to juxtapose the rugged exterior walls and thatched roof against the young Haitian girl's delicate skin. My greatest challenge was creating the look of dust-laden feet. Over the dark, rich skin, I scumbled the pale hue of the dust.

Watching and Waiting by Joyce Ann Birkenstock, oil on acrylic-primed canvas, 48" x 24" (122cm x 61cm)

A POSE CAN EXPRESS A RELATIONSHIP

KATHLEEN PUTNAM NEWMAN

My daughter Linzie and her cousin Melanie have had a special bond all their lives. Being born one day apart and living two blocks away from each other, they're siblings without the rivalry! On a perfectly clear and sunny fall day, we drove out to the Indiana Dunes on Lake Michigan to spend one more "summer" day at the beach. After flying up and down the dunes, spinning cartwheels and splashing through icy-cold waves, they sat in this relaxed pose that reflects their togetherness as an autumn sun warms them. Portraiture, for me, is about capturing a likeness, but also about telling the story of a special moment.

True Confessions by Kathleen Putnam Newman, transparent watercolor on Strathmore 114 cold-pressed watercolor board, 15" x 20" (38cm x 51cm)

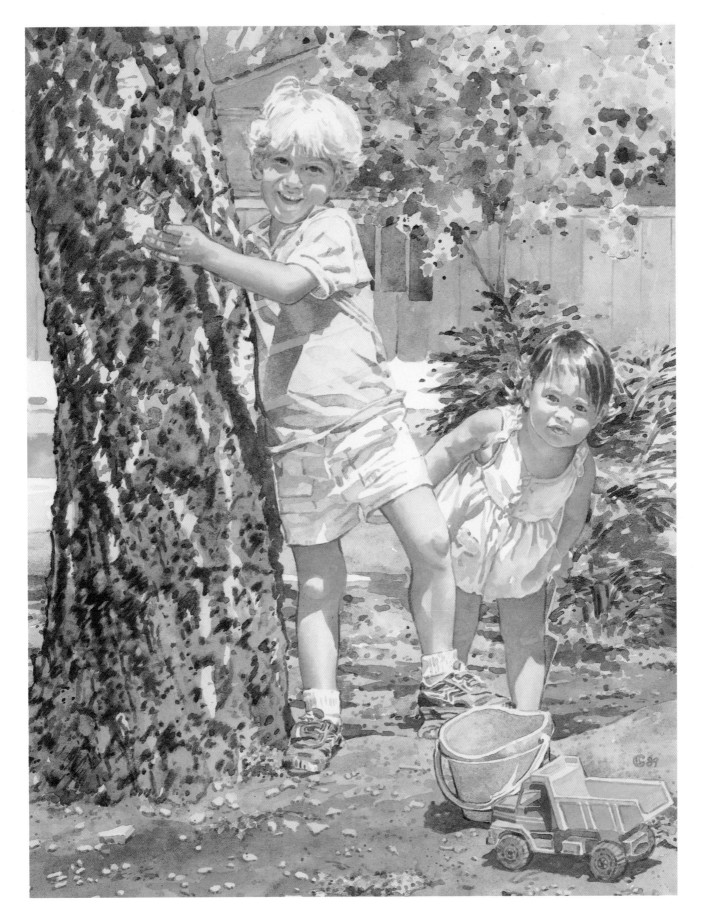

BODY LANGUAGE CONVEYS PERSONALITY

CLAIRE SCHROEVEN VERBIEST

Because body language and gesture help me better convey a model's personality, I prefer to paint casual, full-length portraits that include bits of the individual's everyday environment. Although I work from photographs, it is essential for me to meet the people I have been asked to paint. With young children, I try to optimize the first twenty minutes of the photo shoot, as they tend to lose interest quickly. By playing peekaboo with their children, the parents of these siblings helped me capture spontaneous and playful gestures.

Peekaboo by Claire Schroeven Verbiest, watercolor on Arches 140 lb. hot-pressed watercolor paper, 15½" x 11½" (39.5cm x 29cm)

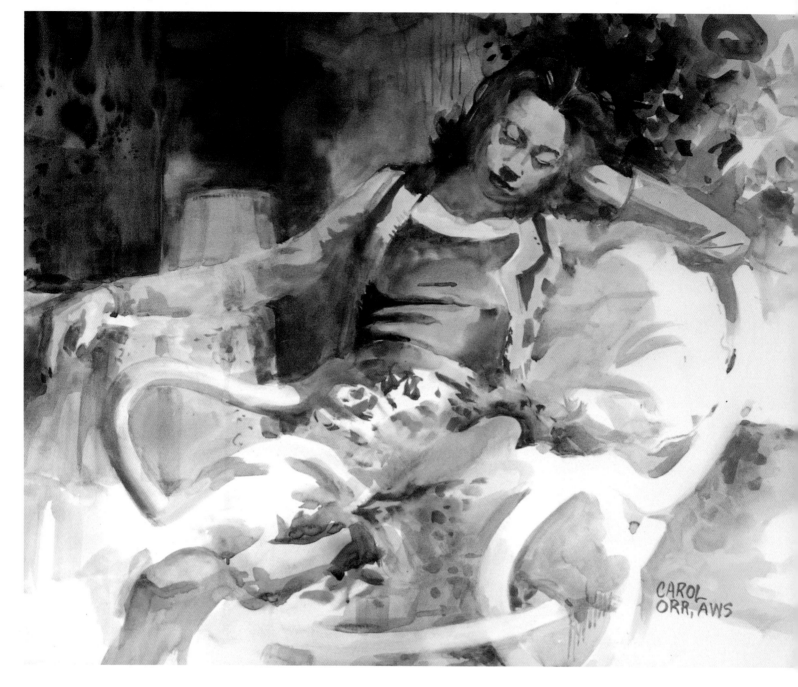

SUPPORT THE SUBJECT'S GESTURE WITH THE RIGHT BACKGROUND

CAROL ORR

Painting directly from a model in a two-and-a-half-hour sitting, the painting was complete except for the background. I was pleased with the languid quality of the pose, but my problem was to create a supportive background that did not detract from the mood of the subject. I added to and subtracted from the background several times before I was satisfied with the complete painting. Painting on Bristol board is a rewarding experience. Color remains vivid but can be removed and restated easily.

Moment of Rest by Carol Orr, AWS, NWS, watercolor on Strathmore 500 series Bristol board, 21" x 34" (53.5cm x 86.5cm)

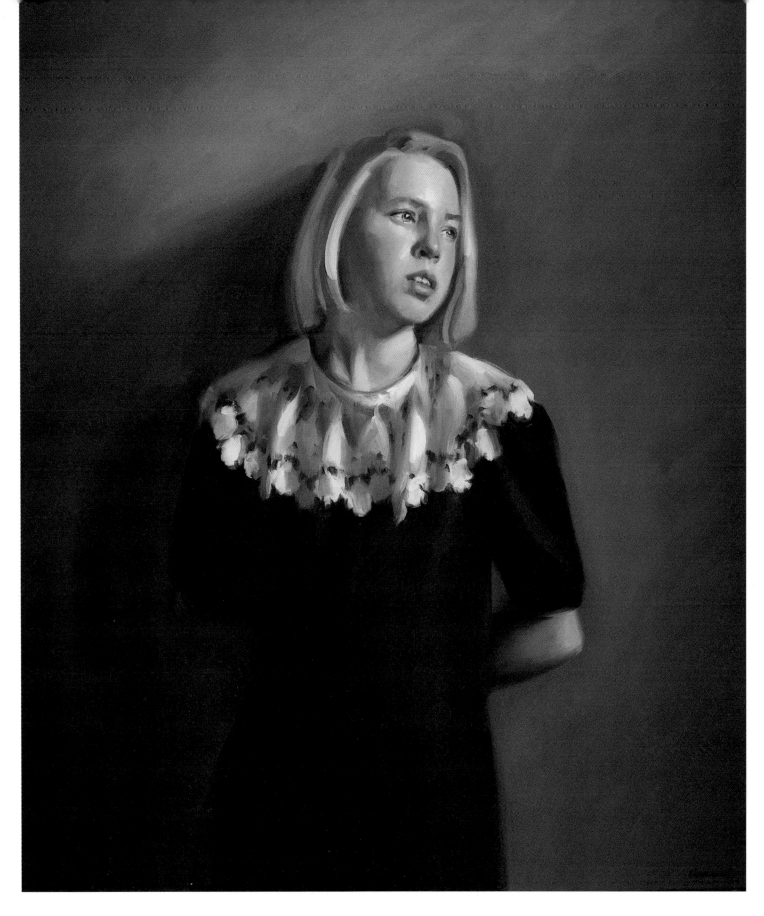

TRY A STANDING POSE

KURT ANDERSON

I think the most important aspect of portrait painting is choosing the right gesture and expression for the subject. When this young woman came to my studio to pose, I spent a great deal of time trying a variety of different seated poses. Nothing quite worked, so I pulled away the model stand and had her lean against the wall. When she turned her head toward the window, the pensive personality I was trying to capture suddenly came through.

Portrait of Jennifer Shegos by Kurt Anderson, oil on canvas, 40" x 30" (102cm x 76cm)

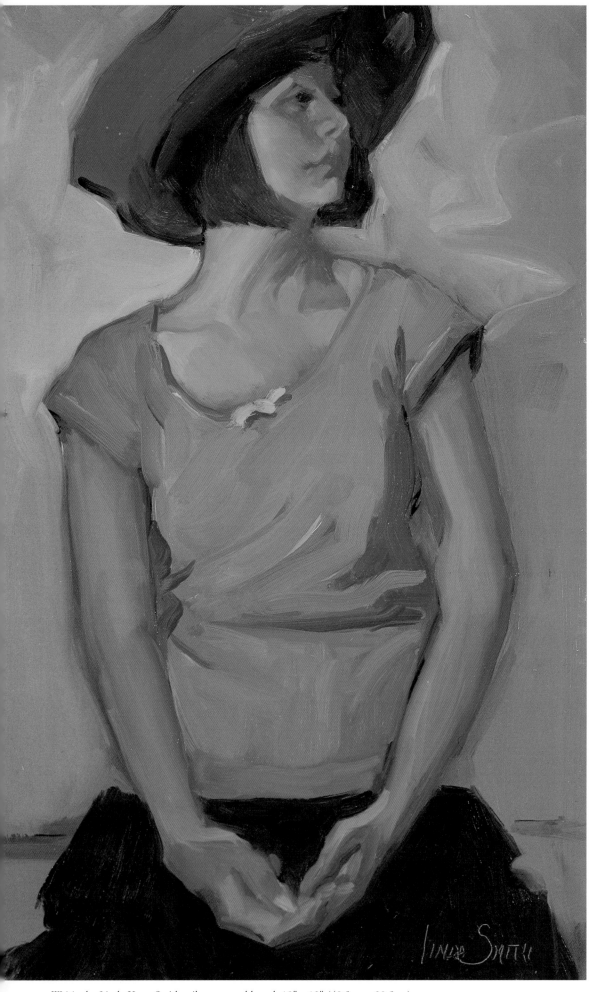

FIND A MODERN "GARBO"

LINDA KYSER SMITH

The model used in this painting has a face and attitude reminiscent of actress Greta Garbo, as well as the youth and modernity of today. The challenge was to record all of this and to keep life in the static pose. *Waiting* was painted on a gessoed board that had been toned with a mid-gray-green. I wanted to capture the gesture to indicate personality and create harmony of color for mood. Wet-into-wet, this painting was finished in a matter of hours. As it cured over the next week, the wet background wash infused itself into all of the colors used in the painting and created the harmony of color.

Waiting by Linda Kyser Smith, oil on gessoed board, 19" x 12" (48.5cm x 30.5cm)

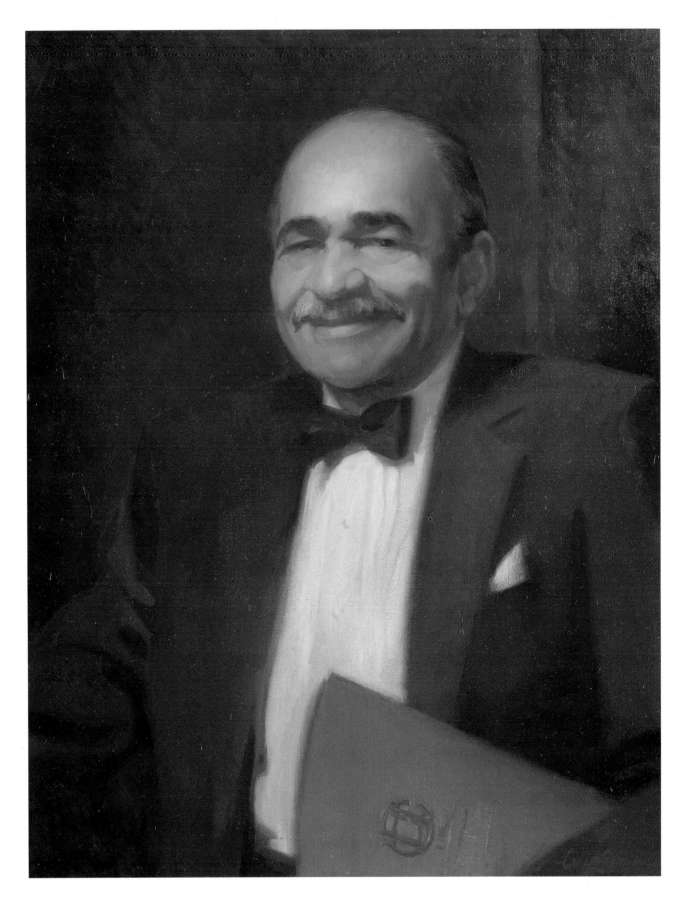

CAPTURE THE RHYTHM OF THE TORSO

CARL J. SAMSON

To honor their longtime friend and head maitre d', a group of University Club of Cincinnati members commissioned this portrait to grace one of the club's dining rooms. The goal was clearly defined: to paint Roscoe with his characteristic welcoming gesture, menu in hand and smiling broadly, as they have known him for some thirty years. As there are no hands showing, the bulk of this expressive gesture had to be conveyed by the rhythm of the torso and expression on the face. When painting from life, practice engaging your sitter in pleasant conversation, but never ask for a smile. Rather, try to say or do something amusing to elicit a natural expression.

Roscoe by Carl J. Samson, oil on linen canvas, 28" x 22" (71cm x 56cm)

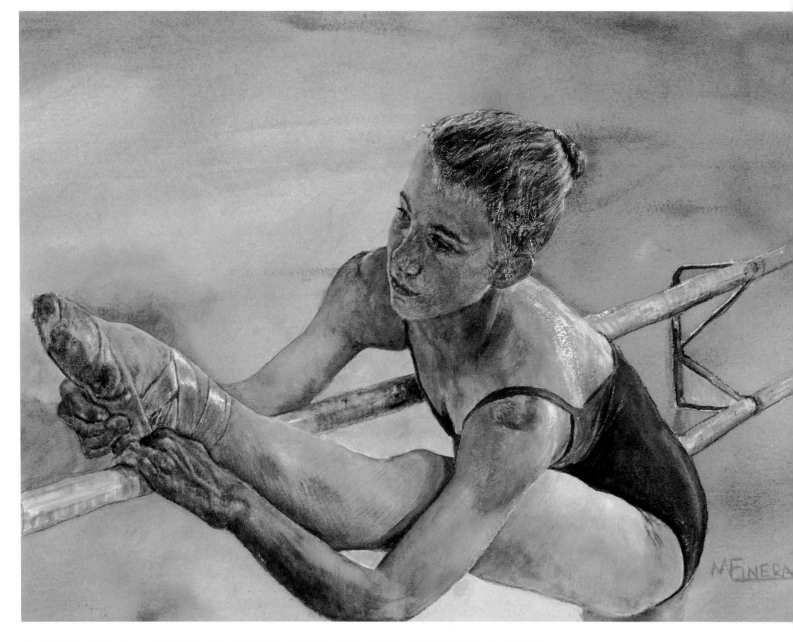

DEVELOP EMOTION WITH THE ANGLE OF THE BODY

MARTY FINERAN

My goal for painting *Kelly* was to capture the intensity and focus that this young woman possesses, at the age of thirteen, in the pursuit of perfecting her art. The purity of line and angle of her body, combined with the backlight, seemed to provide the right emotional atmosphere. I actually made her hands and shoes the focal point and her face secondary. But even with her face in the shadows, I wanted to convey her introspection and her melancholy. Instead of a more traditional frontal pose, I chose this diagonal line, accentuated by the barre.

Kelly by Marty Fineran, watercolor and acrylic on Arches 300 lb. cold-pressed watercolor paper, 16" x 22 ¾" (41cm x 58cm)

WATCH THE WAY YOUR SUBJECT MOVES

MARGARET CARTER BAUMGAERTNER

Clare takes over a room. She throws her shoulders back, tilts her head coquettishly and levels her direct gaze. Zap. You've been "Clared." Even at the age of six, Clare has a very distinct personality, temperament and attitude. After spending time with Clare, watching the way she moved, postured and related to the world, I allowed the painting to be directed by my impressions of her.

Clare by Margaret Carter Baumgaertner, oil on linen, 32" x 26" (81.5cm x 66cm)

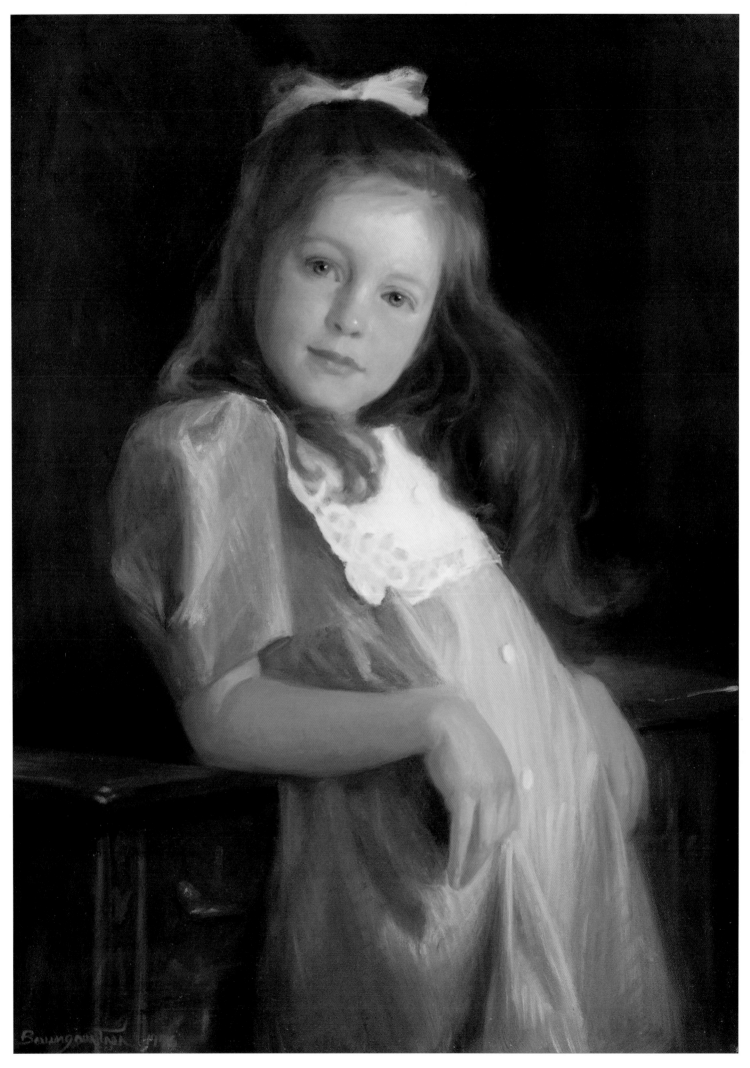

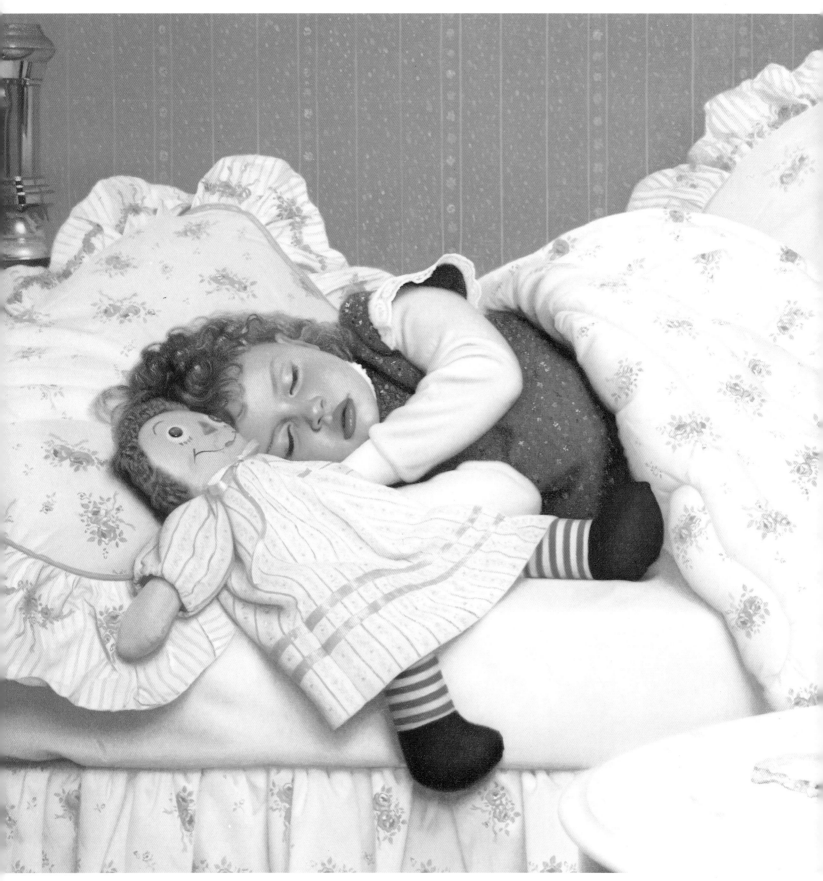

Jacqueline (Four O'Clock) by Stephen Gjertson, oil on canvas, 24" x 38" (61cm x 96.5cm)

TELL A STORY WITH

SETTING OR PROPS

The right props and setting can tell a story, set a mood or color scheme and generally affect the whole concept of your painting. Stephen Gjertson says that Jacqueline Olson's natural complexion is like a painted china doll: Capturing her coloring was the motivation for this complex portrait arrangement. Gjertson chose a sleeping motif to avoid the distraction of the model's dark eyes and to unify the value of her fair complexion. He then shopped for several days for the appropriate props and costume, built a tall model stand in his studio and arranged the props on it. When the model came to pose, she took her position under the covers and usually fell asleep. The painting was completed from life under the north light of Gjertson's studio skylights.

DEPICT A FAVORITE PASTIME

LORYN BRAZIER

With this particular portrait, the challenge was to make the composition fit within a long horizontal wainscoting over a mantel. A favorite pastime of the boys was to canoe on the canal near their home. Working from several of the ninety-six slides I took of them on the canal, I placed the younger, more outgoing brother in front so the eye would be drawn into the painting to the more reserved big brother. The goal was to have the portrait tell a story, show their personalities and describe the relationship between the two brothers. After establishing colors and value notes with a thin watercolor-like wash, sittings are important to capture likeness and personality.

Big Brother by Loryn Brazier, oil on canvas, 39" x 50" (99cm x 127cm)

INTEGRATE SUBJECT AND LANDSCAPE

JOHN POTOTSCHNIK

Working from photos provided to me by Mr. Lemert's daughter, my concern was to make the figure appear natural in the landscape, rather than cut out and pasted onto a background. This naturalism is achieved through hard and soft edges, accurate values and unified color. I always try to integrate all the colors through every part of the picture. Depth is achieved by lightening the value of background colors.

Mr. Amos Clay Lemert by John Pototschnik oil on Masonite, 16" x 12" (41cm x 30.5cm)

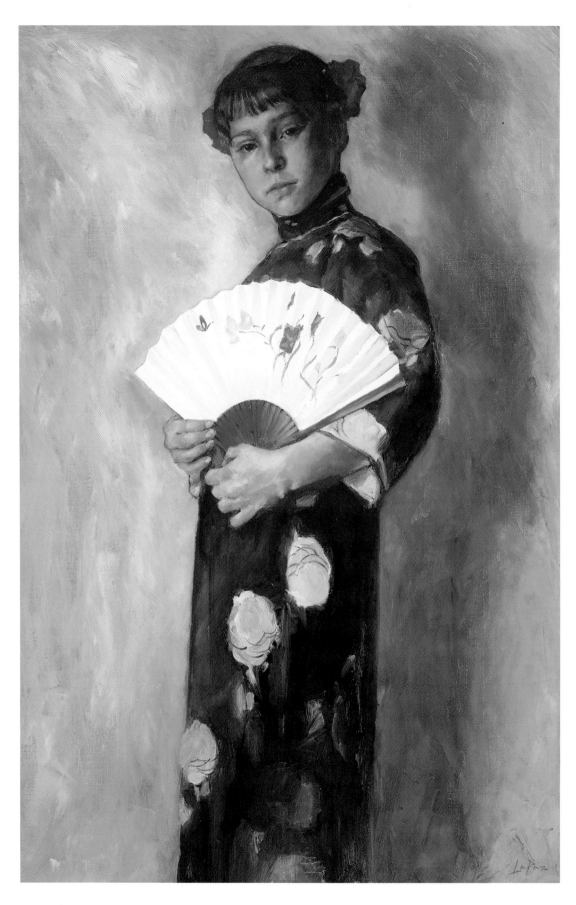

The Fan by Gail De La Paz, oil
on oil-primed linen, 38" x 25"
(96.5cm x 63.5cm)

LET THE MYSTERY OF OTHER CULTURES INSPIRE YOU

GAIL DE LA PAZ

The Fan was inspired by a *cheongsam* (Chinese dress) that my father bought while stationed in the
China-Burma-India theater during World War II. I am intrigued by the mystery of other cultures and
eras. For this painting, I researched Chinese clothing, hair, gestures, history and music. The model, my
daughter Jade, added to this spirit of youth — bold, honest and unguarded. I wanted to capture her
poise and create a sense of serenity. After sketching in charcoal, I paint in grisaille and then later cover
with a wash of color. Having my easel light off through most of the painting helps me see value and
avoid excessive detail.

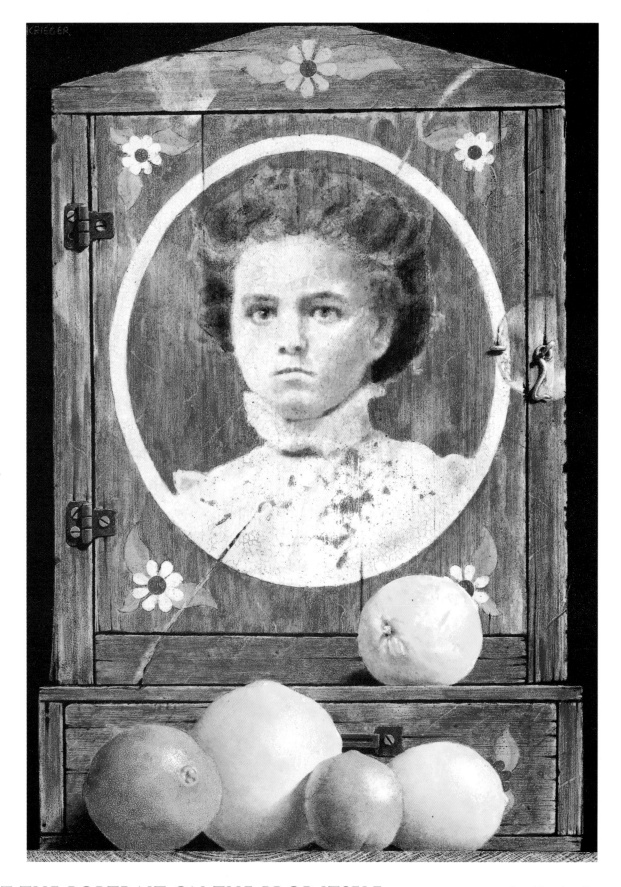

PAINT THE PORTRAIT ON THE PROP ITSELF

BUTCH KRIEGER

I am always experimenting with new ways to paint portraits and also to incorporate elements that express each personality. One way to achieve these goals is by doing a portrait in the form of a still life. This permits me to integrate an unlimited variety of images into my composition. Ghee Rhodes impressed me as a delightfully old-fashioned young woman. I imagined her face on a quaint old spice cabinet with fresh citrus fruit — all brought to life by her reserved yet enchanting gaze. I chose the super-realistic techniques of trompe l'oeil, building up textural effects with a monochromatic acrylic underpainting, over which I applied transparent glazes of oil colors. To ensure that Ghee remained the focus of attention, I placed her face in the center, so that she makes direct eye contact with the observer.

Grand Daughter (Portrait of Ghee Rhodes) by Butch Krieger, acrylic and oil on Masonite, 20⁵⁄₁₆" x 13¹³⁄₁₆" (51.5cm x 35cm)

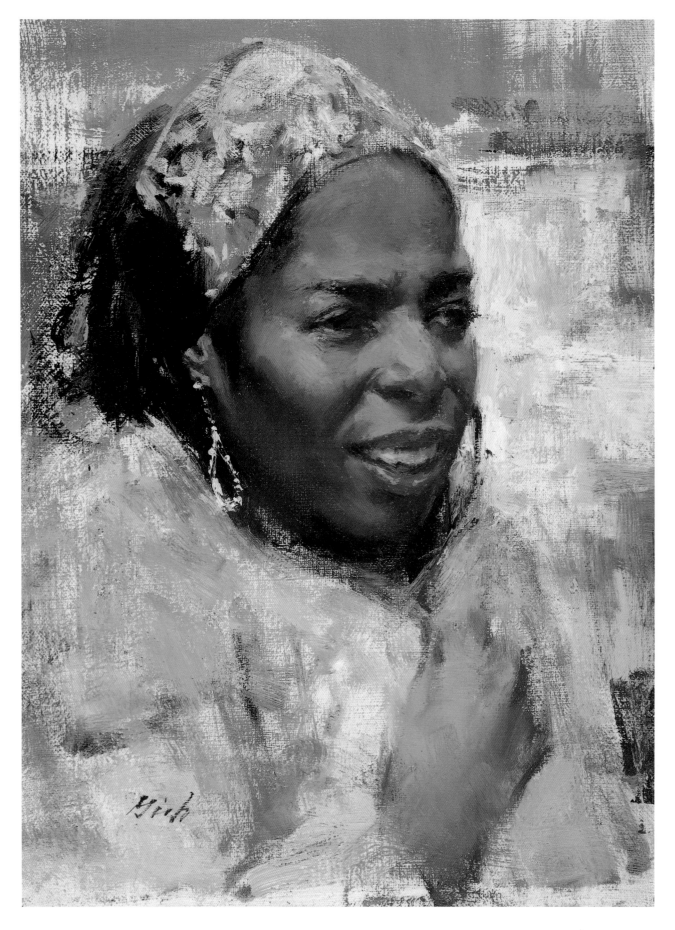

A PAISLEY HEADBAND INSPIRES A PORTRAIT

DEL GISH

Iris and I worked for the same organization, and I drew and painted her several times. She was an aspiring actress and wasn't shy about posing. When I saw her in this paisley headband, I suggested it would look good in a painting. She agreed to a photo because there was no time to sit. The painting was done on oil-primed linen glued to a Masonite panel. My idea was to leave a lot of canvas showing. This required drybrush work, except on the face, where care was taken to model the features.

Iris by Del Gish,
oil on linen,
12" x 9"
(30.5cm x 23cm)

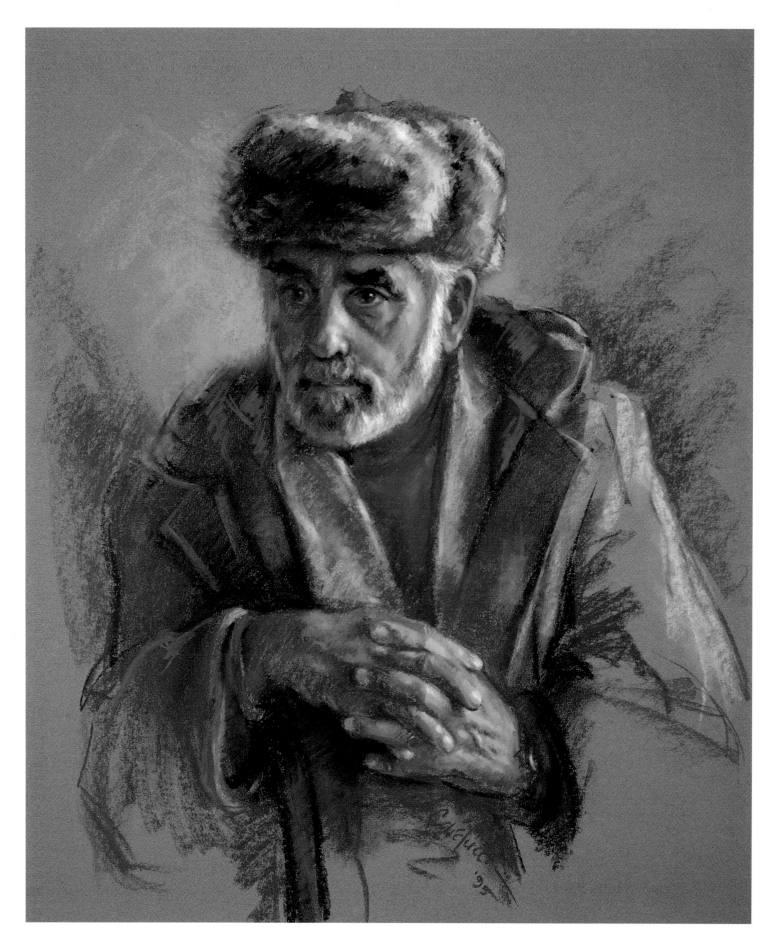

Man in a Russian Hat by Judith B. Carducci, soft pastel on Canson Mi-Teintes paper, 25" x 21" (63.5cm x 53.5cm)

A RUSSIAN HAT FOR A MEMORABLE PORTRAIT

JUDITH B. CARDUCCI

This portrait of my husband was painted purely for pleasure, a vacation from formal commissioned pieces. He bought the hat when we were in Moscow, but since he's shy about wearing it, I had to paint him in it to preserve the memory. He is an intense and thoughtful man, and he took a lively interest in the painting process, which contributed to the alert expression.

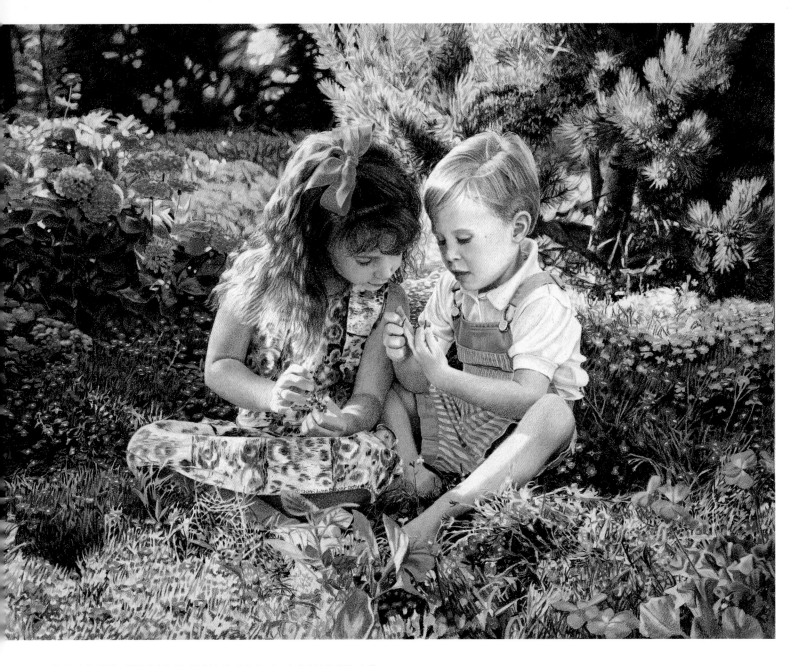

PLANT CHILDREN IN A NATURAL ENVIRONMENT

SHERI LYNN BOYER DOTY

In *A Study in the Violets*, my client wanted her children in a natural environment, with flowers framing them. We "planted" them in a patch full of violets. After they had settled into their environment they became a part of it, exploring the bugs and vegetation. I photographed the children in late afternoon so long shadows and side lighting would define the scene. In this pencil painting, I wanted to express the timeless inquisitiveness of children and capture the likenesses of the client's son and daughter: a portrait *and* an expression of life.

A Study in the Violets by Sheri Lynn Boyer Doty, Prismacolor color pencils on cold-pressed Bristol board, 14½" x 19" (35.5cm x 48.5cm)

SURROUND A CHILD WITH HIS FAVORITE TOYS

ROBERTA CARTER CLARK

Having painted several portraits of Michael's family over the years, I was delighted when Michael's mother asked me to paint him. He had always been his "own man," and had enormous eyes and a smile to light up the world! I wanted something very different for his portrait, so I painted him standing, with all his favorite toys around him. He was barely four, so to convey his youth I wanted primary colors in the toys and clothing. The background is entirely from imagination. Not everyone will like this very busy background, but to me it expresses Michael's exuberant personality.

Michael by Roberta Carter Clark, AWS, transparent watercolor on Arches 220 lb. cold-pressed paper, 40" x 26" (102cm x 66cm)

FAVORITE BOOKS SPEAK OF INTROSPECTIVE NATURE

JOSEPH H. SULKOWSKI

I communicated Allison's introspective nature by including a stack of favorite books. Her dog, Annie, gazes up with devotion. I conveyed my sitter's young, dynamic personality by placing her at an angle on the chair and by emphasizing the tension and determination in her left arm and hand. Allison's distinctive red hair and luminous green eyes made painting this portrait a delightful experience. I have always been drawn to the chiaroscuro technique of the Old Masters. In this method, the head is illuminated in a three-quarter light, so that the forms of the face are revealed with dramatic relief. Shadows accentuate the mystery of a sitter's countenance and become a profound reference to the more private nature.

Allison by Joseph H. Sulkowski, oil on Belgian linen, 42" x 38" (107cm x 96.5cm)

Mr. and Mrs. George Draper
by Joy Thomas, oil on linen,
54" x 40" (137cm x 102cm)

A HOME SETTING CAN EXPRESS HOSPITALITY

JOY THOMAS

When I met with Mr. and Mrs. Draper to discuss their portrait, they gave me a tour of their grand
Victorian home, filled with wonderful treasures. Since they are among the most gracious and hospitable
people I have ever met, it was important to capture their grace and sense of tradition in the portrait.
Making the interior of their home a part of the composition, I arranged furniture and objects in a beau-
tifully lit corner of their parlor. I did much work from life, starting with small charcoal and watercolor
studies. Eventually I took some photographs and began the large canvas in my studio, using my studies
in combination with the photo details. One more sitting from life resolved the final composition.

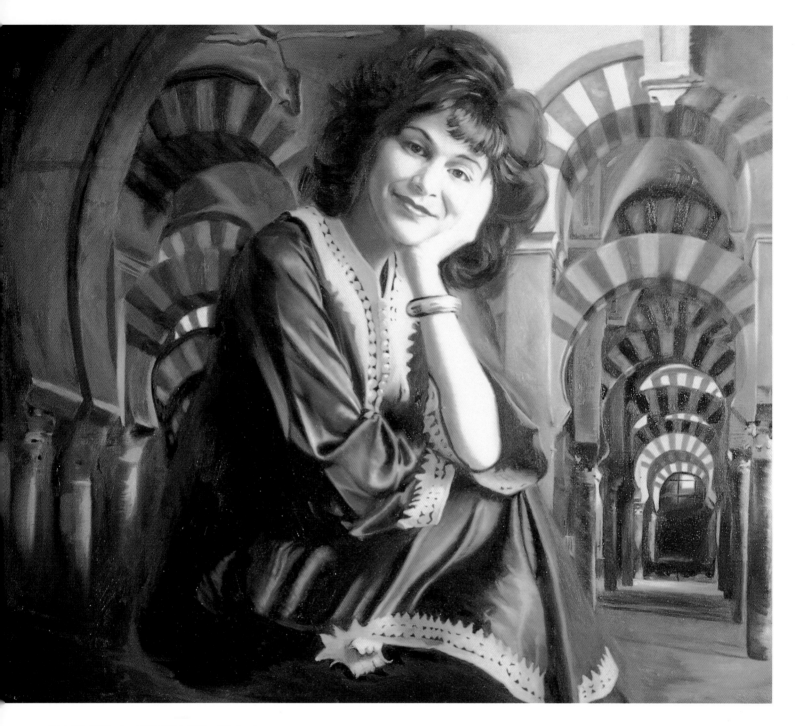

PAINT A FRIEND IN A MEANINGFUL LOCATION

THOMAS JOYCE

I like to place people in surroundings that convey something unique about them. Cristina is a good friend who introduced me to the magnificent architecture and art of Spain. So in this painting, I tried to harmonize her vivid clothing with the splendor of the Mezquita-Catedral in the background. I have profound respect for this monument, which dates to the eighth century; it was a perfect place to paint Cristina.

Cristina in Cordoba by Thomas Joyce, oil on Belgian linen, 32" x 38" (81.5cm x 96.5cm)

PORTRAY A CULTURE WITH A TRADITIONAL COSTUME

SHUQIAO ZHOU

This is one of a series of portraits of ethnic minorities I visited in many of China's fifty-six indigenous communities. I feel an eternal interest in documenting their glamorous costumes and their traditional cultures. Young Miao women design, cut, print (like batik) and sew their own garments from start to finish, thus becoming skilled seamstresses before marriage. Their best dress becomes their wedding costume. In a preliminary version of this painting, I had chosen an imaginary landscape as a background. When that canvas was stolen, my anger made me determined to complete a larger version. Here I used an elaborate and delicate woodcarving, an example of the expert craftsmanship of this people. In this portrait, rich color and three-dimensional volume have been sacrificed to emphasize strong, glowing color and light and fine-detail drawing.

The Miao Girl by Shuqiao Zhou, oil on canvas, 51" x 37" (129.5cm x 94cm)

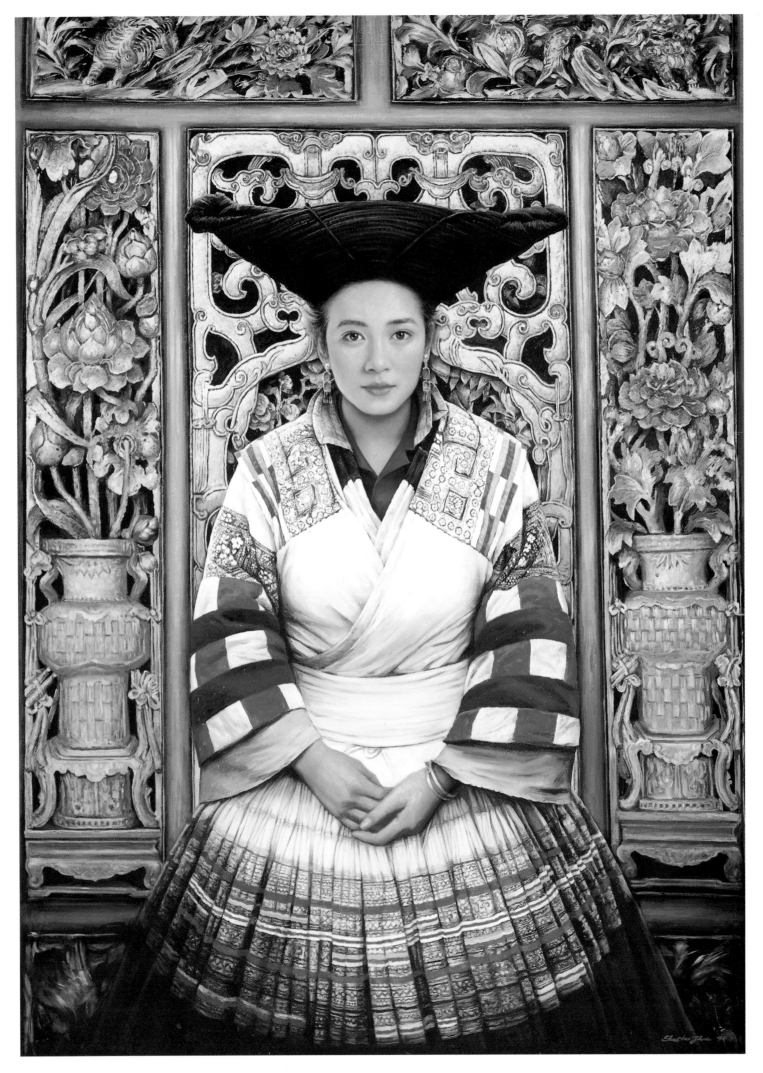

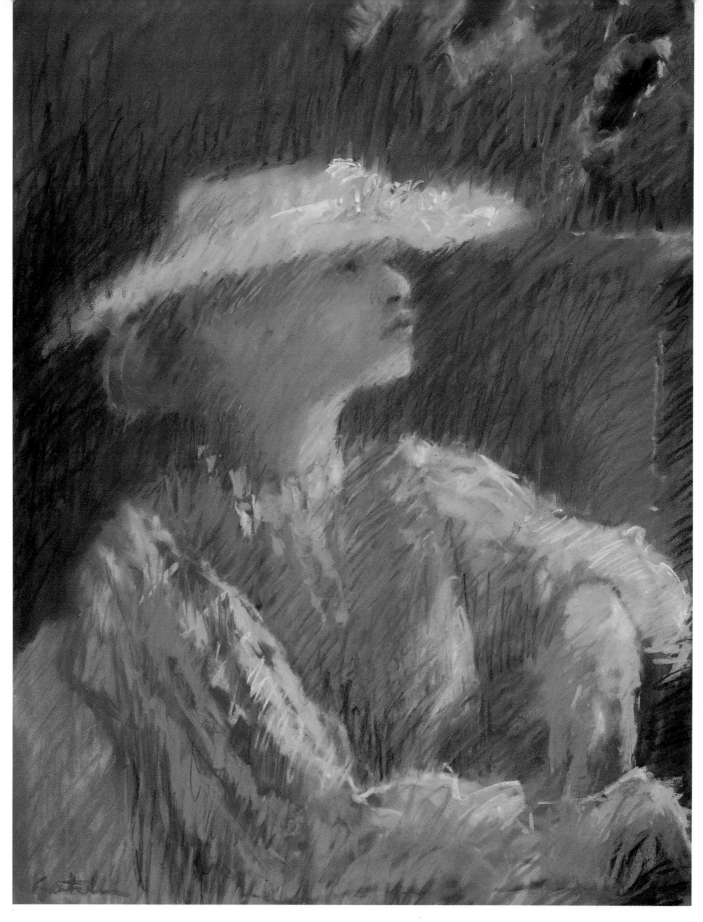

Miss Annabelle Sue by Carole Katchen, Sennelier pastels on La Carte paper, 25" x 19" (63.5cm x 48.5cm)

AN OLD HAT SUGGESTS A MODERN SOUTHERN BELLE

CAROLE KATCHEN

This painting began with a wonderful old hat. After I found the hat, I needed a model who would look comfortable in it. I found her in a friend who has just the right combination of femininity and independence to be a modern Southern Belle. She took this pose naturally, with her chin tilted up. I emphasized that attitude with lighting, having a highlight fall on the neck and tip of the chin. The hint of sunflowers in the background suggested a gracious environment. When I paint from a live model I like to work fast, and the loose, sketchy quality of the strokes reflects that. The most defined part of the painting is the contour of the face, to emphasize the subject's attitude.

HEIRLOOMS EXPRESS PROUD HERITAGE

MARY BETH SCHWARK

Little Girl Blue by Mary Beth Schwark, oil on canvas, 14" x 11" (38.5cm x 28cm)

Native American pow wows are colorful events attracting inventive costuming from tribes nationwide. Beads, feathers, buckskin, yarn and exquisite fabrics swirl in rhythm to the drums. Often the outfits include a family heirloom: *Little Girl Blue* is no exception. Her beaded headband was handmade by an aunt, and her headpiece made of porcupine hair — called a *roach* — was passed down through generations. I was attracted to her contented countenance and painted her as a testimony to her proud heritage.

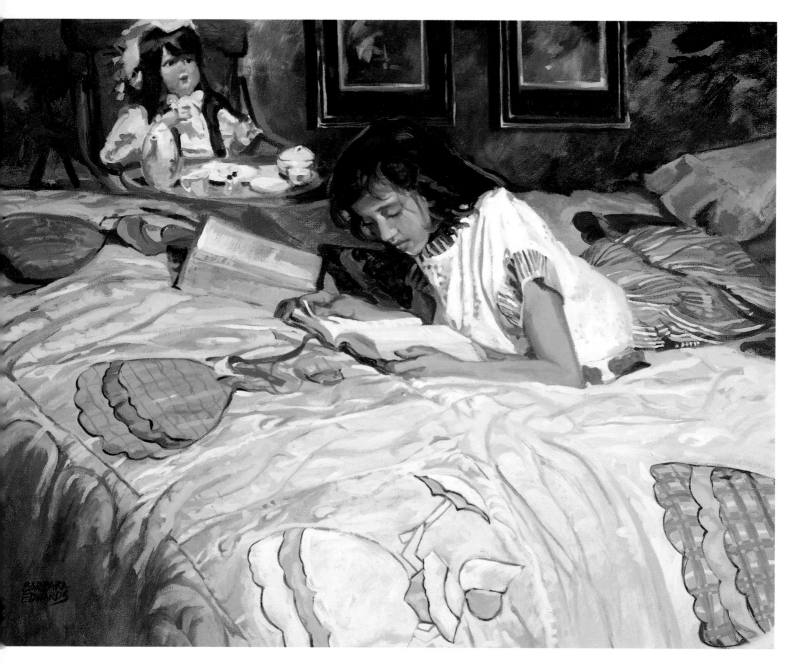

When I Was a Child by Barbara Summers Edwards, oil on canvas, 22" x 28" (56cm x 71cm)

BIBLE VERSE RECALLS CHILDHOOD EXPERIENCE

BARBARA SUMMERS EDWARDS

This work was inspired by a spiritual experience I had as a girl. When I first heard the Bible verse 1 Corinthians 13:11, "When I was a child, I spake as a child, I understood as a child, I thought as a child: but when I became a man, I put away childish things," it was an awakening experience for me. I wanted to share that inspiration through this painting. I found a model, set up the props and shot photographs using a good solid light source. I let my model pose naturally with as little direction as possible. I covered the canvas with a wash of cool blue so I could work warm against cool.

A LOCAL COFFEE HOUSE IS THE PERFECT SETTING

CLAIRE SCHROEVEN VERBIEST

When a friend commissioned me to do a portrait of her toddler, she knew exactly what she wanted. Mother and daughter were regulars at the town's bustling coffee house, where the child's habit was to request a cup of foamed milk. Employees and patrons alike were always amused by her charming table manners. Inevitably, some of the drink would become a milky mustache and the spoon a makeshift drumstick — but of course, kids will be kids! For skin tones in watercolor I like to use a combination of Aureolin, Permanent Rose and Cobalt Blue.

Latté Time by Claire Schroeven Verbiest, watercolor on 140 lb. Arches hot-pressed watercolor paper, 7" x 5" (18cm x 13cm)

Highland Path by
Gail De La Paz,
pastel on La Carte
paper, 24" x 16"
(61cm x 41cm)

SEE ANOTHER PLACE AND TIME IN THE PATHS AROUND YOU

GAIL DE LA PAZ

The cliffs and coves along the west coast of Whidbey Island inspired *Highland Path*. The slopes and pathways are timeless — reminiscent of the Scottish Highlands. To enhance this idea, I researched the geography, history, clothing and music of Northern Scotland. My daughter, Crystal, posed. Her expression reminded me of the Valkyries, maidens of the mythological Norse god Odin, who conduct heroes slain in battle to Valhalla. I wanted to create a peaceful and enchanting mood using the charming, gentle side of youth.

CONTRIBUTOR INFORMATION AND PERMISSIONS

MONICA ACEE
Hillcrest Farm
6618 Bogusville Hill Rd.
Deansboro, NY 13328
Portrait of an American Farmer
© Monica Acee, pp. 60-61

KURT ANDERSON
275 E. Fourth St., Suite 750
St. Paul, MN 55101
(612) 292-9560
Portrait of Jennifer Shegos © Kurt
Anderson, p. 115

CAROL BAKER
32661 Pearl Dr.
Fort Bragg, CA 95437
(707) 964-2309
Christmas Angel © Carol Baker,
private collection, p. 93

CORINNE BAKER
1825 Jessica Rd.
Clearwater, FL 34625
(813) 797-7404
Elizabeth © Corinne Baker, p. 110

HOLLY HOPE BANKS
P.O. Box 233
Safety Harbor, FL 34695
Ms. Ramona Tumblin © Holly
Hope Banks, collection of H.R.
Tumblin, p. 72

MARY JANE KLATT BARNARD
P.O. Box 453
Dayton, WY 82836-0453
Katherine © Mary Jane Klatt
Barnard, collection of the artist,
p. 91
Nancy, My Daughter, My Muse
© Mary Jane Klatt Barnard,
collection of Nancy Barnard
Ramsey, p. 102

SABINE M. BARNARD, NWS
1722 South Delaware Pl.
Tulsa, OK 74104
Klein at Home © Sabine M.
Barnard, p. 99

MARGARET CARTER BAUMGAERTNER
Baumgaertner Portraits
621 South Twenty-eighth St.
La Crosse, WI 54601
Clare © Margaret Carter
Baumgaertner, p. 119

JOYCE ANN BIRKENSTOCK
11692 North Lake Dr.
Boynton Beach, FL 33436
(561) 737-5931
(561) 737-1270 (fax)
http://www.prtraits.com/
birkenstock
Watching and Waiting © Joyce
Ann Birkenstock, p. 111

JOSEPH S. BOHLER
556 Trumbull Lane
P.O. Box 387
Monument, CO 80132
(719) 481-4251
*Afternoon Sunshine — Piazza San
Marco* © Joseph Bohler, private
collection, p.37

LORYN BRAZIER
Brazier Fine Art
3401 West Cary St.
Richmond, VA 23221
(804) 359-2787
Big Brother © Loryn Brazier,
collection of John T. West IV,
p. 122

TOM BROWNING
P.O. Box 2193
Sisters, OR 97759
New Dresses © Tom Browning,
p. 109

CAROL BRUCE
5004 De Quincey Dr.
Fairfax, VA 22032
Smile © Carol Bruce, collection of
Mr. and Mrs. J. Roan Rickard,
Okemos, MI, pp. 10-11

JUDITH B. CARDUCCI
197 Sunset Dr.
Hudson, OH 44236
Man in a Russian Hat © Judith
Carducci, private collection,
p. 126

ROBERTA CARTER CLARK, AWS
47B Cheshire Square
Little Silver, NJ O7739
Michael © Roberta Carter Clark,
collection of Mr. and Mrs.
James W. Warshauer, p. 129

A. HEESEN COOPER
201 West St.
Media, PA 19063

Linda and Baby © A. Heesen
Cooper, collection of the artist,
p. 44
Old Friends © A. Heesen Cooper,
collection of the artist, p. 98

GAIL DE LA PAZ
P.O. Box 816
Snohomish, WA 98291
The Fan © Gail De La Paz, collec-
tion of the artist, p. 124
Highland Path © Gail De La Paz,
collection of the artist, p.138

L. KATHY DEATON
604C Griffin St.
Santa Fe, NM 87501
The Seventh Summer © L. Kathy
Deaton, collection of the artist,
p. 51

JANE DESTRO
The Studio of Jane Destro
1122 Tenth St. SW
Rochester, MN 55902
I'm Ready! © Jane Destro, private
collection, p. 15

FRAN DI GIACOMO
P.O. Box 503
Addison, TX 75001
Kleinert Family © Fran
Di Giacomo, p. 85

MIKKI R. DILLON
662 Dorsey Circle
Lilburn, GA 30247
Nigerian Dreaming © Mikki R.
Dillon, p. 33

D.J. DIMARIA
220 Chadeayne Rd.
Ossining, NY 10562
Waiting © D.J. DiMaria, p. 65

SHERI LYNN BOYER DOTY
2995 East 4540 South
Salt Lake City, UT 84117
A Study in the Violets © Sheri Lynn
Boyer Doty, collection of the
Webber family, p. 128

MOHAMED DRISI
Drisi Studio of Fine Art
100 W. Main St.
Glenwood, IL 60425-1616
(708) 758-5143
Donna © Mohamed Drisi,

collection of Wayne and
Yvonne Cowell, Downer's
Grove, IL, p. 22

NANETTE DRISI
Drisi Studio of Fine Art
100 W. Main St.
Glenwood, IL 60425-1616
(708) 758-5143
Leona © Nanette Drisi, private
collection, p. 17

JEANE DUFFEY, FCA
211 Morningside Dr.
Delta, British Columbia
Canada V4L 2M3
(604) 943-4406
(604) 943-3863 (fax)
Susannah © Jeane Duffey, collec-
tion of Mr. and Mrs. Lyle Flaig,
p. 64

ANATOLY DVERIN
Clementine © Anatoly Dverin, pp.
42-43
A Man in a White Hat © Anatoly
Dverin, p. 95

BARBARA SUMMERS EDWARDS
580 Canyon Rd.
Smithfield, UT 84335
(801) 563-3553
When I Was a Child © Barbara
Summers Edwards, collection
of William and Marie Bodily,
Smithfield, UT, p. 136

LOUIS ESCOBEDO
1045 Garfield St.
Denver, CO 80206
Garden Flowers © Louis Escobedo,
p. 48

MARTY FINERAN
4510 Cuttinghorse Pl.
Colorado Springs, CO 80922
Kelly © Marty Fineran, p. 118

LISA FIELDS FRICKER
Fricker Studio, Inc.
8865 North Mount Dr.
Alpharetta, GA 30202
(770) 642-2148
Portrait of Martha McInnish
© Lisa Fields Fricker, p. 76

BOB GERBRACHT
1301 Blue Oak Court

Palos Park, IL 60464
(708) 361-0679
Linzie © Kathleen Putnam
 Newman, p. 91
True Confessions © Kathleen
 Putnam Newman, p. 112

ANNE MARIE OBORN
1226 E. 1800 S.
Bountiful, UT 84010
(801) 298-5694
Cecile © Anne Marie Oborn,
 private collection, pp. 24-25
Remnants of Korea © Anne Marie
 Oborn, private collection, p. 39

CAROL ORR, AWS, NWS
P.O. Box 371
La Conner, WA 98257
Moment of Rest © Carol Orr,
 p. 114

JANET PALMER
13th Lake Rd.
North River, NY 12856
October Light © Janet Palmer,
 private collection, p. 97

JOYCE PIKE
2536 Bay Vista Lane
Los Osos, CA 93402
(805) 528-3331
Jeanette © Joyce Pike, p. 16

JOHN POTOTSCHNIK
6944 Taylor Lane
Wylie, TX 75098
Painter, Sculptor, Teacher, Friend ©
 John Pototschnik, collection
 of Mr. and Mrs. David Ferre,
 p. 40
Vanishing Resources © John
 Pototschnik, collection of Elliot
 Maisel, p. 67
Mr. Amos Clay Lemert © John
 Potoschnik, collection of Lisa
 McGovern, p. 123

MARILYN-ANN RANCO, PSA
211 Outremont Ave.
Montreal
Canada H2V 3L9
(514) 495-2943
A Pair of Wings on the Dock ©
 Marilyn-Ann Ranco, p. 55

CONNIE LYNN REILLY
913 Main St., Suite B
Stone Mountain, GA 30083
(770) 879-1066
Christine © Connie Lynn Reilly,
 p. 90

CONNIE RENNER
6623 S. Prescott Way
Littleton, CO 80120
(303) 795-2178

Sarah © Connie Renner, private
 collection, p. 12

KIRK RICHARDS
P.O. Box 50932
Amarillo, TX 79159
Marissa (Starting a New Ristra)
 © Kirk Richards, p. 96

CARL JOSEPH SAMSON
2152 Alpine Place
Cincinnati, OH 45206
Amanda © Carl J. Samson, private
 collection, p. 29
Roscoe © Carl J. Samson,
 collection of University Club,
 Cincinnati, OH, p. 117

CHRIS SAPER
Chris Saper Portraits
125 East Coronado
Phoenix, AZ 85004
(602) 957-8107
Jesse's Braids © Chris Saper, p. 81

DONA R. SAWHILL
3671 Summit Ridge Dr. NE
Atlanta, GA 30340-4119
Storytime for Katie © Dona R.
 Sawhill, p. 28

MARY BETH SCHWARK
612 Oreja De Oro
Rio Rancho, NM 87124
(505) 892-7752
Pueblo Beauty © Mary Beth
 Schwark, p. 32
Little Girl Blue © Mary Beth
 Schwark, p. 135

RACHELLE SIEGRIST
3396 NW Thirty-fourth Ave.
Okeechobee, FL 34972-1232
(941) 467-9858
Pure Country Pride © Rachelle
 Siegrist, p. 78
The Cradle Robber © Rachelle
 Siegrist, collection of Steve and
 Dianne Hulen, pp. 104-105

LINDA KYSER SMITH
Portraits, Etc., Inc.
P.O. Box 1888
Ruidoso Downs, NM 88346
(505) 378-8101
Waiting © Linda Kyser Smith,
 p. 116

PERRI SPARKS
3114 Gladiolus Lane
Dallas, TX 75233
Alexander Was Here © Peri Sparks,
 p. 94

JOSEPH H. SULKOWSKI
212 Paddock Lane
Nashville, TN 37205-3337

(615) 352-5493
Allison © Joseph H. Sulkowski,
 collection of Mr. and Mrs.
 Thomas Patten, p. 130

BRUNO SURDO
7929 N. Tripp Ave.
Skokie, IL 60076
My Twin © Bruno A. Surdo,
 p. 53

ROBBY D. TATUM
Fork Mountain Art Studio
2354 Virgil H. Goode Hwy.
Rocky Mount, VA 24151
(540) 483-7278
Waiting © Robby D. Tatum,
 p. 56

JAMES E. TENNISON
5500 Bradley Court
Arlington, TX 76017
Rush © James E. Tennison,
 collection of Mr. and Mrs. Jim
 Dorsett III, p. 21
Pamela © James E. Tennison,
 collection of Mr. and Mrs. Bill
 Evans, p. 80

JOY THOMAS
Thomas Studio
5303 Wiswell Rd.
Murray, KY 42071
(502) 435-4361
http://www.prtraits.com/thomas
Mr. and Mrs. George Draper © Joy
 Thomas, collection of Mr. and
 Mrs. George Draper, p. 131

ALEKSANDER TITOVETS
6213 Fiesta Dr.
El Paso, TX 79912
(915) 585-3043
Ebb Tide — Persephone
 © Aleksander Titovets, p. 66

MAGGIE TOOLE
3655 Colonial Ave.
Los Angeles, CA 90066
Candidly Posed © Maggie Toole,
 collection of Jimi Toole,
 p. 19

CARON R. TUTTLE
P.O. Box 233
Poteet, TX 78065
(210) 276-3488
(210) 742-3515
Erinn © Caron R. Tuttle, p. 27

ANNE VAN BLARCOM KUROWSKI
16 First St.
Edison, NJ 08837
Face Up © Ann Van Blarcom
 Kurowski, p. 14
Naomi © Ann Van Blarcom
 Kurowski, p. 68

CLAIRE SCHROEVEN VERBIEST
3126 Brightwood Court
San Jose, CA 95148
Peekaboo © Claire Schroeven
 Verbiest, private collection,
 p. 113
Latté Time © Claire Schroeven
 Verbiest, private collection,
 p. 137

SHARYNE E. WALKER
P.O. Box 4023
Napa, CA 94558
The Crimson Palette © Sharyne
 E. Walker, p. 69

ARNE WESTERMAN
711 SW Alder, Suite 313
Portland, OR 97205-3429
Hilary at the Piano © Arne
 Westerman, private collection,
 p. 83
Amaya Lathrop on Chair © Arne
 Westerman, private collection,
 p. 108

PAUL F. WILSON
P.O. Box 133
Rollinsville, CO 80474
Jennine © Paul F. Wilson, p. 35

SHUQIAO ZHOU
1133 S. Monterey St.
Alhambra, CA 91801
(818) 289-9687
Mr. Pennington © Shuqiao Zhou,
 collection of the Occidental
 College Library, Los Angeles,
 p. 87
The Miao Girl © Shuqiao Zhou,
 p. 135

INDEX

More Great Books
for Beautiful Art!